Praise for *R

"A sensitive look at the inner world of India's first woman doctor, the pain and suffering she endured, and the determination that drove her remarkable and inspiring journey."

 — **Shrabani Basu**, author of *Victoria and Abdul*

"In the company of a brave and determined young woman, *Radical Spirits* takes us to the fraught social and religious frontier between two cultures, India and America in the late 1800s. The journey makes for a captivating story, every page granting insights into the age-old struggle to surmount entrenched borders and barriers."

 —**Robert Kanigel**, author of *The Man Who Knew Infinity*
 and *Eyes on the Street*

"Deeply researched and accessibly written, this intimate portrait is also a social and cultural history of the circuits of a transnational figure who made medical history. Readers of *Radical Spirits* will come away with a critical appreciation of the worlds Anandi Joshee traveled through and the challenges she faced as she pursued a medical education and "a new independent self." Of equal historical significance is the history of her husband, Gopal, and the frictions at the heart of "companionate" marriage in 19th century India that this study makes visible. Despite her short life, Dr. Joshee found kith and kin in India, Britain and beyond. Nandini Patwardhan has brought the paradoxes of her life alive for a new generation of readers."

 —**Antoinette Burton**, historian of 19th and 20th century Britain and its empire, with a specialty in colonial India, University of Illinois, Urbana-Champaign

"*Radical Spirits* is the story of a remarkable woman and of a life lived across borders of many kinds. By telling the history of Anandi-bai Joshee, Nandini Patwardhan has crafted a uniquely intimate and revealing portrait of the long history of migrants from India to America. A beautiful story and a rich history, *Radical Spirits* reveals how individual lives matter, and how one pioneering woman crossed the borders of nations and cultures, as well as the gendered boundaries of the medical profession."

–**Nico Slate**, Professor of History at Carnegie Mellon University and author of *Lord Cornwallis Is Dead: The Struggle for Democracy in the United States and India* and *Gandhi's Search for the Perfect Diet:Eating with the World in Mind*

"As an Indian-American woman, I am so grateful to Nandini Patwardhan for taking the time and effort to excavate the life story of Anandi Joshee, a remarkable Indian woman. Patwardhan has capably incorporated letters and newspaper articles to craft a compelling, poignant, and inspiring biography of Dr. Joshee. I thoroughly enjoyed every word, and I am in awe of Patwardhan's accomplishment. Dr. Joshee's life story will stay with me forever. This book is a treasure for anyone interested in strong, path-breaking women."

–**Jyotsna Sreenivasan**, author of *And Laughter Fell from the Sky* and *Aruna's Journeys*

"Every significant life needs to be chronicled and remembered so it can be an inspiration to future generations. Through extensive research and lucid writing, Nandini Patwardhan has brought Dr. Anandibai Joshee's amazing achievement, grit and dedication to her goal into the public space once again. I am sure the book will inspire, motivate and educate even as it proves a great read of a great life."

–**Sathya Saran**, Indian journalist, author, and former editor of *Femina*

RADICAL SPIRITS

India's First Woman Doctor
and
Her American Champions

RADICAL SPIRITS

India's First Woman Doctor

and

Her American Champions

by

Nandini Patwardhan

Story Artisan Press

Raleigh, NC and Singapore

First published in 2020 by Story Artisan Press

Paperback ISBN: 978-1-7340631-1-0
E-book ISBN: 978-1-7340631-0-3

Library of Congress Control Number: 2019919904

Book design: Melinda Fine
Cover design: http://www.AuthorSupport.com

Story Artisan Press
Raleigh, NC and Singapore
http://www.storyartisan.com

I dedicate this book to
my parents Aai and Appa
And my grandparents Aji and Nana

Contents

AUTHOR'S NOTE

In order to retain the authenticity of the period, I have used the then-prevalent names of various Indian cities. Hence, Bombay for present-day Mumbai, Kolapore for Kolhapur, etc.

Two special styles have been used to highlight statements by a "speaker."

> *In the first case, quotes from letters are displayed using this format. It is hoped that the reader will get a clearer sense of the relationship between the writer and the recipient of the letter.*

In another case:

> Excerpted material from all other sources, including newspaper reports, diary entries, and books are displayed like this.

Finally, after introducing the main protagonists—Anandi Joshee, Gopal Joshee, and Theodocia Carpenter—I have referred to them by their first names.

Anandi is popularly referred to with the honorific suffix *bai* (approximately meaning *Madame Anandi*). I chose to drop the suffix because it is not part of her given name. I also wanted the reader to remain focused on her youth, which in turn highlights her vulnerability and courage. In the case of Gopal, it seemed equitable that his default honorific suffix, *rao*, be dropped as well.

As for Theodocia Carpenter, her relationship with Anandi and Gopal was like that of an Aunt. Since she was not the formal and distant Mrs. Carpenter to the Joshees, I decided to bring the reader into their circle of intimacy by referring to her as, simply, Theodocia.

INTRODUCTION

Writing a biography is a delicate—not a reckless—process, where the end result, if done properly, is simply the truth revealed.
Carol M. Ford

I invite you to read the story of Anandi Joshee, the first woman from India who became a doctor, and of the many Americans who made it their mission to help her succeed. It is the story of a daughter of India who became a niece of America. It is a remarkable chapter in the story of the universal human search for progress—a story that continues to unfold even today.

My recollection of Anandi Joshee was triggered over a decade ago when I read a biography of Indian mathematician S. Ramanujan (*The Man Who Knew Infinity* by Robert Kanigel). Having majored in mathematics in India, I had heard of Ramanujan. I enjoyed the biography because it told a story that was richer and more layered than the one I had known. I savored the spot-on descriptions of Ramanujan's humble and ascetic lifestyle. It was fascinating to learn of the complex relationship between Ramanujan and his English mentor. Just as important, it felt wonderful to realize that, despite the relative scarcity of preserved artifacts in India, it is possible for a skilled researcher to shed new light on long-forgotten Indian lives.

As I reached the end of the book, the name "Anandi-bai Joshee" popped into my head. I had not thought of her in nearly four decades. Having heard of her when I was growing up in India, I had a child's understanding of her story:

> The first Indian woman who became a doctor was Anandi Joshee. She had to go abroad to study. While she was there, her husband wrote her angry letters. When she became ill, she could not use Western medicines because they might contain meat and alcohol. She died soon after returning to India.

Reminiscing, Anandi's story seemed like one of Aesop's fables or an event from Hindu mythology—stories that offered a pat moral. Except, was there a moral to this story? If yes, what was it? I was too young then to be curious about the specifics.

A few months after reading Ramanujan's biography, in a stroke of serendipity, I came across a story about Anandi online. It jumped out at me because it mentioned that her ashes were buried in a cemetery in upstate New York, in a plot belonging to the family of a woman named Theodocia Carpenter.

I was electrified by what this could mean. The late nineteenth century time frame meant that the two women had bonded in an era when racial and religious attitudes were more rigid than they are today. How did the two women find each other? What made them so committed to each other? I was fascinated.

My grandmother, who was educated in India only through the fourth grade, was married at fourteen. Being familiar with her simple life that revolved around the home, I could well imagine the internal leaps and external hurdles that Anandi

would have had to master—almost fifty years before my grand-mother's time—in her quest to become a doctor. How did Anandi learn English? How did she cope with the cold weather? Was she ostracized because she looked, dressed, and ate differently, and because she practiced a strange religion? Why did her husband write her angry letters? When she became ill, why did she eschew the fruits of the very training that she had worked so hard to acquire? My mind buzzed with questions. Inspired by the Ramanujan biography, I could not let them go. I had to find out more.

As I researched Anandi's story, I realized that there are many points of confluence, as well as divergence, between her life and mine. For example, she came to the United States in 1883 and I came in 1983. Like her, I was the first Indian acquaintance of many Americans. As with her, they were surprised by my command of the English language. Like her, I sometimes felt alone and lonely; like her, I came to know many Americans who knitted me into their networks of care. The most amazing similarity between her life and mine is the fact that we both found our spiritual home among Unitarians (Unitarian-Universalists for me).

As for the contrasts: whereas Anandi was married at the age of nine to a man chosen by her father, I got married in my twenties and chose the man I would marry. Anandi had to be tutored at home because there were no schools for girls. In contrast, I came of age in an India in which the question of whether girls should be educated had been long settled—my mother was a college graduate and my family prioritized my education and encouraged me to pursue a professional career. Whereas

Anandi's choices—crossing the seas, traveling without her husband, and pursuing an education despite being female—were considered sinful by her family and community, my travel to America was seen as the next logical step in the career of a high achiever.

When it comes to our American lives: unlike Anandi, I came to an America in which I did not feel judged by the color of my skin. Fearing the disapproval of Americans and Indians, she had to put a great deal of thought into her choice of attire; I freely chose to switch to Western clothes. Unlike her, I was never pressured to convert to Christianity; unlike her, I gave myself permission to eat meat. While she suffered from the bitter cold and from not knowing how to keep the fireplace lit, I lived in homes with central heat. While it took Anandi almost two months to reach America by ship, for me it is now a non-stop fifteen-hour flight. It took weeks for letters from India to reach her. In contrast, I can today send text messages and make phone calls in real time.

Against this background, it is no surprise that my study of Anandi's life was powered by equal parts empathy and wonder. Learning her story in its fullness helped me better understand my own story—as an Indian, as an American, as an Indian in America, and as a woman.

Just as important, telling her story has allowed me to illuminate forgotten but important aspects of American history—America as a destination for women's higher education, Spiritualism as a faith tradition that supported a scientific outlook as well as women's leadership, Americans' openness to world cultures and religions, and most important, our history of welcoming and supporting a stranger.

I offer this book to you, dear reader, in the hope that you will feel as enriched, energized, and inspired as I was, by spending time with Dr. Anandi Joshee and her American champions.

A CLUB OF ICONOCLASTS

Rough work, iconoclasm, but the only way to get at truth.
Oliver Wendell Holmes

*P*oughkeepsie Rural Cemetery, established in the mid-late 1800s by well-to-do residents of Duchess County, New York, is a beautiful burial site containing several hundred plots. Beyond a small welcome center at the entrance gate are gently rolling hills. The meandering roadway that cuts through them is gracefully framed by stately trees. It is a most tranquil setting.

Lot 216-A is much like the lots that surround it. It contains a dozen tombstones for members of the Eighmie ("Amy") family: a monument for Jeremiah, the patriarch; his wives Mary Anne and Naomi; his two sons and his daughter Theodocia. There are also small tombstones for the four children that Theodocia lost before the age of five. Like most such cemetery plots, the close arrangement of the tombstones and their fixed nature seem to proclaim to the world the individuals' commitment to each other for eternity.

One tombstone distinguishes this lot from those that surround it. That tombstone marks the location where the ashes of a young Indian woman named Dr. "Ananda-bai" Joshee are buried. It indicates that she lived from 1865 to 1887 and identifies her as the "first Brahmin woman" who came to

America to become a doctor.

Who was this woman? Why were her ashes buried here? What was her connection to the Eighmie family? The tombstone offers just enough information to raise these questions. This book provides the answers and much more besides.

Her American friends and acquaintances called her Ananda-bai. They did not know that "bai" was just a suffix, an honorific like Mrs. or Madame, tacked on to add gravitas and a veneer of formality. They did not know that her name was Anandi (which means "joyful"), nor did they know that the name given to her at birth was Yamuna, after one of the great rivers of India. They were unaware that her first name had been changed, as was the custom, when she was married at the age of nine. Most importantly, her American friends could not have imagined the many ways in which her gender negated the privilege otherwise accorded by her high caste status.

Yamuna was born in March 1865 to a middle-aged Ganpat-rao Joshee (*rao* is the equivalent honorific for men) and his much younger wife Gunga-bai. They lived in a rambling house in the town of Kalyan, which was about thirty miles northeast of the city of Bombay (today's Mumbai). In keeping with custom, the household consisted of Ganpat-rao's wife and children, his parents, his brothers and their wives and children, as well as a constantly shifting entourage of cousins, guests, and other dependents.

The Joshees belonged to the Chitpawan Brahmin caste, one of the so-called "highest" castes in the stratified society of the time. They had lived in Kalyan for generations. The Maratha

rulers in Poona had given land holdings and tax-collecting rights to an ancestor of Ganpat-rao as a reward for his loyalty and bravery in battle. Possessing abundant social and financial capital, the Joshees were the local elite.

The large Joshee house had a layout common for its time: a central courtyard was bordered on three sides by several rooms. Rooms on the upper floor were primarily used by the men. Rooms on the main floor were not assigned to individuals; rather, they served a communal purpose. There was a kitchen, a storeroom, and a general purpose "middle" room used at mealtimes or as a sitting room. The "birthing room" was for women in labor and for new mothers. Set a little away from the main household, it offered privacy and quiet while also minimizing exposure to contagion.

The courtyard was a wonderful play space. The trees offered shade in the hot climate and were great for climbing. The swing was a favorite spot to catch a cool breeze in the evenings. There was also a *vrindavan*—a small square structure used in devotional rituals. A wash space in the corner was used for washing clothes, dishes, and hands and feet upon returning home.

Yamuna had a carefree childhood, with days spent playing with her many friends and cousins. Because of the presence of several adult women in the family, she had few household chores. However, Gunga-bai often got frustrated by her daughter's rambunctiousness and sometimes beat her in the hope of subduing her exuberance. Unable to shield his daughter from his wife's temper, Ganpat-rao made up for it by indulging little Yamuna whenever possible.

One fixture in the large Kalyan household, as in others of

its kind, was the priest, or *bhatji*. Unlike in congregational religions, the duty of the priest was not so much to deliver sermons or explain the holy texts as it was to perform religious rituals (*pujas*) and offer prayer. The dedicated *puja* room in the house was his domain. At the center of the room was the altar that held idols of the various gods that the family worshiped. These ranged in size from a few inches to a foot or more and were cast in bronze, silver, or gold. There was a figurine of a baby Krishna, an idol of the elephant-headed god Ganesh, and a composite of Ram, Sita, and Hanuman. Prayers were chanted in Sanskrit. Lamps filled with clarified butter (*ghee*) were lit, and fragrant incense sticks were used to create a spiritual atmosphere. Freshly picked fruits placed as offerings to the gods (*naivedya*) were later consumed as a blessed gift from the gods (*prasad*).

Little Yamuna had never thought of the priest in a serious way and was only four years old when she sat one day in the *puja* room playing with her dolls. She watched as the priest "bathed" the figurines, "dressed" them in clean clothes, and adorned them with freshly picked flowers. Suddenly, a thought flashed into her mind: there was no difference between the figurines and her dolls. They did not move, and they lay passive as the priest handled them. They did not cry like children when he rubbed them hard nor did they rejoice when he left them to themselves.

Later that day, Yamuna waited for her father to finish his lunch before seizing his hand and drawing him to the bench under a tree in the courtyard. "Baba," she exclaimed, "how can a God bear to have his face washed by a man?" And then, not waiting for an answer from her astonished father, she described

what she had seen and how the idols lay in the priest's hands just like her dolls lay in hers.

"Those images are not Gods," replied her father. "They are meant to hold the thoughts of the devotees while they pray. Some of them represent the love, and some the justice of God, and some only God's creative power." And then, being the indulgent father that he was, Ganpat-rao asked, "Can you pray to God without looking at the idols?"

"Yes, indeed!" she said.

"Then you need never think of them again," he replied. "You don't need them."

This was a time when conservative Hinduism held sway and a Hindu's life was governed by strict ideas of virtue (*punya*) and sin (*paap*), including how one should go about amassing the former and avoiding the latter. Religious virtue could be accrued by performing the many fasts and readings prescribed by the religion. It could also be earned by obeying caste strictures, which mandated complete separation from those of lower castes, and upholding standards of ritual and sexual purity. As Brahmins, the Joshees sat at the top of the religious hierarchy and so were the standard-bearers and interpreters of religious doctrine. And yet, Ganpat-rao was not just open to considering alternate, more rational, interpretations of the rituals of Hinduism, he was willing to share his views with his very young daughter.

Ganpat-rao possessed a genealogical record that dated back several generations. It was a scroll that contained descriptions of major events, such as victories in battle, in the lives of the family's illustrious ancestors, and drawings that depicted their stances and their attire. Such records were generally kept under

lock and key. They were brought out only occasionally when it was time to make new entries or to show them to the young males in the family as they came of age. Yamuna did not know of the existence of this scroll.

When she was about five years old, Yamuna dreamed of a handsome young man who was dressed in a manner, and carried weapons, that she had never seen.

"Who are you?" she asked, like any frightened child might, when he fixed his eyes upon her.

"Do you not know who I am?" he asked gravely.

"No."

"Go then to your father," commanded the soldier, "and tell him to make you acquainted with my life; for it is you who are to tread in my footsteps."

At this she awoke, trembling and bathed in perspiration. She went to her father and earnestly begged him to tell her about the "god" whom she had seen. Ganpat-rao was unable to identify the figure from Yamuna's description. However, when Yamuna recited the figure's admonition—"It is ungrateful to be ignorant of him whose blood flows in your veins"—Ganpat-rao felt certain that it was one of his ancestors who had appeared to his daughter.

He reverently opened the family scroll and showed it to Yamuna. At last they came to a figure that she immediately recognized as the man from her dream. The picture was of the young general who had founded the fortunes of her family.

Ganpat-rao was even more tender toward his daughter after this incident. He came to believe that she possessed an exceptional mind and resolved to nurture her as well as he could. However, he could hardly have imagined just how exceptional his daughter's life journey would eventually be or how important his early care

of her would prove in that journey.

The men of the Chitpawan Brahmin caste traditionally served as priests in ritual-performing roles. It was also common for them to be farmers and, thanks to their literacy, teachers and accountants. Beginning in 1713, when Balaji Vishwanath Bhat was appointed *Peshwa*, the prime minister of the Maratha Empire, his fellow Chitpawan Brahmins found their way into all departments of government and began to acquire positions of power and privilege in the provinces.

One such was Yamuna's paternal ancestor who was a governor of the province of Kalyan and had been granted commensurate land and tax-collecting privileges. Chitpawans had come to be considered "a very frugal, pushing, active, intelligent, well-taught, astute, self-confident, and overbearing class"; they were described as following "almost all callings and generally with success."

However, the defeat of the Peshwas by the British East India Company in the 1820s fundamentally altered the prospects of the community. They lost patronage and, more importantly, they lost their access to and hold on power. When the Company later won a decisive victory over the Indians in the war of 1857, the Chitpawans, along with other Indian elites, became aware of their shared pan-Indian identity—an identity that transcended the fractured one defined by the intersection of caste, region, religion, and language. Their overarching condition— of being occupied and ruled by a foreign power—came into sharp focus. They started trying to understand and overcome the factors that rendered them weak vis-à-vis the British. This process gathered steam over the ensuing decades.

Back in London, the British government realized that if they hoped to retain control of India, many changes would be required. Knowing that the Indians resented the British East India Company, the government wrested control of India from it. In addition, they laid railway lines, improved the law and order situation, and made communication affordable and reliable through the postal service. Their primary purpose was to better serve British trade and military interests. However, a secondary benefit was that these improvements made the Indians somewhat less inclined to resist British rule than they might otherwise have been.

As manpower was needed to run the new infrastructure, new job opportunities became available to Indians, and especially to those who knew English. So, the Indian elite started petitioning the British government to open schools and colleges for Western learning. They hoped that such an education would create a class of able workers while also developing men with modern ideas. And, these men would promote social and economic progress by countering crippling religious orthodoxy.

In response, the British government diverted some of its resources to establishing and operating high schools and colleges that taught English. The Chitpawans were among the first to send their sons to these institutions, and from there to jobs with the railways, the ports, and the postal service.

Ganpat-rao was one of those who embraced the importance of education. To that end, he established a small school in one of the upstairs rooms in his large home. The idea was to provide basic education to the boys in the family, in order to better pre-

pare them to pursue higher education in the universities that the British had begun to establish.

An unlikely student in this home-based school for the boys of the family was little Yamuna. She had to be coerced to attend, however, and, surprisingly, the enforcer was not Ganpat-rao, but her mother, Gunga-bai. Living in a society that expected girls and women to be compliant and demure, Gunga-bai believed that it was her job to prepare Yamuna for the life that awaited her. Alarmed by Yamuna's tomboy tendencies, she often beat her daughter in the hope of subduing her. When this failed to have the desired effect, she decided to send her to school. Gunga-bai hoped that the discipline and focus required in class would make her daughter more docile. At the same time, she hoped and prayed that the "sin" of educating a girl would not attach because she was not sending her daughter to school with the intention of educating her.

Yamuna missed the days of carefree play, especially since none of her friends were forced to attend school as she was. She stayed in class only because the alternative—being beaten by her mother—was considerably worse.

An extended-stay guest in this rambling household was a man named Gopal Joshee. When he came to live in Ganpat-rao Joshee's household in 1870, he was a twenty-five-year-old widower. Originally from the small town of Sangamner, he had attended an English school in Nasik and possessed a high school education. He had a job with the postal service and had just been transferred to the post office in the nearby town of Thane. Much younger than Ganpat-rao, Gopal too was passionate about education and its importance for achieving social progress.

Even though Gopal shared the family's surname, he was not

related to them. However, he did belong to the same caste. This made it easy—even imperative—for Ganpat-rao to offer Gopal a place in his large household when Gopal moved to the region. The railway line that the British had built in 1854 proved convenient; Gopal could easily commute between the home in Kalyan and the post office in Thane.

Perhaps it was because Gopal's interest in teaching had been thwarted by circumstances, or maybe it was because the teacher hired by Ganpat-rao was away, but somewhere along the way, Gopal started teaching in the little home school. Somewhere along the way, Yamuna became less averse to both sitting in class and learning to read and write.

By the time she turned nine, Ganpat-rao had become anxious about the fact that Yamuna was unmarried. Even though the family was well-to-do, two things made finding a match for her difficult. One was that she had a darker than average complexion, a negative feature in a culture that valued fair skin. The second reason was that she had scars on her face as a result of a bout of smallpox.

And so, Ganpat-rao approached Gopal Joshee—his houseguest with a good postal service job who occasionally taught in the home school—with the proposal that he consider marrying little Yamuna.

There was no question of asking Yamuna's opinion—she was just nine years old. Additionally, the society did not consider females of any age as possessing judgment. Love between husband and wife, to the extent that it blossomed, was expected to stem from lives lived together. And a younger bride was pre-

ferred so she could more easily be molded to the ways of the family into which she would marry.

Similarly, there was little question of worrying about the almost twenty-year age difference between Gopal and Yamuna. After all, Ganpat-rao himself was considerably older than his wife. Many factors contributed to making marriages between older men and preteen girls commonplace. Custom dictated that girls were to be married well before puberty. The lack of medical care for women meant that many of them died very young. This resulted in an abundant "supply" of men wishing to be married. At the same time, widows were not permitted to remarry, further contributing to a high "demand" for young brides.

It is unlikely that an older widower like Gopal would have been the first choice of bridegroom for Yamuna. However, considering her "advancing" age and her less-than-desirable physical traits, Gopal seemed like a reasonable compromise to the worried Ganpat-rao. Indeed, in his view, Gopal had the distinct advantages of being educated and being employed by the postal service. In an undeveloped preindustrial society, his was a rare job that offered both stability and upward mobility. Having observed him over four years, Ganpat-rao knew that Gopal was a person of self-discipline and good habits. His daughter would not want for anything.

Gopal proposed a condition before he would agree to Ganpat-rao's proposal. However, it was not a demand for gold and dowry, as was customary. Gopal intended to educate Yamuna, and he would brook no interference or objections. Ganpat-rao was likely surprised, and surely relieved, by the nature of Gopal's demand.

Having observed his daughter's intelligence and energy,

Ganpat-rao knew that she would blossom under Gopal's tutelage. Of course, in a society that offered few opportunities to educated women, it was impossible to imagine what good additional education might do her. However, in keeping with the progressive thought of the time, he thought that furthering his daughter's education was preferable to the alternative. Furthermore, he lived in a society that considered a married daughter as no longer the responsibility of her parents. Thus, his only charge would be to stay completely out of the way. Ganpat-rao readily agreed to Gopal's condition.

Sangamner is situated about ninety miles from the cities of Bombay and Poona. Without a rail connection, being in Sangamner during the nineteenth century was akin to being isolated in the middle of nowhere.

Gopal Joshee was born in Sangamner in 1845. This Joshee family belonged to the Chitpawan Brahmin caste, just as did Yamuna's family. He was the second of five children. His older sister Mathu was only a year or two older than he was, and their father started including her in his lessons when he tutored Gopal at home. This was far from a simple or easy decision. The grip of ignorance and superstition was such that any deviation from tradition—in this case female education—carried the risk of being perceived as the root cause of any calamity that might befall the family. But the winds of change that originated in the cities of Bombay and Poona soon reached far-off Sangamner. Although aware of the social risks and religious superstitions, Gopal's father was in favor of imparting basic literacy to his daughter.

Mathu was a bright student and often mastered the subjects more readily than her brother. Unhappy about this, Gopal once ripped all of Mathu's books and papers to shreds. What started as a childish sibling rivalry would have a profound effect—not directly on Mathu but on two other girls who would later cross Gopal's path.

Because of the custom of early marriage, Mathu was soon married and sent to live with her husband's family. This put an end to her relatively carefree life and her educational opportunities in the bosom of her birth family.

As a male, Gopal was exempt from both early marriage and separation from his parental home. But, he was subject to another custom—moving, at a slightly older age, to the nearest big town (in his case Nasik) in order to obtain an English education.

Males were commonly married in their teens. It was not necessary for them to be financially self-supporting at the time of the wedding, as family life was communal in nature. Thus, while a teenager, Gopal was married to a girl who was just six years old. Her given name was Mai, and it was changed to Savitri during the wedding (as Yamuna's would later be changed to Anandi). Even though it was customary to let brides stay in their parental home until they attained puberty, Savitri was sent to live with Gopal's family following the wedding.

As the youngest and newest person in the hierarchy, the little girl-bride was expected to help the older women in the family with household chores. Beginning with the simplest tasks, she would move on to ones of increasing complexity as she matured and learned from the older women in the family. This regimen allowed little room for play or for any other self-

chosen pursuits. Separated from her family and all that was familiar, a young bride often became shy and timid.

As an observant and sensitive person, it troubled Gopal when he saw his young wife being roped in to work. Indeed, he had frequent vocal disagreements with his mother in this regard. It led him to think about his sister's married life. Gopal was only about eight when Mathu was married and left for her marital home. Over the ensuing years, Gopal came to realize the futility of his early rivalry. He realized that she was very capable of learning and thinking, and even that she was better at it than he was. Yet, he also simultaneously realized that she had no power to exercise, or benefit from, those abilities. He did not want his wife to suffer that same fate.

Over time, Gopal came to believe that if brides were not sent to live with their in-laws, they would be spared both the trauma of separation from their birth families and the denial of their childhoods. He could see that being separated from their birth families inflicted pain in various forms— living among virtual strangers at a still tender age, feeling constrained to ask for anything (even perhaps food, when hungry), fearing the "authority figures" (all the members of the in-law household), and having to adapt while still so young to the various personalities and quirks of all of those in the new "family." Worst of all, in Gopal's eyes, there were no opportunities for the young brides to learn anything besides family and household chores.

So it was that Gopal decided that he would educate his young wife, Savitri. Aware of the many hurdles he needed to overcome to achieve such a goal, he arranged for her to move back to the home of her parents. He also contacted Savitri's cousin, Gangadhar-punt (*punt* is another male honorific)

Ketkar, who was both his friend and who shared his views about educating girls. Ketkar was a member of Savitri's extended household and was studying to become a lawyer. Ketkar readily agreed to teach Savitri at least enough to be able to write occasional letters. Gopal hoped to create a remarkable and irrefutable example by educating a female, thus establishing his claim that women were capable of learning and thinking.

Unfortunately, Savitri died only a few years later and Gopal's project came to an abrupt halt. Remarriage was an option, but he was not willing to marry another unformed girl, wrench her from the bosom of her family, and impose an education regimen on top of all the other duties with which she would be burdened.

His iconoclasm had evolved to encompass not just women's education but also the other challenges of women's lives. Recognizing that widows were uniformly vulnerable and ill-treated, Gopal made it known that he was willing to take a widow as his second wife. This noble goal was thwarted, but what occurred instead would change the lives of women in his country for generations to come.

The wedding of Gopal and Yamuna took place in the big house in Kalyan. In keeping with custom, Gopal exercised his right to change his bride's name. From this day forward, while she would remain Yamuna to her birth family, she would be "Anandi" to Gopal and his family. While customarily the bridegroom returned to his parents' home after the wedding and the bride continued to stay with her parents until she achieved puberty, theirs was not to be a traditional marriage.

Gopal remained in the home of his father-in-law and in keeping with the condition agreed upon before the wedding, Anandi continued to attend the home school. In addition, Gopal continued to regularly tutor her after returning from work.

Although the men—Ganpat-rao and Gopal—had made a pact and understood each other when it came to Anandi's education, her mother and grandmother strongly disapproved of the plan. They worried that educating a girl would attract God's wrath. Also, although they were probably unaware of this, they resented the fact that Anandi could dodge the strictures with which they had had to comply as young brides themselves. So, they put an end to her days of both school and play and instead assigned chores and tasks intended to tire her and keep her from her studies.

From their perspective, the quality of Anandi's "achievements" as a housewife was a reflection on them as nurturers and teachers. So, as much as they worried about what kind of woman Anandi would grow into, they worried at least as much about their own standing within the community. It is sad and ironic that even though Anandi was still with her birth family, she faced the exacting expectations that she would have encountered in the home of her in-laws. Gopal had not anticipated this outcome.

Laboring to form Anandi as they had been formed, to ensure she became an obedient and traditional wife, the women started urging Anandi to go to Gopal's room at night, even though she had not yet achieved puberty. Their ignorant teasing and indirect references to what might happen confused and frightened Anandi. While before the wedding she willingly, even eagerly, went to Gopal's room so that he could tutor her, after

the wedding, she started to resist those visits.

Wanting to be understanding, Gopal did not force the issue. However, this led to yet another conflict with the older women. Anandi's grandmother admonished him—if Gopal did not show his young wife that he was in charge, Anandi would grow up to be defiant and unmanageable. These women had been so subjugated that they became the willing agents of another female's subjugation.

Anandi was caught between a rock and a hard place—wanting to be educated, but not wanting to go near her teacher. Gopal, too, was in a similarly impossible bind. He could be kind to his wife, but that would risk slowing her education, and he would be castigated for not being in control. One night, things came to a head. In the middle of tutoring, Anandi begged to be let out of the lesson and Gopal lost his temper. He beat her with a stick until she was black and blue.

After his temper cooled, it was clear to Gopal that their living arrangement was not conducive to executing the plan of educating his wife. He decided to request a job transfer to another town.

When he announced his plan, there was confusion in the household. Because Anandi had not yet achieved puberty, culture dictated that she should not accompany Gopal to live apart from family. However, Anandi was devastated at the thought of her education coming to an end. "I thought I should never learn anymore... and I would rather have died," she would later write to describe her predicament.

A compromise was devised. Anandi would go with Gopal, but so would Aji, her grandmother. Aji would help her run the household and teach her the things that she had not yet learned.

Gopal was happy with this arrangement; he hoped that having Aji would free Anandi to focus on her studies and be spared from performing some household chores.

Gopal was transferred to the small seaside town of Alibaug, and the trio stayed there for a little over two years. During this time, Anandi's education progressed in a mostly unimpeded manner. Gopal tried the "carrot and stick" approach, using whatever it took to move closer to his goal. He humored Anandi and rewarded her by buying her shoes, an indulgence unheard of for women of the time. As an additional carrot the two of them went out for strolls on the beach—a welcome respite from days spent within the confines of home. Though both these actions went against the custom of that time, and invited scorn from their neighbors, Gopal and Anandi were undeterred.

Gopal's sticks were more beatings as well as threats of abandonment. Although Anandi was not a stranger to the former, the latter was a new and debilitating threat. An abandoned wife would have no choice but to return to her parents' home disgraced, bringing shame and compromising their standing in their community. As a result, Anandi reluctantly labored to complete the homework assigned by her husband.

As Anandi matured, so did her interest in dressing up. She tried different looks by mixing and matching pieces from her collection of nose rings, toe rings, bangles, necklaces, and ear ornaments made of pure gold. As was the custom, they had been given to her as part of her wedding endowment. She experimented with different-sized red dots on her forehead and

wore her sari in a style that was crisper than the norm. She enjoyed getting together with other girl-women in the neighborhood to chit-chat and play games. Gopal refused to allow such distractions. He criticized Anandi's innocent fascination with color and shine as a sign of a mind that was too focused on appearances. He railed at her girlish pastimes as immature, shallow, and useless.

Aji was of no help. She continued to challenge Gopal for his beliefs and expectations and Anandi for neglecting her duties as a homemaker. The unusual threesome muddled along unhappily. Anandi attained puberty at the age of twelve and became pregnant soon after.

In keeping with custom, Gopal brought Anandi to her parents' home in Kalyan a few weeks before her expected delivery date. A reluctant, scared, and frustrated student-wife, she looked forward to being away from her husband and to being doted on by the women of her family. Having children was an important milestone in a woman's life as it cemented her position within her husband's family. There were many celebrations and parties. But the flip side of this expectation, though not often mentioned, was that if a woman was unable to have children, her husband might eventually send her back to the home of her parents, or might seek and marry a second wife. All in all, Anandi was filled with anticipation about the birth of her baby.

When a boy was born, it was occasion for great joy. Then, as even now in many traditional communities, male children were prized. But sadly, Anandi's joy was short-lived, as the baby died after only ten days.

She was devastated by the loss. Most women in this

unfortunate situation found solace in the beliefs of *karma* (that this was meant to be) and *paap* (punishment for sin in a previous life), and they became more devout. This offered both solace and a way to accrue *punya* (virtue) to ward off future calamities. They also drew support from their sisters and mothers, who were not unfamiliar with such an experience. A subsequent pregnancy, which often followed fairly quickly, helped erase the memory of loss.

However, only a few years of schooling had altered Anandi's thinking. She was convinced that her baby lost his life because of a lack of medical care. She also saw that her misfortune was just another page in the larger narrative of women's lives, in the havoc brought because the notion of modesty dictated that male doctors (all of the few available doctors were men) could not treat women.

This unfortunate brush with a common scourge of her time opened a window to a new perspective for Anandi. "What if I were to become a doctor?" she wondered to herself. And this one simple question fired her imagination. It also enabled her to channel her grief over the loss of her baby into something meaningful and constructive—something for which she had exactly the means. Anandi returned to Alibaug with new energy and new resolve. Her education would no longer be just her husband's project.

2

Missionary Zeal

Never let your zeal outrun your charity.
The former is but human, the latter is divine.
Hosea Ballou

The Anandi who returned from her parents' home in Kalyan after the death of her baby was a fundamentally changed person. She was just thirteen, but the grief she experienced through the prism of her educated mind had matured her beyond her years. Almost overnight, she became a passionate student, eager to absorb all that her husband wished to teach her.

Gopal and Anandi became equal partners in a shared mission—to become empowered in order to ease the burdens of women's lives. For Gopal, it was to create a stunning example that would provide irrefutable proof of women's capabilities. Anandi's achievement would surely persuade other husbands and fathers to stand on the side of emancipation and progress—first for their wives and daughters and, through them, for Indian society as a whole. For Anandi, the mission was to become a doctor so that she might alleviate the widespread pain and suffering of women. She hoped to help mitigate the havoc and precariousness that were all too present in the lives of women, their families, and their young children.

At this point, Anandi could already read and write Marathi, her and Gopal's mother tongue; she also knew grammar and could do basic arithmetic. She had started to learn English and could translate elementary Marathi books into English. But Gopal not entirely happy. Because he could tutor her only after work, he worried that she would not be able to progress as fast and as far as she needed to, particularly if her newfound desire to become a doctor was to be realized.

Gopal decided that they should move to a place where there were European teachers (at the time, all whites were typically referred to as "Europeans") and where the larger community was less likely to oppose female education. He chose Kolapore, a city with prominence as the capital city of one faction of Maratha rulers who were direct descendants of Shivaji (founder of the Maratha Empire). More importantly, an English governess had been retained to educate the younger members of the royal family—including the girls. Gopal believed that since the court was positively inclined toward female education, he and Anandi would not be mocked and harassed by the community as had been the case in Alibaug. He hoped to convince this same governess to accept Anandi as a student. His request for a transfer was promptly granted.

The year was 1878, and the Joshees were soon settled in Kolapore.

The governess, Miss Mary J. Moysey, taught the two princesses—one already a widow at twenty and the other just ten—to read, write, and speak English. Miss Moysey was in high demand. She took on private students from families that were closely allied with the palace. In addition, she served as Superintendent of the Girls' School, which she visited twice a week.

In a letter to a friend, she described the goal of the school as "rendering the girls useful in their own homes." The students were taught sewing and embroidery in order to earn some money and become a little less dependent on their husbands and in-laws.

The handful of colleges that the British government had opened over the previous two decades used English as the language of instruction, so Gopal knew that mastery of English was a must. Eager for Anandi to be properly educated by an English-speaking teacher, Gopal was not fazed by the non-academic focus of the Girls' School. He requested Miss Moysey to accept Anandi as a student, and Miss Moysey agreed, though somewhat reluctantly. The reason for this became clear over the ensuing months.

Miss Moysey lived near the Joshees but at a distance from the school. Because women did not generally venture out of the home alone, it was decided that Anandi would ride in Miss Moysey's horse carriage to the school. Anandi was now attending a formal school for the first time in her life. And, for the first time since she had come of age, she had a teacher other than her husband.

Waves of Christian missionaries started arriving in India as early as the sixteenth century, following closely in the footsteps of explorers and colonizers. They ranged from Portuguese and French Catholics to Danish, British, and American Protestants of every denomination—Presbyterians, Baptists, Methodists to even the "broad" Unitarians. Their primary goal was to convert as many Indians as possible to Christianity. To that end, the missionaries employed all manner of strategies, from coercion

to persuasion.

Some Catholic denominations performed forced conversions by throwing bread in wells and announcing that anyone who drank from those wells would be considered Christian. By contrast, missionaries like Scottish Rev. Dr. John Wilson in Bombay established schools and colleges in the hope of spreading literacy and knowledge. They believed *that* would be a more persuasive way to lead their students to reject the superstitious aspects of Hinduism and accept the message of Christ. Others, like generations of the American Scudder family, established and ran hospitals. Regardless of the means employed, the missionaries saw themselves as doing "God's work"— spreading a "true" religion powered by altruism, and vice versa.

The most surprising group among the missionaries was the Americans, for they came from the youngest country, a country that was not yet wealthy; they traveled the farthest; and their government had too small a presence to provide them with supportive services or protection. Beginning in the 1840s, Kolapore had become a major center of the American Presbyterian Church's Foreign Mission. This was "pioneered" by Rev. Royal G. Wilder, who served there for over twenty-five years.

By the time the Joshees arrived in Kolapore, Wilder had returned to America because of poor health. Rev. Joseph M. Goheen, a native of Centre County, Pennsylvania, was the new mission head. Only a little over thirty at the time, he had been in Kolapore for about two years. Goheen was known to "give himself with all the intensity of a nature true noble and unselfish," and would go on to serve the Kolapore mission for

three decades.

Gopal introduced himself to Goheen, and the two men struck up a close friendship. Both were roughly the same age and both enjoyed discussion and banter, and sharing their cultures and ideas. However, this was also a relationship in which each party possessed an ulterior motive. Gopal, as ever, was on the lookout for people who might help educate Anandi. Whether they were English or American did not matter. What mattered was that Goheen spoke English and, in keeping with the missionary ideal of helping the locals become enlightened, seemed eager to help him. For Goheen, helping the locals was a close second to bringing more of them to the Christian faith. He thought that it would be to his credit if he were to convince a high-caste Hindu, a Brahmin like Gopal, to convert to Christianity. Moreover, Gopal might persuade others to do the same.

Most Christians considered idol worship a practice devoid of meaning, one that was steeped in superstition and ignorance. They were either unaware of, or unpersuaded by, the role of idols as instructional and reverential objects. From their discussions about religion, Goheen knew that Gopal did not believe in idol worship. Because this was an essential step on the path to renouncing Hinduism, it gave him hope about the likelihood of a high-profile conversion.

As he got to know Gopal better, Goheen learned about his passion for women's education and his ardent desire for social progress. Being sympathetic to these goals, Goheen shared with Gopal the latest news from America. He told him that the Civil War had been recently fought for the abolition of slavery. He described women's agitation for equal rights and the schools and colleges that had been established to educate women.

Gopal was enthralled and eagerly shared this information with Anandi. To both of them, America sounded like heaven on earth, a place and a people among whom all the traditions and customs that constrained them—both Indian and British—could be discarded swiftly and completely. The fact that the Americans had overthrown the British a century earlier only made it easier for Gopal and Anandi to see the Americans as a different kind of European, at once more accessible and more trustworthy.

The same idea came to both men at about the same time.

What if Goheen were to arrange for Gopal and Anandi to go to America? Goheen expected that the enormity of the favor, and the gratitude it would create, would surely help turn Gopal and Anandi toward Christ. As for Gopal, for the first time in all his years of struggle, it seemed that he had found a true champion, someone who was willing and able to facilitate Anandi's education to the greatest extent that he and Anandi dared imagine.

Goheen suggested that Gopal write a letter describing his purpose and request. He would forward it, along with his personal recommendation, to Rev. Wilder in Princeton, New Jersey.

Upon returning from India in 1877, Rev. Royal Wilder and his wife tried to settle into their new lives in Princeton and re-adjust to the rhythms of "home." After having been away for over two decades, even months after their return, they continued to feel as though they were on vacation. In contrast to the Indian heat, the summers felt cool. The quiet rain and soft snow seemed like well-behaved partners of their orderly community. For simple pleasures, little could top the familiar meals

that they had missed while abroad—meatloaf, turkey, steak with mashed potatoes, and yellow corn.

Their new friends and neighbors enjoyed hearing their tales of strange "Hindoo" customs. They were filled with curiosity and wonder and the little they learned from the Wilders made them want to know more. Stories about the caste system and the state of women in India made them feel sorry for *those people*. They felt proud of their Christian faith and relieved that they were spared lives of such ignorance and superstition. The more thoughtful among them were eager to help. "Can we send money?" they asked. "If only we could convince the Hindoos to accept Christ..." their voices trailed in thought.

Even though Wilder basked in his friends' admiration of his life of selfless service, he was not entirely happy. He had left India, but India continued to live within him. He missed her fierce monsoons and fragrant tropical flowers, the colorfully decorated idols used in worship (he couldn't bring himself to think of the idols as gods), the sound of low-pitched and fast-paced Marathi, a language, he had gradually come to use more than English. He even missed the blend of cooking smoke, roasting spices, and incense that so often wafted through the streets—not always the most pleasant smell but one to which, he realized, he had become quite attached.

Princeton was prettier, more organized, and less crowded, but to him it felt sterile. Maybe it was because there seemed to be nothing left to achieve in Princeton: No hurdles to overcome, no needy, desperate people to elevate. Most importantly, because he was surrounded by Christians, there was nobody to whom he could preach the teachings of Christ. He even missed the challenges—learning a new language and deciphering a new

society—that had marked his years in India.

Like many missionaries, Wilder had gone to India as a dedicated and ambitious striver. As he had written to a friend, "...the one passion and purpose of my soul was to win as many of them as possible to Christ." As was the case with many missionaries at the time, it had probably not occurred to Wilder that the Indians might not have been looking to be converted or "saved." They had their own religions, philosophies, and rituals, which were tied to their families, customs and traditions—just as was the case with Christians. They had resisted the Christian message of salvation; it had been a constant uphill struggle.

Over the course of the years he spent in India, Wilder studied the history of the ancient Hindu civilization and read the Vedas—the Hindu holy texts. He realized that India was more advanced philosophically than most Westerners imagined. He gradually came to believe that it was "idolatry" and other accompanying beliefs—rather than any inherent deficiencies— that rendered the Hindus weak and therefore easy prey to Moghul conquests and British colonization. So, though he sympathized with the Hindus, Wilder continued to believe in the "Christian faith and civilization as prominent elements" in the preeminence of Christians and, by extension, of Western civilization.

Early in his years in India, Wilder noticed that many Indians, especially the younger ones, were eager for a different kind of elevation. They desired to be educated, and preferably in English. They hoped to better qualify for the jobs that were becoming available in the British infrastructure of railways,

ports, and postal services. So, Wilder founded schools to educate these men (in the beginning they were only men), using this circuitous route to bring them to Christ. His endeavor gradually developed a life of its own. Under her husband's guidance, Mrs. Wilder began teaching Indian girls and women. They began instruction in the local Marathi language and gradually moved their studies toward English. How proud he felt when one of their students got a job in the British civil service! But even that accomplishment paled when a student chose to be baptized because he wanted to be a "transforming force" like the Wilders.

Indeed, by the end of his stay in India, Wilder had witnessed the profound effects of the education that missionaries like him offered. He was eventually convinced that, empowered by a Christian education, Hindus would "attain equality with the best scholars of Christendom." With their "abundant promise," he foresaw a future in which "the Aryans of India [would] be surpassed by no other people on the globe."

Over the years, Rev. Wilder was transformed by India as well. Once back in sedate Princeton, his years in India felt like a dream; he felt restless and useless. He decided he would continue his missionary work for India from Princeton. He founded *Missionary Review*, a magazine featuring news for and about missionaries in far-flung corners of the globe. It would serve to connect them to others like themselves and keep them abreast of comings and goings, births, weddings, and deaths within their dispersed community. It would also include first-person accounts of the triumphs and challenges of missionary life, made all the more compelling thanks to their intimacy and authentic voice.

More importantly, the *Review* would be able to capitalize on the curiosity and Christian generosity of Americans. Wilder was all too familiar with the constant lack of funds that plagued missionary families and limited their reach. They needed financial support both for their own sustenance, and to buy land and build churches. They also needed money for books, clothing, and other social support for their reluctant flocks.

In the beginning, *Missionary Review* was mailed to a few churches and friends. Gradually, it developed a following and started receiving subscriptions from people near and far, people who believed it was their Christian duty to spread the Gospel in far-off lands and help to bring enlightenment to the "natives."

Rev. Wilder was on a new mission.

When he found Rev. Goheen's letter in his morning mail, Wilder opened it eagerly. He breathed in the scent the letter carried—for a moment he was back in the dusty alleys of Kolapore. Goheen had written about a quite unusual Brahmin, Gopal Joshee, whose acquaintance he had made. The man was passionate about educating his wife and, in that quest, was willing to incur the wrath of his community. Goheen had never met a man who was as passionate and as unafraid of what others might say.

Goheen felt that the Joshees deserved help. More importantly, he believed that by helping them, the mission of bringing as many souls as possible to Christ would be advanced. Goheen hoped that Gopal Joshee would feel sufficiently indebted and obliged to return the favor. Indeed, he might be so moved by the power of the Christian faith to act with charity

and compassion that he might willingly accept Christ and work to convince others to do the same. Goheen thought that this would be a win-win for all involved. He urged Wilder to consider helping Joshee's wife travel to America to be educated.

Wilder felt heartened to note the tone of deference in Goheen's letter. He may have become old and infirm, but he still commanded respect. He agreed with Goheen's reservations about how the couple would fare in America without any support or assurances. He set the letter aside and sat back in his chair, allowing his mind to meander across the jumble of emotions he was feeling.

He pictured the Kolapore parsonage with its little garden and the church next door. He thought of his loyal servant who was ever grateful because he was treated more kindly at the mission than by his fellow Indians, especially the Brahmins. How nice it would be to have the young couple from India here in America! He imagined conversations in Marathi, discussions about Indian history and British affairs. He imagined introducing them to the curious and generous Americans, and he thought of how much easier it would be to raise funds with this couple by his side. His wife had been feeling homesick for India since their return. He knew her excitement would know no bounds at the prospect of long-term guests from India. "Like the mountain coming to Mohammed," Wilder chuckled to himself.

He turned to the other letter, the one written by the Indian. The author used the peculiar idiom of the English-educated "native"—formal and somewhat subservient. The letter conveyed all the coordinates of the man's social standing: his religion and caste, place of birth, and father's name. Wilder

understood that it was a way of establishing his credentials as well as his high station in the rigid caste hierarchy. He was impressed by the man's articulateness. "My education, though very poor, has caused me to suffer rather than enjoy." Having been a teacher in India, Wilder knew the leaps of personal growth needed to progress from basic literacy to this level of critical thought and expression. He read on:

> *Ever since I began to think independently for myself, female education has been my favorite subject. I keenly felt the growing want of it to raise the nation to eminence among civilized countries. It is the source of happiness in a family. As every reform must begin at home, I considered it my duty to give my wife a thorough education, that she might be able to impart it to her country-sisters, but customs and manners and caste prejudices have been a strong barrier to my views being prosecuted. Besides, our attempts have been regarded with suspicion by foreigners. On the other hand, female education is much looked down upon among all Brahmins, the highest class of people in India. My attempts have been frustrated, my object universally condemned by my own people. I have difficulties to encounter and no hopes to entertain in India, and yet I cannot give up the point. I will try to the last, there being nothing so important as female education for our elevation morally and spiritually.*

Wilder felt overwhelmed by the Brahmin's zeal. The man's goals—uplift of family, community, and country—seemed too lofty to be mastered in a single lifetime. A lone crusader with few resources, the man was willing to risk all and start with the baby step of educating one woman—his wife. "He has the mis-

sionary impulse," Wilder thought to himself as he put both letters aside. He would seriously consider helping the Indian couple in their quest.

Wilder had never come across an Indian, let alone a Brahmin, who so energetically berated his own community. Neither had he come across many who had a pan-Indian view of their country; most were still too mired in identities defined by their caste, language, and religion. However, he had come to know a few educated Indian men and so knew that they had the potential to become a most powerful force. He noted the parallels to the American colonists' desire for independence from Britain, "… the old problem of 1776 is again looming up, and demanding the attention of British statesmen. Educated Hindus are petitioning for representation in the British Parliament." He was reminded of the impatience of one of his students for the British to recognize Indians' "growing intelligence" and for Indians to "rise to equality with the natives of England."

Therefore, Wilder sympathized with Gopal Joshee's passionate desire for progress and equality. However, he felt conflicted about offering material assistance. Although he could foresee the inevitability of change and the Indians' push and capacity for it, he had also personally experienced the Hindu traditionalists' staunch opposition to changing the status of Indian women even slightly. He was skeptical about the extent to which an educated Indian woman would be able to change, or even begin to change, her community.

He reread the letter, savoring the words on the page, trying to imagine a man clothed in the traditional flowing white *dhoti*, and with the *shendi* tuft at the top of his shaved head. As for

the wife, he could imagine only a shy girl-woman laden with jewelry and wrapped in yards of sari, one who would stare at the floor making no eye-contact, speaking only when spoken to, mumbling her responses in a hushed shaking voice, and fleeing to the inner sanctum at the earliest opportunity. Surely the missionaries were more than equipped to provide whatever "education" this little woman was capable of receiving.

Even if the couple were to come to America, he continued to ponder, would they be able cope with the harsh winters? What would they eat? Their spices and vegetables, yogurt and *ghee,* and rice and lentils would simply not be available here.

Then there was the issue of race. It was one thing for someone like him—educated, thoughtful, and a true disciple of Christ—to go and live among heathens. It was quite another—isolating at best and dangerous at worst—for black non-Christians (Indians were considered black at the time) to live among Americans. Sure, some Americans would be warm and welcoming. But many others might see them as akin to the recently emancipated slaves and might reject them. The most extreme were likely to resort to taunting, or even violence, to make them leave.

The most important consideration, however, was the issue of Gopal Joshee's willingness to accept Christ. Even though Goheen saw reason to hope for a high-profile conversion, Wilder was skeptical. He could well imagine that Joshee would readily accept help to attain his goal of educating his wife and yet, feeling no obligation to convert, would also resist attempts to make him forsake his gods and idols and accept Christ.

The more Wilder thought about it, the more he felt that as much as he would enjoy the Joshees' company in America—it

would be like having *Little India* right in his backyard—helping them come to America would be an ill-advised move.

In his response, he commended Gopal Joshee for valuing female education and assured him that more American missionaries were on the way: "Your dear wife will have a good opportunity to prosecute her studies there," he wrote. And, being a passionate missionary, he closed his letter by urging Gopal to "confess Christ as your Savior."

The hope of sending Anandi to America to be educated was thus nipped in the bud. The great hope with which the Joshees had moved to Kolapore—to be taught by the English governess Miss Moysey—soon came to naught as well.

Miss Moysey's initial hesitation to tutor Anandi was prompted by the attitude of the person who had hired her. This was Mahadeo Vasudeo Barve, who was the *Karbhari*—Chief Administrator—of the Kolapore court. He was an educated and accomplished man and had held several positions of increasing prestige and responsibility.

The Joshees and Barve belonged to the same Brahmin caste. However, this was insufficient to ensure the latter's cooperation. Barve likely saw Gopal as a potential traitor and competitor. He may have been opposed to Gopal's friendship with Goheen as it raised the possibility that Gopal might convert to Christianity. Barve may also have wanted to discourage a fellow Indian's access to the royal family through Miss Moysey. In any event, he prevailed on Miss Moysey to cease teaching Anandi.

Unfortunately, lacking the courage to tell the Joshees the truth, Miss Moysey started to spurn them by behaving in a rude and uncivil manner. She left Anandi standing on the doorstep

("like a servant") when she arrived for their shared ride; if Anandi was delayed, Miss Moysey left without her; in the carriage, she insisted that Anandi sit far away from her. So offended was Gopal by this ill treatment, that he put a stop to the arrangement. He did not care that it meant an end to Miss Moysey's tutelage.

Fortunately, there was a silver lining in this series of setbacks.

One of Gopal's European acquaintances was Col. Frederick Schneider, the British political agent in Kolapore. The Colonel was impressed by Gopal's zeal and troubled by the attitudes of Rev. Wilder, Karbhari Barve, and Miss Moysey. He told Gopal about a Miss Prescott, who ran a girls' school in Bombay, and provided a letter of reference. He also kindly recommended Gopal to the head of the post office in Bombay, so that the couple might quickly relocate.

A transfer came through within months. Anandi and Gopal were once again on their way to a new city. In their quest for an education for Anandi, the Joshees had so far passed through Kalyan, Alibaug, and Kolapore. Bombay was bigger, wealthier, and the most progressive city in the country.

The city of Bombay was the capital of Bombay Presidency—one of a handful of governing entities into which the British government had organized their empire in India. It was a major port and the entry point for all visitors arriving from the West, be they British government personnel, European businessmen and traders, or Christian missionaries.

With the start of the American Civil War in 1860, the supply of cotton to British mills from the American South was

interrupted, allowing India to emerge as their primary cotton supplier. As a result, the role of Bombay as the commercial and financial capital of India grew more prominent, and it was not long before it emerged as a cosmopolitan and thriving hub of international trade and commerce:

> Bombay, with its population of seven to eight hundred thousand, is the second city in the British empire. It is the great nucleus of traffic between East and West.... Behind it is all India and before it is the sea connecting rather than separating India and Western Asia, Africa, and Europe. Hindus of all tribes and castes, Mussulmans from every Mohammedan country, Negroes, Arabs, Persians, Beloochees, Afghans, Malays, Parsees, Jews, Indo-Britons, Indo-Portuguese and pure Europeans jostle each other in the streets of Bombay and every deity finds its worshippers in the temples, mosques and churches of all descriptions and denominations.

The market at Bhendi Bazaar, a bustling marketplace even today, was already a center of an earlier era of globalization:

> It is not only full of everything Oriental but everything Occidental even to the idols so largely manufactured in Europe for the Indian markets from the costliest gems from the mines of Punnah and Golconda to the commonest English prints and since the introduction of free trade one can absolutely purchase English goods cheaper in this market than in the cities where they are manufactured.

A unique dynamic in nineteenth century Bombay was that it was home to Christian missionaries as well as wealthy Indian businessmen. These two disparate groups were soon to be united in a common purpose—education. Recognizing the importance of education for India's business success and social progress,

businessmen secured land and funding for the establishment of schools. They partnered with the missionaries because of the latter's command of English and their zeal for educating the "natives." As a result, Gopal had a choice of several girls' schools for Anandi; he chose one that was within walking distance of their home.

The school was operated by the Church Missionary Society and its offshoot, the Society for the Propagation of the Gospel. Here, under the tutelage of a Miss Dobson, Anandi became fluent in both spoken and written English. She developed great penmanship and impeccable grammar.

However, new challenges soon emerged.

Impressed by Anandi's mastery of English, Miss Dobson urged Anandi to read the Bible. After all, the primary purpose of the missionaries' enterprise of education was to lead their students to Christianity. Miss Dobson probably thought she was bestowing an honor on Anandi, but Anandi was not to be persuaded. When she refused, Miss Dobson threatened to expel her from the school. Outraged, Anandi stomped home, vowing never to return.

For the first time in her life, Anandi challenged an authority figure. She was beginning to think for herself and to know herself, albeit within the few degrees of freedom that her circumstances allowed. She was unwilling to submit to expectations that seemed unjust—even if they were for the larger purpose of her education. Describing her experiences at the school, she would later write in a letter, "I love these Mission ladies for their enthusiasm and energy in their work but I dislike blindness to the feelings of others."

Having acted impulsively, Anandi could not have predicted

how Gopal would react. She had momentarily forgotten his proclivity toward violence and his unbending resolve. Thankfully, he did not resort to his old ways. Instead, he reasoned with her and persuaded her to keep her eyes on the prize:

> *I informed my husband of the occurrence and expressed my desire not to go to that school again. But he expostulated with me against the rashness. He said that we would not lose anything by reading the Bible & brought me round to going to the same school again where I then abided by the school rules.*

Finding a convenient school and a willing teacher was only half the battle for the couple. The other half was coping with the ire of family members and of the people in their neighborhood.

The Joshees were provided accommodation above the post office in a market area called Girgaum, a part of "Black Town" or "Native Town," as the British called it. It was situated just outside the Fort area that housed government offices and the homes of the political and business elite. In comparison to Fort, Native Town was densely populated with both humans and animals, resulting in a "foul murky atmosphere." The journey from Fort to Native Town was described thus:

> Europe was left behind and the East was realized... the narrow winding streets, the open shops, small but highly characteristic, where the owner, Hindu, Mohamedan or Jew, squatted among his wares.

Fortunately, the part of Native Town where the Joshees lived was "the domain of the literate Maharashtrian middle classes, many of whom held clerical posts in the government and in

commercial firms." The Joshees had settled among people who seemed to be very much like them. Unfortunately, those outward appearances masked attitudes that were starkly different.

The primary style of accommodation in the environs of the post office was the *chawl* or tenement. Each residence consisted of one or two rooms, each not much larger than one hundred square feet. The inner room served as a kitchen, and the outer room served as a sitting room, or "everything else" room. Each row of these small homes shared an outside veranda that ran the length of the row. This served as a common area for people to interact informally, catch a cool breeze, and buy commodities from the many itinerant vendors.

It was a communal existence—one in which privacy was neither expected nor possible. It suited the residents just fine as it recreated the ethos of the villages from which they had relocated. Also, they did not expect to live long in these cramped homes. They planned to return to their farms and villages as soon as they had saved sufficient money to live comfortably there.

It was a short walk to her school, but for Anandi, it was more like an obstacle course. An unaccompanied woman on the street was already an unusual sight, but it was even more so because Anandi carried books and wore "boots-and-stockings" like an Englishwoman. Anandi would later describe her experiences thus:

> *Passers-by whenever they saw me going, gathered round me. Some of them made fun and were convulsed with laughter. Others sitting respectably in their verandahs made ridiculous remarks and did not feel ashamed to throw pebbles at me. The shop-keepers and venders [sic] spit at the sight of me and made ges-*

tures too indecent to describe.

Angrey-wadi is a chawl that exists even today. It sits diagonally across from the post office, which also continues to operate from the same location. Gopal arranged for Anandi to pick up cooked meals from the home of one of his friends who lived in Angrey-wadi. It was here that Anandi had her most difficult experiences. Having no alternative, she faced her detractors and continued to go to school.

A few months after Gopal and Anandi had settled into their routine in Bombay, Gopal's father, Vinayak-rao, visited from Sangamner. He was quite disturbed by the fact that his daughter-in-law was attending school, walking there alone, and even learning to speak English. He shared his worries with Gopal in the hope of dissuading him from his chosen course of action:

> With all the independence granted from such a young age, she will become impossible to control. Women need neither independence nor education. Their role is to make the best use of what we men-folk provide. If women become educated, where will that leave men? And who will take care of the housework?

Even as he talked about the risks that an educated wife posed to family life, Vinayak-rao was concerned about the effect on the family's standing in the community. "We are not upper class and we should not forget our station in life," he reminded Gopal. Because they were part of a web of interdependent relationships, he had no doubt that defiance of the community's norms would invite scorn and rejection.

Out of his love for his son and his desire to spare the couple future anguish, Vinayak-rao tried to inoculate them with the

vaccine of his worldly wisdom. He knew that accepting the status quo was safer than dreaming of what might be, and suffering in the pursuit of that dream.

There were many discussions, disagreements, and arguments, but, Gopal was too committed to his desire to educate his wife to turn back. Finally, Vinayak-rao gave Gopal an ultimatum: "if you continue along this path, I will never again set eyes on you." Gopal did not budge, and neither did Vinayak-rao.

Vinayak-rao died soon after this incident; indeed, father and son never saw each other again.

A Door Opens

No friendship is an accident.
O. Henry

*T*heodocia Eighmie Carpenter was a daughter of the well-to-do Eighmie family of Duchess County, New York. She was in her late thirties and lived with her husband Benjamin Fowler Carpenter and their two little girls, Eighmie and Helena, in Roselle, New Jersey. In keeping with the norms of the day within their social class, Theodocia and Benjamin both possessed a high school education. Benjamin owned a string of small businesses, a few more successful than the rest. Theodocia was a homemaker. By all appearances, the Carpenters were an unremarkable American family.

On a cold day in October 1879, Theodocia visited her dentist in the nearby town of Elizabeth. While waiting, she browsed an old issue of *Missionary Review* that lay on a nearby table. Several articles caught her eye. There were letters from and about missionaries in China, India, and Africa. They described their attempts to educate the "natives" and, when possible, convert them to Christianity. The religions, rituals, and sacrifices seemed exotic and faintly troubling. How could human beings—who surely had the same ideas about happiness,

family, and community—be so different from the American norm? Theodocia was fascinated.

As a curious person, Theodocia found the natural world "full of charms" and had already "formed a cabinet of objects from the animal, vegetable and mineral world." Her collection had "grown to almost two hundred specimens" that represented various countries in Europe. As she read the *Review,* she wondered if one day she might add items from Asia and Africa to it.

Her attention was drawn to a letter written by a man named Gopal Joshee in Kolapore, India. The author sounded formal and earnest. His wife was just fourteen, and his letter expressed a keen desire to educate her in America. Theodocia could not quite imagine a young native girl being tutored by her husband. Having read about their strange customs just a few pages earlier, she found this man both unusual and courageous. The next letter was from a Rev. Goheen, an American missionary who was acquainted with Mr. Joshee. Rev. Goheen thought assisting Mr. Joshee was a good idea because he seemed amenable to converting to Christianity. This correspondence captivated Theodocia. She felt she was reading the story of a heartfelt struggle and found herself rooting for Mr. Joshee and his young wife.

Unfortunately, the third letter was not quite what she had hoped. Rev. Wilder, the editor of the *Review* and the person to whom the two letters were addressed, refused the Joshees' request. He suggested that the couple remain in India because more missionaries, already on their way, could provide all the instruction that the couple sought. Even though he seemed to support the idea of female education, Wilder seemed oblivious

to Gopal Joshee's larger project of empowering his wife to improve the lives of their "country-sisters."

On the way home, Theodocia kept thinking of the couple in far-off India. Her heart went out to them; the husband seemed willing to withstand all the opposition of his community in order to educate his wife. She could not help pitying the young wife for being married at such a young age. Did she have young friends like American girls did? What happened to her after Rev. Wilder refused to help? Theodocia could almost taste the frustration of being denied opportunities to improve oneself and to help one's community. She felt indignant at Wilder's response. That an appeal in pursuit of an education should be met with the promise of mere literacy was bad enough. It was worse that the Joshees were expected to "work for a religion" other than their own in order to receive it.

The 1870s was a decade when America experienced the forces of change unleashed by the end of the brutal Civil War. Attitudes about people of color were beginning to change, albeit very slowly. The agitation for women's rights, put on hold during the War, was taken up again. The country was healing and rebuilding—not only economically, but socially and culturally. Religion was being rethought and reinvented. Educational institutions were being established, including ones for women, and a trickle of people from all corners of the globe was heading for America to pursue a modern education.

As citizens of a newly-prospering nation, Americans were becoming aware of their good fortune, ranging from their high standard-of-living to their generally enlightened social mores.

This was particularly apparent when compared to the destitution and the superstitious practices prevalent in the rest of the world. One outcome of this was that there were large numbers of Christians willing to serve as missionaries in far-off lands. Another outcome was the even larger number of religious people willing to make financial contributions to support that missionary work. In their frame of reference, bringing the light of Christianity to people eking out lives of want and ignorance was not considered mere charity, but rather, "God's work."

But in a smaller segment of American society, exemplified by the Eighmie-Carpenter families, the awareness of their good fortune had engendered thoughtfulness and open-mindedness toward others and their divergent beliefs, rather than a sense of moral superiority. Indeed, they were seeking to lead more enlightened lives, and to that end they were open to the spiritual wisdom of non-Christian faith traditions. They believed in broad emancipation and empowerment, in making education and medical care available to all; and they believed in providing these without the expectation of acquiring Christian converts. The Eighmie-Carpenters and other families like them were eager to do their part to make the world a better place. They too, saw this as "God's work."

While still a minority in the larger American society, this group possessed a stable, confident sense of identity and of purpose. And as a member of this group, the otherwise unremarkable Theodocia Eighmie Carpenter, with the support of her family and friends, accomplished something quite remarkable.

The day after her visit to the dentist's office, Theodocia made time in her busy schedule to write a letter to the young

Indian wife. She wondered if the letter would even reach the Joshees and how very long it might take to get there. She set these doubts aside, firm in her conviction that reaching out to the Joshees was the right thing to do. Although she could not imagine what impact, if any, her words of encouragement and offer of help might have, she knew that they would not hurt.

Theodocia could hardly have imagined the series of events that her letter would set in motion. Even though the Joshees had already moved twice since the publication of the missionary newsletter that she stumbled upon, the postal service persevered. It helped that Gopal Joshee was an employee of the service. Theodocia's letter reached its intended recipients almost nine months later.

Bhuj was the capital of the province of Cutch in northwest India. Its population was primarily Hindu, with significant numbers of Jains and Muslims. Although the Joshees had traveled extensively—from Kalyan to Alibaug, Kolapore, and Bombay—Cutch seemed a world apart, almost a new country. The language, Cutchi, was quite different from the Joshees' language, Marathi. The sparsely populated desert landscape seemed especially desolate compared to the bustle of Bombay and Kolapore and to the lush greenery of Alibaug and Kalyan. Even the ever-zealous missionaries seemed to have taken a pass on winning souls for Christ in this arid region.

By 1879, when the Joshees arrived in Bhuj, the royal court was at the forefront of bringing progress to the province, just as the royal court in Kolapore had been. There were already over seventy schools in the province, but only one was a high school. The two schools for girls were only for the primary levels. After

the year of tutelage with Miss Dobson in Bombay, Anandi had advanced far beyond what the schools in Bhuj could provide her.

Fortunately, all was not bleak. The modernization set in motion by the royal family had led to the appointment of able and progressive administrators, among them Dewan (Prime Minister) Vinayak-rao Bhagwat, who belonged to the same caste as the Joshees. Strongly believing in education, Bhagwat had generously established a "book fund" in his home province of Konkan.

Arriving in a new place in India, a sure way of finding one's bearings was to locate others of the same caste. So it was that the Joshees became acquainted with Bhagwat. They moved quickly from unknown newcomers to connected and credentialed residents. Unlike Mr. Barve in Kolapore, who had actively obstructed their quest, Bhagwat and his wife took Anandi under their wing, treating her like a daughter. Through Bhagwat, Anandi and Gopal were introduced to Mr. Battye, the British Resident in Bhuj, and his wife. Mrs. Battye took an interest in Anandi's education, teaching her sewing as well as academic subjects. Anandi soon became proficient at making her own clothes, a skill which would serve her well in the coming years.

Anandi and Gopal settled into their new home in Bhuj, next door to the post office where Gopal worked. Because post offices were typically located in market areas, there was hustle and bustle about their home. A steady stream of vendors, each with his distinct call and lilting sound, offered a plethora of household items, from brooms to pottery. Thus, Anandi's day was punctuated by dealings with all manner of daily help—the milkman, the vegetable seller, and the servant who swept the

floors and washed the clothes, pots, and dishes.

The calls of the hawkers amused Anandi; they were almost like the calls of exotic birds, she thought. Although she was no stranger to such itinerant vendors, here they called out in Cutchi, a language that she was only slowly beginning to understand. Their large mustaches, elaborate headdresses, and brightly colored outfits complete with ruffles and gathers, reminded her of birds with exuberant plumage. Anandi smiled to herself as she looked forward to describing this to Gopal when he returned from work. It would be good for a shared laugh; he would be pleased with her imagination and keen observation.

However, she felt lonely in this new place. Even though living in Bombay had been challenging because of the taunting neighbors and her disapproving in-laws, she had at least been able to go to school every day. At school she met other women, some of them missionary teachers and others students like herself. She had been angry with Miss Dobson for insisting that she read the Bible. She had felt impatient with her fellow students because she learned much more quickly, and then was forced to wait until they caught up. But now she missed it all. She missed Miss Dobson the way a young woman might miss an older friend—someone who exasperated you on occasion, but who cared about you as well.

In Bhuj, there was no school for Anandi and therefore no teachers or friends to see every day. Gopal remained committed to educating her. After returning from work every evening, he reviewed the homework he had assigned the previous day and prepared a new set of exercises for the next day. He was reserved when it came to offering praise. Although Anandi knew this

was because he thought he might spoil her or that she might treat it as permission to ease her efforts, it still disappointed her. In the evenings, tired after a day's work, Gopal fell asleep by the time she finished in the kitchen. So again she was by herself, mind buzzing with thoughts, ideas, and observations, unable to fall asleep.

Anandi was hardly a stranger to the limitations and challenges of women's lives. She knew from her mother and her aunts of the aches and pains borne quietly and stoically, of the long days that revolved around cooking, religious rituals, and family. In Bombay, she had experienced the dangers of venturing out of the house alone. However, in Bhuj Anandi became aware of new levels of deprivation and ignorance. She learned that unwanted girl babies were sometimes killed after birth. She heard that *sati*, the practice of burning widows on the funeral pyres of their dead husbands, was practiced in villages just a few miles away. The desert landscape seemed to reflect the inscrutability and hardness of the people among whom she lived. She would later characterize Bhuj as "an abode of superstition and orthodoxy."

Anandi felt restless, like a caged bird that could neither fly nor sing. Some mornings, after her husband left for work and she was alone at home, she felt reluctant to take up her home-work. "What is the point?" she asked herself. She worried that she might never again find a school like the one in Bombay. She continued to fret: What use was all this hard work if she could not use it to help other women? Anandi felt as though she had traded her illiteracy, not only for a useless awareness, but for loneliness and frustration as well.

One evening, when Gopal came home from the post office,

in keeping with custom, he washed his hands and feet and changed out of his work clothes. Anandi brought him a home-made snack and cool water from the clay pot in anticipation of sitting down with him to review her homework.

But Gopal did not seem to be in a hurry to get started. He told Anandi about his day at the post office, but she sensed that he was suppressing some exciting news. Were they going to move again? Had Gopal been promoted so soon after arriving at this new posting? If so, where would they be sent this time? Might it be their fate to have to relocate to an even more distant outpost where there would be neither a single person who spoke Marathi nor a single Englishwoman?

When she sat at her small floor-desk, Gopal held out a letter. "Read it," he commanded, with a smile hovering on his lips. Not knowing what to expect, she carefully pulled the letter out of the envelope. "Dear Sister," the letter began. It seemed to be addressed to her! How strange. Who would write to her in English and address her that way? It couldn't be Miss Dob-son, for she always called her Anandi-bai.

Anandi read on with anticipation. The letter contained words of praise and encouragement for her desire to be edu-cated."When I read the heartfelt letter written by your husband to Rev. Wilder, and when I read of your eagerness to obtain an education to serve your country-sisters, I was drawn to you and was filled with sympathy for you."

The letter mentioned God, not as the insistent one of the Christian missionaries, but as their common "Father." The humility of the letter's author was something she had never experienced in all her years of dealing with missionaries.

When good fortune smiles on them, I have seen people

become proud, selfish, and ungrateful. There are many
qualities among your people that we need to emulate
… If we get to know each other and understand each
other, we will both benefit equally. What one lacks, the
other will provide.

Almost breathless from drinking in the words, Anandi looked up at her husband for just a moment before continuing. Her eyes flew to the end of the letter—it was signed, "Your sister, Mrs. B. F. Carpenter"—and then hurried back to the beautiful words of friendship and support offered in the last two paragraphs:

> *"I will send you magazines or newspapers from New*
> *York. You will come to know our ways, our ideas about*
> *books and libraries and education."*

She almost laughed at the irony of the next sentence. "Since your husband's letter was published, I imagine many Americans readers have probably already written to you, and told you much about this country." If only it were so, Anandi thought to herself.

Then she came upon the words that changed everything:

> *Know that my husband and I are your true friends.*
> *We will help you in whichever way we can. We are in*
> *complete agreement with you about your desire for edu-*
> *cation, and your desire to help others. Do write to us*
> *about yourself, and how your studies are progressing.*
> *We are all students for life, for there is no end to the*
> *pursuit of education. Everything that has an end is*
> *constantly moving towards the eternal.*

Gopal and Anandi were both stunned; an array of wild thoughts and questions swirled in their heads. Was this a real letter or merely a hoax perpetrated by one of their many adver-

saries? Should they trust the sender? Who was this Mrs. Carpenter and how might her help change their situation? They chatted for a few minutes, each excitedly quoting to the other some of the surprising and heartening words and phrases they had just read; it was as though they were examining a bright shiny object from all angles and marveling at its strange beauty. Having experienced both the religious zeal as well as the rejection of others, they were inclined to be cautious. They agreed that Anandi should compose a response, if only to thank Mrs. Carpenter. If they were lucky, Anandi might be able to continue a different kind of instruction and dialogue in English.

Anandi reread the letter, savoring every word in it, until she nearly memorized it in its entirety. By the time she finished, she was not the Anandi she had been before. Sleep was impossible, but tonight she would not mind. She had just found the key to her life, one that would open the door to a new way of being. With the help of her new friend, Mrs. Theodocia Carpenter of Roselle, New Jersey, in the far-off country called America, she felt hopeful that she just might find a way to achieve her purpose.

That first letter from Theodocia was the start of a mutually sympathetic, supportive, and rewarding correspondence between the fifteen-year-old girl-woman in India and the fortyish mother in the United States. The two wrote to each other about their families and the cultural practices prevalent in their societies. Anandi mailed Theodocia a sweet she made from sesame seeds, along with its recipe. It marked the Hindu festival of *Sankrant* which was, fittingly, a celebration of

goodwill and friendship. To treat a fever Anandi wrote about, Theodocia mailed a remedy prescribed by her doctor in New Jersey. Theodocia mailed newsletters, books, and other reading material; Anandi sent silver art objects. They exchanged photographs, locks of hair, and flowers.

It took each letter about a month to reach its recipient on the other side of the planet. A few letters got lost in the mail and others crossed one another on their long journeys. But the two women remained steadfastly connected, responding to each letter as it arrived and apologizing for delays and missed connections. Far from hampering their budding relationship, the vast distance that separated them offered each woman the privacy she needed to be frank as well as bold. Within the context of their friendship, Anandi developed her own voice, and found in Theodocia a sympathetic reader with whom to share her unique point of view. At the same time, Theodocia sought a connection to the mystical East and found a meaningful expression of her values in offering Anandi her heartfelt and selfless encouragement and support.

Anandi wrote at length about the circumscribed and super-stition-driven lives of Indian women:

> *It is not customary among us to take or give husband's name as it is supposed that the taking of husband's name goes to shorten his life. I have no faith in this tradition and so will give you my husband's name is Gopalrao.*

She described how she was standing up to her community, albeit with Gopal's support:

> *I do not expect much encouragement from the other members of my family. They are, properly speaking, orthodox to the letter, and cannot be expected to sympathize with me. But as my husband is so much in favor of female elevation and emancipation, no one dares turn his face against me.*

She even went so far as to call out the perversions inherent in some Hindu practices:

> *Men & women are saved alike by good and meritorious actions but the duties prescribed to obtain the end are different. Like the Mormon, husbands are the altar on which women should make sacrifice of self. In other words, they should worship husband as God. . . . But I do not believe so. . . . It is no doubt perverted imagination (and) false traditions that dictate that man should do one thing & the women the other.*

Anandi's boldest indictments of Hindu customs were those that caused women unnecessary hardships:

> *We never put on western clothes as it is considered indecent nor do we wear shoes or boots as we seldom go outdoors. In short all these luxuries are for men who feel cold and not for women who are supposed to be impervious to all these changes of climate. Should not we envy you then?*

She described the precariousness of the lives of Indian women because of the conservative beliefs of the community and their neglect by their families:

> *It is thought indecent to let them get the knowledge of the other sex, much more [let alone be] examined by male Doctors. You may therefore imagine the mortality among Indian women. If I make no exaggeration,*

fifty percent die in the prime of their youth of diseases arising partly through carelessness on the part of their guardians or husbands. It is not a calamity if a father loses a daughter or two as he is thereby spared much trouble and embarrassment to which he is exposed by abominable customs and manners.

In response to Theodocia's questions, Anandi described the cruel treatment meted out to Hindu widows. Being deprived of all their jewelry and having their hair shorn off was only the beginning of a widow's degradation:

She is given a peculiar dress to put on, her head is shaved against her will and desire, all the ornaments on her person are removed and the glass bangles and wreathes of beads are broken. She is in fact deformed and reduced to a state horrible to look at; she is not allowed to move in society, especially when marriage or other ceremonies are performed; her face if first seen in the morning before anybody else's is seen as a bad omen for the day; if a traveler meets a widow on his first setting out, it is ten to one but that he will return home and sit for a while before he resumes his journey; but at home she is bitterly cursed by her parents-in-law, she is not given enough to eat; she must not eat twice a day; in short religion enjoins her not to enjoy life.

It is no surprise that Theodocia was quite horrified upon reading this description. In her next letter, she asked if Anandi expected the same fate for herself. Anandi's response was intended to put Theodocia's mind at ease, but also to shed light on Gopal's rational and passionate commitment to women's empowerment— and Anandi's confidence in that commitment:

I do not share the old prejudices, nor do I give much weight to old customs and manners, but mentioned them for your information. You should take them as not applicable to me. We are both growing fast in new tenets and principles. We have chalked out our path of life quite different from that of our ancestors, but we cannot fully work it out for many constitutional and social difficulties. . . . Soon after my marriage, or say before that, my husband got my parents bound to give their tacit consent to my future education in any way he liked. His object in getting me educated was the same as you cared for. That I may not be subjected to social degradations and humiliation and lead the life more of a slave than of an intelligent being after his death. He set aside all religious and social restrictions and sent me to school in spite of all oppositions. He will not be satisfied till I shall be able to live as you wish me to. So you need not be saddened.

Theodocia was probably thinking about women's lives in both of their countries when she expressed the radical idea that women's dependence on men was the root cause of the many challenges that they faced. This elicited agreement from Anandi:

You have correctly detailed the circumstances which enfeeble women. I agree with you in the main. It should be the motto of man and woman to live independent of each other. One should not be housed for the other, then half of the misery of this world will be alleviated.

Engaging in the process of explaining her world to Theodocia led to a fundamental change in Anandi's perspective. She also became sufficiently self-aware to recognize this change:

When I received your letter for the first time, I had no

taste for reading correspondence. Your second letter
made me look to you for interesting matters and en-
abled me to see how daily occurrences of life which
formerly were considered trifling were turned to ac-
count for instructing the mind. Your subsequent letters
have opened my eyes to the contrast between the lives
that you and we lead. Whenever I was to write a letter
to my friends and relations in India, I felt as if I had
nothing to write upon, even though surrounded by in-
numerable things for my amusement in literary pur-
suits. My eyes are now directed to the daily receipt of
letters from you.

In the process of responding thoughtfully to Theodocia's
questions, Anandi developed the ability to observe, analyze, and
describe her physical and social environment. Although neither
woman could know this at the time, this ability to think
critically would prove to be excellent preparation for Anandi's
time and studies in America.

Just a few months into their correspondence, Anandi visited
her family in Kalyan. When she and Gopal lived in Bombay,
she looked forward to these visits home. But now, even though
she lived farther away and in a place that was culturally very
different, being in Kalyan no longer provided her the same
respite. She felt restless from the lack of a study regimen. No
longer accustomed to living in a large communal household,
she felt out of touch with its rhythms. She wished that her
family members would ask her about her experiences in the
many places she had lived. She wished she could tell them about
Theodocia and her many thoughtful and encouraging letters.

But that could not be. Anandi saw that her family members

were busy with their everyday lives, pursuing them in the only way they knew how—locked into their individual and community orbits, defined by age, gender, caste, and class status. She now had a more meaningful relationship with Theodocia than with anyone else in her life, perhaps with the exception of Gopal. It became clear to Anandi that Theodocia was now the fount of everything she needed, valued, and aspired to in a way that her own mother could not be. Theodocia was her champion and protector—a special kind of maternal aunt who eclipsed her still-living mother. And so, she made a most unusual request in her next letter:

> We are day by day being tied closely and firmly. . . I really wish and feel that I should call you my aunt. There is a saying among us, "it does not matter much if a mother dies but not let an aunt die." This expression will show you in what respect & estimation a maternal aunt is held among us. If you allow me, I wish to look upon you as such.

The Marathi word for one's mother's sister is *mavshi*. The concept that one's *mavshi* was the closest stand-in for one's mother was a powerful one. *Mavshi* was the refuge of last resort in the event of a mother's death, and the idea of such a "godmother" offered solace to mothers and children alike.

Because they were denied access to medical care, women had no choice but to stoically tolerate their many health challenges. The most challenging prospect was early death of the mother, which often happened during childbirth or owing to related complications. Widowers were encouraged to remarry, and they were encouraged to start new families with their new, often much younger, wives. This cast the children by the

deceased wife in the role of unwelcome reminders of a chapter that was considered closed. The solution—preferred by "mavshi,"widower and children alike—was that the children be sent to live with her.

It was with this concept in mind that Anandi asked Theodocia if she could call her "Aunt." Theodocia readily agreed to Anandi's request. In almost all subsequent letters, the two women addressed each other as "My dear Aunt" and "My dear niece."

Anandi blossomed under the supportive and engaged mentorship that Theodocia provided. The aunt made the niece feel sufficiently safe to write about the distinctive and strange aspects of her society. In one letter Anandi described the practice of polygamy, which was permitted for men of means. In another she described the importance of sons for social as well as religious reasons. When describing practices of household cleanliness, Anandi mentioned that "walls and floors are daily swept and weekly cow-dunged." It is hard to imagine what Theodocia might have thought after reading that "in the Deccan, near Poona, we have dried cow-dung half burnt for teeth wash."

Amazingly, there was no change in Theodocia's level of engagement. She was practicing not mere tolerance, but complete acceptance. Theodocia's open and egalitarian mindset, which had been apparent in her earliest letters to Anandi, remained unchanged. She understood the importance of women doctors and encouraged Anandi's desire for a medical education:

> *The field of labor which you would choose for yourself*
> *is very honorable: and one in which more of your sex*

> *is needed. It is also a very responsible one. To be a good*
> *physician one needs to have a natural adaptation to*
> *this work.*

She mentioned "God," but this was not the Christian god of the missionaries. Rather, this was a god who was aligned with Nature and who worked through natural laws for the welfare of human beings:

> *Seekers after knowledge, in any line, need to lay aside*
> *prejudice and bias of every kind, and seek for truth*
> *everywhere—seeking they shall find—not all in one*
> *institution, -ology or -ism, but everywhere. Just as the*
> *Infinite God is everywhere so are his laws everywhere*
> *at work. Doubt those who would make you believe*
> *that truth is narrow and one-sided. The true student*
> *of Nature would as soon go to India to study as any-*
> *where else, and for the true philanthropist there need*
> *be no better field. If in your heart you would save hu-*
> *manity, your true work shall find you, even though it*
> *be at the ends of the earth.*

The most astounding aspect of Theodocia's flexible concept of God was that she expressed an interest in being converted to Hinduism:

> *Your description of a Hindoo's religious life is anything*
> *but attractive to me, nevertheless I should very much*
> *like to commune with one of your priests. I don't sup-*
> *pose you could induce one to try to convert me by*
> *letter, could you? I am ready and anxious for Truth*
> *and if your learned priest thinks I am in outerdark-*
> *ness, while he has the light, I would welcome any at-*
> *tempt on his part to enlighten me.*

Anandi and Gopal were used to being proselytized by missionaries. They were also familiar with the missionaries'

criticism of Hindu practices, particularly idol worship. And yet, here was an ostensibly Christian woman who seemed not to share the missionaries' views of the supremacy of Christian beliefs. Indeed, she was willing to be *converted* to *their* religion. Theodocia's query helped to establish trust between the two women even though they had not met in person and lived on opposite sides of the globe in very different societies.

During the first year of their correspondence, neither Theodocia nor the Joshees dared to think about the significance of their unlikely relationship. All recognized that their relationship was too special to burden it with the expectation of achieving a specific outcome. It was sufficient that they had opened a door that most did not know existed. They would continue to learn and grow in each other's remote company.

4

FRIENDS IN A STRANGE LAND

And in the end, it's not the years in your life that count. It's the life in your years.

Abraham Lincoln

*E*ach time a letter from Theodocia arrived at the post office, Gopal brought it home to Anandi, anticipating an evening of joyful discussion. Just as when they received the first letter, they each read the latest letter and then discussed its contents together, marveling at Theodocia's continued interest in them. Each letter brought new information about life in America and new questions through which to examine and explain life in India.

They were surprised when they received a small box instead of the usual thick envelope containing letters, cards, and pamphlets. The box contained two books. The books were not about medical studies, such as *Gray's Anatomy* or the *Materia Medica* that Theodocia had mentioned in her earlier letters. One of the books was called *The History of the Origin of All Things*; the other was called *Principles of Nature,* and was written by a woman.

Trying to get a sense of what the books were about, Anandi and Gopal flipped through the pages. The books' dry language

and use of unfamiliar words suggested that they would not be easy to read. Even so, out of regard for Theodocia and a curiosity to know why she considered the books important enough to send to the other side of the globe, Anandi and Gopal decided to make a sincere effort to read them.

After Gopal left for work the next day, Anandi quickly completed her morning chores, eager to get to the books. She held them in her hands and traced the lettering with her fingers. She breathed in their clean, woodsy fragrance, which was now associated in her mind with everything that originated in America. She felt overwhelmed by the thought that just a few weeks before, Theodocia herself had held these books. She reminded herself that the same was true of the letters she had received. But this felt different—it was a concrete, and thus a more meaningful sign of Theodocia's commitment to them.

Anandi chose the book titled *Principles of Nature*, whose author was Maria King. Because her knowledge of English was not as advanced as her husband's, she hoped that the book written by a woman would be the easier of the two to understand. She kept a dictionary on hand to look up the meanings of unfamiliar words. It would be slow going, but she would not mind in the least.

Eager to dig in, Anandi skipped over the preface; after all, she did not need to know just yet how the author acquired the knowledge and the authority to write the book. The next section, the Introduction, was just five pages long and was not at all difficult to understand.

The first page summarized what the book was about:

A concise exposition of the laws of universal development, of origin of systems, suns, planets; the laws

governing their motions, forces etc.; also a history
of the development of earth from the period of its
first formation until the present.

Anandi already knew something about *jyotish*, the Hindu
system of astrology. Priests used it to draw a person's life chart
based on the alignment of the planets at the place and time of
birth. The horoscope was used to find a well-matched prospec-
tive bride or groom as well as auspicious days for the wedding
and other family or community celebrations. She wondered if
the book would confirm the Hindu beliefs in the power of plan-
ets to influence human affairs.

The book also promised an "exposition of the spiritual uni-
verse." Would this be about multiple births, the eternal soul,
and the afterlife? These concepts ruled the lives of Hindus, in-
spiring them to live lives of virtue (*punya*) and cautioning them
against committing sin (*paap*).

The introduction went on to assert that seers and prophets
of the world's religions, from Zoroaster to Jesus Christ, were
spiritual mediums who could explain the "divine plan" to hu-
mans. Because Anandi knew that many religions were practiced
in India, this idea made sense to her. Having been tormented
by proselytizing Christian missionaries, it was heartening to read
that Maria King recognized the gods of other religions on a par
with Christ.

The ideas that King derived from this one were even more
novel. She believed that scientists like Benjamin Franklin and
Isaac Newton were modern versions of the earlier religious pro-
phets; that the purpose of these seers and of their work was for
the "use of man" and that divinity lay not in believing some-
thing because "thus saith an angel of the Lord," but because it

was supported by scientific proof.

When Anandi reached the end of the introduction, her mind was racing. She couldn't wait to tell Gopal the extent to which the book was consistent with Hindu ideas. She knew he would feel encouraged. Anandi also felt confident that Gopal would be pleased by her efforts and by her ability to understand such a complex text. While she waited for him to return from work, Anandi turned to the "Scribe's Preface." Knowing that meat was an integral part of the diet of Christians, she felt heartened when she read that, just like her family and community, the author did not eat meat.

Anandi and Gopal discussed the book over the next few days. For the first time, they had come across a Western book that did not challenge or scorn Hinduism. More importantly, they now knew a European whose beliefs were not in opposition to theirs.

In her next letter, Anandi told Theodocia how much the book meant to her:

> From the reading matter to hand, I am very glad to learn that America is not so orthodox in religion as I was led to believe from the missionary labors in India. Mrs. Maria King is really an adept in Hindu philosophy. My religion teaches the same thing. Man is an attribute of God and can attain to divine perfection.

She requested that Theodocia arrange to send her all the other books written by Maria King, promising to remit the cost upon receipt of the bill.

Gopal's progress when reading *The History of the Origin of All Things* was slow. It was a dense tome and he could read only

in the evenings after work.

The author, L.M. Arnold, believed he was the conduit whom the spirit world had chosen in order to reveal "truths" to humans. One such truth was that human civilization was at the dawn of a new era in which the answers to man's eternal questions would be revealed through spirit communication:

> What man is, was, and will be, has always occupied his thought and engaged his deep research. But heretofore he has had few materials for his study, and thus has made small progress in solving the problems upon which his curiosity impelled him to work. Recently the minds of many have experienced the dawn of brighter anticipation, through the communications of spirits.

A second truth was that this communication was initiated by the spirits of "departed friends":

> There is now proceeding from God's spirit, an influence which acts on man, through the spirits of his departed friends; friends who have left the body to exist in spirit-form only.

Finally, Arnold wrote that the spirit state should be welcomed, rather than feared. Indeed, the opening paragraphs of the book provided an interpretation that a Hindu would find familiar:

> This state-of-the-spirit is a blissful one, compared with that of bodily existence, because man is thereby relieved from the temptations which the bodily nature impels [nirvana] and having no thought for self only, or no need to have such

thought, he delights in doing good to others with himself [punya]. Being relieved from bodily temptations, he ceases to sin, and becomes purified by the fire of God's love from the consequences of the sins he has committed in the body. Being purified gradually from these, he ascends to a higher condition in which he possesses a greater measure of God's presence in him [moksha].

Gopal and Anandi discussed this book just as they had done with *Principles of Nature*. Once again, they felt gratified to know that the Carpenters were interested in such books. Although they could not know this at the time, Theodocia had not sent the books only because she thought they might appeal to the Joshees. She had sent them because they were an important part of her family's belief system.

Starting at a very young age, Theodocia's husband Benjamin had worked as L.M. Arnold's confidential clerk and silent partner. Even though Arnold had died more than fifteen years earlier, Benjamin continued to publicize his work and sell his books.

A few months later, Gopal wrote a letter to Benjamin:

> *I have read some portion of* The History of the Origin of All Things *so kindly presented to my wife by Mrs. Carpenter. It is very easy in style but so difficult to understand that it no doubt requires to be studied prayerfully as Mrs. Carpenter writes to say. I am glad both of you take such a lively interest in the study of mind and soul. But how important would it be to you to study Vedic literature of the East on the same subject?*

The Joshees felt affirmed by the idea that Hindu philosophy

had parallels in Western thought, and that at least a few Americans were aligned with Hinduism's core beliefs. The books may well have occasioned a first—a Hindu venturing to encourage a Westerner to study *his* religious tradition with the ease and authority that were typically beyond *his* reach.

The authors of the two books that the Carpenters sent all the way to India attributed their knowledge and wisdom to mediumship. Both believed that a mysterious "spirit" had chosen to reveal, through them, important truths to humans.

Both authors were adherents of Spiritualism, a religious movement that was rooted in the conviction that the living and the dead could be in meaningful communication. One event that precipitated modern Spiritualism, as it was called, was the 1847 publication of *The Principles of Nature*, written by Andrew Jackson Davis, a young "entranced seer" from Poughkeepsie, New York. The book speculated on the evolution of the cosmos and its relationship to human culture and religion. In 1848, three young sisters, Margaret, Kate, and Leah Fox, generated public excitement with their claim to have contacted spirits of the dead through telegraphic rapping, in their home near Rochester, New York. Soon, "mediums," who were thought to be sensitive to "impressions" from spirits, began guiding hopeful participants.

This occurred at a time when infant mortality was still quite prevalent and women, in particular, suffered greatly from the deaths of their infants and children. Having lost four babies, Theodocia was no stranger to this form of anguish. (As she would later find out, Anandi, too, was a member of this par-

ticular "club" that no woman willingly joined.) Thus, women were naturally drawn to the solace offered by Spiritualism—that the dead continued to exist in "spirit life," and that it was possible to communicate with them, and be reunited with them, after one had passed on.

Given their grief over the deaths of their children, it seemed reasonable that many more women "received" spirit communications than men. And because women were typically viewed as passive, it was also easy to believe that they were more easily influenced by spirits. This line of thinking had the astonishing effect of making spirit communication, and women's particular authority in that realm, more accepted. Soon, in a departure from established church practice, Spiritualist groups started allowing women to participate on an equal footing with men, even leading worship services.

Although not all feminists were Spiritualists, all adherents to Spiritualist ideology believed in women's rights. Spiritualists asserted that women—half of all humanity—had been deprived of the right to control their persons by church, state, and society. They also believed that it was high time the situation were rectified. At one Spiritualist convention, an attendee expressed widely held Spiritualist sentiment when she said, "…Woman's freedom is the world's redemption."

The Spiritualist movement soon attracted people who dared to think differently about a whole range of issues in addition to the status of women. Some of these were abolition of slavery, health reform, labor reform, and communal living. The movement drew people from most mainstream Christian denominations and, at its peak, was estimated to have eight million followers, almost one-fourth of the white American population

at the time. Some adherents, L.M. Arnold among them, saw a connection between the experiential and mystical core of all religions. Others, like Maria King, looked to Spiritualism—and other "sciences," like phrenology and mesmerism—to reconcile spirit with matter and religion with science.

Far from being a fringe faith tradition, Spiritualism in mid–nineteenth century America was at the root of most of the progressive movements of its time. Despite the absence of definitive proof that spirit communication was possible, many people, particularly the progressives and the avant-garde, were open to it and were willing to dabble in it.

Arthur Conan Doyle, the author of the popular Sherlock Holmes mysteries, was a Spiritualist and wrote a book about it. Mark Twain was a skeptic but kept an open mind and is known to have visited a London medium in the hope of contacting his deceased daughter, Susy. Harriet Beecher Stowe, who wrote *Uncle Tom's Cabin*, had two siblings who were Spiritualists. Abraham and Mary Todd Lincoln are known to have attended séances, some of them in the White House.

However, not all radical ideas succeed. Spiritualism was a flawed "innovation" in that its foundation—communication with the dead and faith in mediums and psychics who facilitated that communication—was an idea of questionable merit. There had been many skeptics, Ralph Waldo Emerson among them. Spiritualism lost its cachet in the late 1870s, and its influence began to wane.

Spiritualists soon became reluctant to publicly proclaim their belief in spirit communication. However, like receding ocean waves that leave their contours in wet sand, progressive ideas and hopes for a better society that rode in on the Spiritu-

alism wave, continued to inspire its true believers.

Both Theodocia and Benjamin grew up in families that were perched at the confluence of the progressive religious movements of their time.

Theodocia's father, Jeremiah Eighmie, was a Spiritualist who relied on "psychic" hints and hunches in his business dealings. He also believed that the "spirits" told him to donate money to help the destitute, the sick, and orphaned children.

As for Benjamin, his family belonged to the Hicksite Society of Friends, named after its founder Elias Hicks, an early abolitionist. The Hicksites were a breakaway branch of Quakerism, and one of their core beliefs was that the "Inner Light," the inspiring presence of God in each person, stands above Scripture and creed. Hicksites were pacifists who opposed slavery and were more open than mainstream Quakers to the idea of equality between men and women.

Given the milieu in which she grew up, Theodocia felt sympathy for Anandi's marginalized existence, owing to her gender and race. She also felt for the precariousness of Anandi's life that resulted from lack of access to education and medical care. The activist in her wanted to be an agent of change—a champion and supporter of one who so earnestly sought an education so that she might bring medical care to the women of her country. Because Theodocia's concept of religion was not limited to Christianity, Anandi's Hinduism presented no barrier at all.

None of Theodocia's letters (only a handful of which are available) contain explicit references to Spiritualism or spirit communication. So it is necessary to rely on Anandi's letters to obtain confirmation of Theodocia's Spiritualist beliefs and her

motivations in reaching out to Anandi.

In a letter to Theodocia, written from Bhuj in November 1880, Anandi wrote:

> From the reading matter to hand, especially the *Banner of Light*, I am led to believe that there are many ladies in America who are given to the study of Spiritualism. There are many stories published in that paper to the effect that the dead appeared before the living and told many things to their survivors. Do you believe in them, or are you an eye-witness to the manifestations? If so, please enlighten me. I think you have heard of Madam Blavatsky and Colonel Olcott. They are making wonders in India. The papers are full with the account of the occult phenomena of Blavatsky. She is the staunch advocate of Vedic philosophy and asserts that all the new things discovered or invented were formerly in practice in India.

In a later letter, this one written after the move to Calcutta, Anandi asked directly for help communicating with spirits:

> It is only a year or two since the arrival of Madam Blavatsky and Col. Olcott that we imagine that there is such a thing as medium-ship and adepts. I wish I had any knowledge of the blessing so kindly placed by God within our reach. If you will kindly let me know how I should commune with spirits and enjoy the messages from the dead, I should be obliged.

This suggests that in an intermediate letter Theodocia had confessed her familiarity with spirit communication. Indeed, Anandi appears quite captivated by Theodocia's revelation:

> ...I will have the pleasure of someone to ward off the evils hovering over me. Pray do me the needful; your account is so interesting that I read it over & over

again & yet I feel inclined to do so; for the idea is novel to me.

The possibility of communicating with and receiving protection from the departed was tantalizing enough. What made it more so was the fact that Anandi had independently come to know of the same beliefs and practices thanks to two individuals—Madame Blavatsky and Colonel Olcott—who had moved to India just a few years earlier.

The duo had founded the Theosophical Society, one of the purposes of which was "to form a nucleus of the Universal Brotherhood of Humanity, without distinction of race, creed, sex, caste or color." They expressed reverence for Hindu teachings, which endeared them to progressive Hindus. Indeed, Gopal soon became a member of the Society.

So, when Spiritualism and its many facets—spirit communication, religious liberalism, scientific inquiry, and universal brotherhood—were introduced in Theodocia's books and letters, the Joshees felt as though the pieces of a puzzle were falling into place. They understood Theodocia as akin to Blavatsky and Olcott, and therefore trusted that she understood them better as well.

Conversely, given that one of her goals in writing to Anandi was to commune with Eastern spirituality, Theodocia found affirmation in the fact that spirit communication was receiving a positive reception in India.

The books that Theodocia sent to the Joshees acted as conduits, communicating aspects of her beliefs in ways her letters alone could not. The books expanded the range of the dialogue between the two women. Theirs became a relationship based on shared values rather than on mere utility.

Preparing for Takeoff

*Friendship isn't about who you've known the long-
est, it's about who walked in to your life, said "I'm
here for you," and PROVED it.*

Unknown

*G*opal and Anandi had been in Bhuj for a little over a year
and a half when Gopal received word that he was being
transferred to Calcutta. Although this was an unexpected de-
velopment, they welcomed the news because the move would
take them from a small provincial town to the capital of British
India. Because the postal service was headquartered in Calcutta,
this move would also likely lead to new career opportunities for
Gopal.

Except for their stay in Bhuj, the Joshees had always lived
within their home province. Bhuj, about five hundred miles
away, had seemed like a new country because of the differences
in language, climate, and custom. Now they would travel three
times as far and would have to adapt to even larger cultural and
language differences.

Because Calcutta was well known as a center of progressive
thought, Gopal and Anandi quickly realized that the
implications of this move for Anandi's education were enor-
mous. There would likely be a wider choice of established
schools for her. They would likely get to know more Europeans

who could help her master English; the Europeans might even help them get to America. Hopefully, they would no longer have to rely on the "kindness" of missionaries. They imagined that they would become acquainted with educated Indians, thus mitigating the loneliness and "swimming upstream" aspects of their lives.

When moving to Calcutta, Anandi and Gopal felt no hesitation. In the aftermath of their experiences in Bombay, they maintained few attachments to family or friends in their home province. Anandi drew strength and emotional support from Theodocia's letters, and she was confident that the move would not alter their connection in any way.

Calcutta was called both the "Second City of the British Empire" and the "City of Palaces." It was a place of imposing government buildings, beautiful parks, and wide promenades. "Men from Cashmere, Afghanistan, China, Arabia, Thibet… dressed in their native costumes" were a common sight, as were Indians of all ethnicities, ranging from Hindus and Muslims to Jews and Parsees. Having lived in cosmopolitan Bombay, the Joshees did not expect to find Calcutta especially challenging.

Despite their optimism, Gopal and Anandi's first few months in Calcutta presented situations that they could not have imagined. The first of these was their German landlady. As Anandi wrote to Theodocia:

> *She is such a bad & cruel lady. . . . When I came here, all her servants gathered around me just to have a look at me. The lady also began to peep through her windows & to laugh in her sleaves (sp). . . . She got up stories. Once she …spread a rumor that we quarreled*

out whole night. So much so that the other tenants
were awakened. This did not satisfy her. She then gave
it out that I am not a married woman but a kept one.

Another problem was that their belongings were delayed in transit. Thus, they were unable to cook their own food, an especially challenging situation, because as Brahmins, they were forbidden from eating food prepared by non-Brahmins:

For a fortnight or so we could not get enough to eat
though our Pocket was full. Our kit baggage, bedding
& clothing all remained behind & we had to content
ourselves with mats to sleep on. The floor or ground
was so damp that the few clothes we had on became
wet & we felt chilly. Such a time had never befallen us
before.

These were such unsettling experiences that Gopal felt defeated. Probably for the first time, he considered abandoning the idea of going to America:

This will show you how hard it is to travel in countries
where we have no friends to comfort us. What then
will be our condition in a country where everything
is strange? My husband has therefore given up all
hopes. He says now that it is no use being forward in
the face of so many difficulties resulting from the going
away from the trodden path of the society amongst
which we live.

But now it was Anandi who became the determined one. Armed with the maturity to accept that "the world is full of hardship and suffering," she drew inspiration from Hindu mythology as well as Christian teachings. In her letter to Theodocia, she wrote about Raja Harishchandra and likened his persecution to that of Job.

Even the weather seemed to conspire to cause them misery:

As I told you before, Calcutta is trying us to the utmost. Physically we are so reduced in strength & health that we cannot digest the food taken in the morning till next day. The climate is awfully warm & I am fearfully suffering from boils. My face has one & thousand getting up which has made me so hideous. It has commenced to rain & yet the heat is not less. I do not know how long we have to continue in this miserable state.

This created a different kind of challenge for Anandi:

My husband comes home fatigued & tired & goes to sleep as soon as he has his back on his bed while I lie by his side sleepless for hours together. I wish that he should speak with me until I am able to shut my eyes but he cannot do so for which I am always wrath on him, though it is not his fault.

And then there was the conservatism of the Calcuttans themselves:

We go out for a walk in the Evening and European ladies & gentlemen are wonder-struck at it & they keep a look on us from a distance till we or they go out of sight. They point to us & seem indulged in talks about us. …The case is still more striking with the natives. …I have observed some natives in carriages to order their coachmen to stop when they come near us & not drive till their curiosity is gratified.

The reaction of a policeman was even worse:

One Police Sepoy had once the impudence to come near us when taking a walk in the Esplanade & asked my husband who this woman was with him. This irritated my husband & he had to ask the

peon's name in order to report him to the commissioner. This brought him to his senses & he left us alone after exchanging modes of courtesy.

Zenana is a Persian word that means "of women" or "pertaining to women." It originally referred to the inner sections of Hindu and Muslim households, which were designated as the domain of women. Over time, the word's usage grew to encompass both the female members of the family and the strict separation of women—from the outside world as well as from the men within the family. A holdover from the Mughal rule in India dating back centuries, the *zenana* system was an example of cultural practices that proved to be resistant to the "changing of the guard" represented by British rule. So ardently was this separation practiced that Christian missionaries had to submit to the custom and establish "zenana missions" if they hoped to reach Indian women.

Anandi was used to living in a society that severely curtailed women's agency and their exposure to the outside world, but the *zenana* system as she saw it practiced in Calcutta was extreme even for her:

> *There is so much of zenana system in this part of the country that a woman can scarcely stand in presence of her own relations more less [sic] in presence of her husband. Her face is always veiled and she is not allowed to speak to any man much less to laugh & indulge.*

Even more shocking to her was the fact that men who were educated and had lived in the West continued to practice such segregation:

*Even the Babus who spent some years in England &
America cannot walk or drive in company of their
wives in open carriages. If you go to their houses, you
will see zenana too rigidly observed. If it is so with the
educated people, how much more prejudiced must be
the illiterate ones.*

Anandi's reaction to the challenges of adjusting to life in
Calcutta exemplifies the truth of Nietzsche's aphorism, "that
which does not kill us makes us stronger." Her resolve to leave
India became stronger—and less cautious even—than Gopal's:

*All this naturally leads me to conclude that either this
country is not good for us or we are behaving in a
manner unwarranted by the customs of this country.
If the former conclusion be correct, I am not then
wrong in pressing my husband to get out of it. But he
says it would be rashness on our part if we were to go
to a foreign land uncared for and unprotected.*

Their shock at life in Calcutta gradually subsided. Upon
learning of their arrival in Calcutta, fellow Chitpawan
Brahmins, Messrs. Patwardhan and Dandekar, visited the post
office and introduced themselves to Gopal. Over time, Mr. and
Mrs. Dandekar came to look upon Anandi as a daughter. When
she fell severely ill with fever, they invited her to stay with them
so that they could look after her and cater to her until she re-
covered.

Anandi also made friends with a few Bengali women from
her neighborhood and invited them for tea:

*I was very much astonished to see them bow down be-
fore me as if I were God. They were peculiarly interested
in my dress and ornaments.*

A cousin of Anandi's, Rama-bai Dongre, was also living in Calcutta at the time. Rama-bai was just seven years older than Anandi, but because she led an itinerant life, the two women did not know each other. Rama-bai had recently achieved an odd combination of fame and notoriety in Calcutta.

She was awarded the title *Pandita*—wise and learned woman—by the "pandit" scholars in the city. This was in recognition of her mastery of Sanskrit and her skillful interpretation of various Sanskrit texts. Rama-bai had come by this scholarship because her father, a Sanskrit scholar and reformer, had taken it upon himself to educate his wife as well as his daughter.

Rama-bai's achievement was soon overshadowed by her marriage to a lawyer who was not a Brahmin. Their marriage was the reason both their communities rejected and even shunned the couple. The death of her husband soon after was a great blow, especially as it came shortly after the deaths of her parents from famine and her younger brother from a serious illness. Rama-bai was alone in the world, except for her little daughter, Manorama.

When Anandi learned of the death of Rama-bai's husband, her heart ached for her cousin. She invited Rama-bai to her home. Neither Anandi nor Gopal felt the need to distance themselves from Rama-bai because of her inter-caste marriage or her recent widowhood. Unfortunately, so scarred was Rama-bai by the ostracizing she suffered that she ignored their invitation.

But years later, Rama-bai would describe the impact of Anandi's thoughtfulness:

> *I was very grateful to her all the same, for she was the only person in the whole country who cared for me, such an outcast had I become in the eyes of my people. Nor shall I ever cease to be grateful to her for*

this kindness.

The two cousins, each a trailblazer in her own way, were not destined to remain strangers for long. It would not occur for a few years, but their reunion would eventually take place in a very auspicious setting…in America.

Anandi's resolve to travel to America continued to solidify. Theodocia's unwavering support and encouraging letters made the prospect of living in America seem less daunting:

> *I don't wish to put you to expense on my account. I am confident that I shall make my way into any country without money in my pocket. All I wish from you is your (n)ever-ceasing kindness & good graces.*

In just another six months, actual plans were being formulated:

> *My husband has made up his mind, unless Providence disposes otherwise, to obtain one year Furlough and spend it in America. While on leave he will get half of his salary, which will enable us to live there economically. It is his intention if I get acclimatized there, to leave me there for the prosecution of my studies and return to India alone. So you see your prophecy will soon come to pass, if it please God.*

The Joshees initially assumed that they would both travel to America for Anandi's education. However, because of the high cost of passage, they eventually decided that Anandi should set out alone. Gopal would join her later after continuing to work and accumulating savings. This decision became significantly easier when Theodocia invited Anandi to stay with her in New Jersey. Anandi's response to such an unexpected and

generous offer was understandably exuberant:

> *I do not know how many thousand times I should*
> *thank you & your noble husband for the privileges*
> *which are already accepted with a joy from the bottom*
> *of my heart. Your noble feelings and generous hearts*
> *are incomparable. Your offerings of privileges & your*
> *desire of welcoming me to yours obliges me very much.*
> *To be sympathized by you is still more. It makes me*
> *happy, very happy, that God has given me two costly*
> *jewels dearest & best of all rewards. I mean one my*
> *dear husband and the other my dear Aunt.*

With their growing confidence in Theodocia, an upcoming
journey no longer felt like a leap into the wild unknown. Soon,
Anandi started readying herself to live in America and to doing
so without Gopal by her side:

> *I must first prepare myself worthy to visit your land. I*
> *have taken up Sanscrit to show to your people what*
> *precious treasure our Vedas and Shastras contain. ...*
> *You know how heavy will be the separation of the wife*
> *& husband fond of each other for more than six*
> *years... This will show you how hard I have made my*
> *heart.*

When information about Anandi's plans reached the
Dandekars, they were not pleased at all. They could have been
objecting to any of a number of caste transgressions—crossing
the seas, a woman pursuing an education, or traveling and living
unaccompanied by her husband. Unaware of their reaction to
the news, Anandi paid the Dandekars a visit in observance of
Sankrant, the Hindu goodwill celebration. She was shocked
when she received a cold shoulder. Even though Anandi was
not a stranger to censure, she had not expected it from the
Dandekars.

Anandi's gifts and goodwill were rejected. Sadly, this experience was an early taste of the opposition that awaited both Anandi and Gopal in the not-too-distant future.

Theodocia's next letter, written on New Year's Eve of 1882, reached Anandi just a couple of weeks after the Dandekars' rebuff. Her warm supportive tone tempered the sting of that rejection:

> Come, if you can, free to select when you get here —
> untrammeled by anyone's claim upon you. . . . The
> new school in Philadelphia is far more progressive
> than the old. . . . I hope, wherever you study, you
> will not give up your common sense, of which you
> seem unusually endowed.

Theodocia was aware of the preferences and prejudices of her fellow Americans and, in her own gentle way, tried to prepare Anandi for what she might encounter in America:

> You will find respectable and influential people ready
> to tell you that white is black and expect you to believe
> it firmly as they do. . . indeed will be quite shocked by
> your want of faith. It will do for them so long as it sat-
> isfies them to so believe, but I beg you not to put out
> your own light in blind obedience to any man or body
> of men who may essay to teach.

This was Theodocia's way of promising her niece that she would stand with her, in the event that Anandi encountered opposition in America. Indeed, she would be there for Anandi every step of the way:

> I hope you have a prosperous voyage and enjoy all the change
> it brings you. I shall expect a letter of when and how you will
> come.

Her next words affirmed the family-like bond that the two women now shared:

> *I am very thankful to the American friends in Cal-*
> *cutta, who have taken an interest in you, and extended*
> *this interest to friends in Philadelphia. I would gladly*
> *help you to return their favors if ever it lies in my power*
> *to do so.*

She closed the letter with words of hope for the coming year:

> *Tomorrow is the beginning of a new year. May it be*
> *one full of useful effort and rapid advancement for*
> *all who strive, and may we belong to this number.*

Theodocia's heartfelt and eloquent words were the clearest expression of her love for her niece and of her unwavering commitment to her success. It is no surprise that Anandi grew in her resolve and confidence; the extent of this growth would become apparent over the coming weeks.

Calcutta holds a unique place in the history of American diplomacy. It is the home of one of the earliest American consulates—President George Washington nominated the first American Consul, Benjamin Joy, to Calcutta in 1792. This decision was the result of the new American government's recognition of the centrality of trade to its affairs and the centrality of Calcutta in the global marketplace.

The consul residing in Calcutta during the Joshees' time there, eight decades after Ambassador Joy, was Colonel Hans Mattson, a Swedish-born American from Minnesota. Mattson had immigrated to the United States with a friend when he was just twenty years old. Previous to that, he received schooling

and military training in Sweden. Although he had spoken four European languages, English was not one of them.

But despite that early disadvantage, Mattson had distinguished himself over the course of his life in America. He had started a settlement in Minnesota and established a bank and a newspaper. He had raised an army and fought for the Union side during the Civil War. It is no surprise that, in 1880, President Garfield tapped Mattson to head the American consulate in British India.

Mattson was initially ambivalent about accepting the post because it meant that he would be separated from his family for a year. He ultimately decided to go, in part because he had heard a fascinating talk, years before, given by a Swedish missionary who had just returned from India. As he wrote in his autobiography:

> I can never forget how eloquently he described the Hindoos, and the Brahmin idolatry, all of which aroused in me an eager longing to visit the wonderful country and learn to know its peculiar people.

Once in Calcutta, Mattson made every effort to get to know India and its inhabitants. He hobnobbed with the elite, developing a friendship with the Viceroy, Lord Ripon. His relationship with his servant Abdul provided him a peek into the lives of ordinary Indians. He attended various events and celebrations in the city and sampled the many cultural offerings, including "nautches," which were shows featuring dancing Indian women.

Mattson's mingling with a broad swath of Calcuttan society helped him develop a keen understanding of the strengths and weaknesses of British rule. Even though "the schools and railroads [were] doing away with ignorance, and [were] fast de-

stroying the caste system," he remained skeptical -about the British government's intentions regarding the welfare of Indians.

> I said that India is better ruled now than ever before; but that is not saying much, for it ought to be ruled still better and more in the interest of the natives. India has civil service with a vengeance, the office-holding class being even more arrogant, proud and independent than the titled nobility. They rule the country with an iron hand, regard it simply as a field for gathering in enormous salaries, and after twenty-five years' service they return to England with a grand India pension. The English look down upon the lower classes with haughty contempt, chiefly because the latter try to insinuate themselves into favor with the former by means of all kinds of flattery. Nobody is of any account in India unless he is an officer, either civil or military. . . . England wants India for a market, therefore nothing is done to encourage manufactures, but rather to cripple them. With the cheapest and most skilled labor in the world, the natives of India are compelled to buy even the cotton garments they wear from England though they raise the cotton themselves, and England is very careful not to establish a protective tariff in India.

One of the more satisfying and often fascinating payoffs of reading history is seeing how something that begins as a minor ripple takes on the force of a mighty wave. Such is the case with Mattson's observations relating to the export of Indian cotton and the subsequent import of British-made cloth back to India. Although the former brought more trade to India and contributed to the growth of Bombay, the latter became a tangible and universally understood symbol of Britain's control and oppression of India. Decades later, during the struggle for independence from Britain, Mahatma Gandhi would focus on the forced

importation of cloth from British mills. He would launch the Swadeshi movement ("Buy Indian") in order to give ordinary Indians a powerful tool with which to resist British hegemony.

Mattson's assessment of the factors that made it possible for the British to continue to rule India was similarly clear-eyed:

> Our British friends are certainly entitled to credit for the audacious pluck which they showed when a handful of their soldiers and citizens conquered that great country with its innumerable inhabitants. The only thing, however, that made it possible to do so, and which makes it possible to hold India today, is the internal strifes, the jealousies and the religious intolerance among the natives themselves. If they were united they could free the country from the foreigners in a month.

He was aware of the presence of "a few very able and highly educated men among the Indians" and "a deep hidden feeling of ill-will toward the English." Just like Rev. Wilder before him, Mattson pondered the likelihood that the British would not be able to rule India forever:

> The time will yet come when a terrible struggle will be fought in India. Perhaps Russia will have a hand in the fight. It will be a bloody, savage war, and will cause Great Britain serious trouble.

Fortunately, Russia had no role in the "great struggle," and independence was achieved by mostly nonviolent means.

When composing his autobiography decades later, Mattson wrote about two topics that intersect with Anandi's story. The first is that he attended a séance during which he reportedly saw many items move freely through the air:

> I know not wherein the invisible power consisted which
> caused these phenomena, but that such a power does
> exist I know for certain, for in this case, at least, there
> was no chance for deception.

Although he had become skeptical and felt somewhat embarrassed to write about this experience, Mattson offered a possible explanation of the appeal of India in general and Hinduism in particular to followers of Spiritualism:

> It is a common belief among the Hindoos that certain
> pundits, or learned men, who for years have lived in the
> mountains as hermits, abstaining from food and all sen-
> sual pleasures, thereby attain such a power of mind over
> matter as to be able to separate the former from the
> body and let it, untrammeled by the laws of matter,
> move from place to place, still retaining the same form
> and ability to speak and act.

In a sense, Hindu practices of asceticism and renunciation offered the tantalizing possibility of an explanation of spirit to the followers of Spiritualism in their quest for a persuasive and plausible explanation of logic-defying occult phenomena.

The other topic on which Mattson wrote at length was the status of women in Hindu society. He thought it deplorable that they were denied education. He was horrified by the practice of *sati* (the burning of the widow on her dead husband's funeral pyre) and by the denial of simple human dignity to widows who were fortunate enough not to be required to immolate themselves.

Anandi's descriptions of these topics in her letters to Theodocia were remarkably similar to those of Mattson. The two accounts by two individuals of starkly different backgrounds serve to confirm the dire condition of Indian women across the entire

subcontinent. At the same time, their descriptions highlight the level of insight and scholarship that these two observers had both attained: one, a sophisticated male and outsider to Indian society, and the other, a still-powerless insider who was only just finding a voice with which to articulate her beliefs.

Given Mattson's views about British rule and the status of Indian women, it is not surprising that he became sympathetic to the Joshees' quest. Even so, that such a meeting—between a "native" postal service employee and the American consul—took place is a testament to Gopal's persistence and to Mattson's wisdom and openness. In Mattson's own words:

> One day in February, 1883, I received a visit at my home by a Brahmin of the highest class, accompanied by his young wife and her little sister. Her name was Anandabai (sic) Joshee. Her husband was postmaster in the old Danish city [of] Serampoor. He was a highly educated man, about forty years of age, with fine, affable manners. His wife was nineteen years old, and they had been married nine years. With the exception of the queen of Kutch Behar and a few in the Zenana mission, she was the first educated Hindoo woman that I had met. Her husband had given her an excellent education. . . . Their errand was to consult me and, if possible, obtain my assistance in a matter of the greatest importance to the women of India.

Mattson quoted Anandi at length:

> *"Since I have acquired education, and the same amount of knowledge as a man, why may not other women in India do the same? In America many women are renowned for their great learning, and many of them are doctors of medicine. The women of India are not allowed to be visited by any man except*

> *their husband, and as all our physicians are men, who*
> *cannot see and carefully examine their female patients,*
> *they cannot, of course, prescribe proper treatment for*
> *them; hence many women in India must suffer and*
> *die without a remedy, which often could be avoided*
> *if women studied medicine. If American women can*
> *become physicians, then I can, and I have decided to*
> *go to America and enter the female medical college in*
> *Philadelphia and study for the degree of doctor of*
> *medicine, and then return to India and do good*
> *among my countrywomen, and disprove the false doc-*
> *trine which keeps Hindoo women in ignorance and*
> *degradation."*

Because of her ability to articulate her views—all the more startling considering she was conversing with a non-Indian male of the *ruling race*, and one whom she was meeting for the first time—Anandi made a most favorable impression on Mattson. He provided letters of reference to "all American authorities with which she might come in contact, also to the mayor of Philadelphia, and to the state department at Washington."

According to a Marathi saying, "There is often darkness right underneath the lit chalice lamp." This proved to be the case when it came to Calcuttan society of the 1880s. In so many respects, it was a modern city with a thriving literary and artistic culture. Brave thinkers—Indian and Western alike—were advancing a reform version of Hinduism in the form of the Brahmo Samaj and the Theosophical Society. Newspapers, both English and Bengali, were flourishing.

And yet, as word of the Joshees' plans spread, an angry reaction began to develop. Some felt outraged by the sinfulness

of crossing the seas and of educating a woman. Others were repulsed by the idea of a woman being not just out of the house on her own but out of the country without her husband. Some threatened to banish the Joshees from the religion, whereas others were concerned that the Joshees' might convert to Christianity.

Throngs of people flocked to the post office just to get a glimpse of the two individuals who were planning to do the unthinkable. The crowds were turning rowdy, and it became clear to Gopal that these concerns needed to be addressed—publicly, honestly, and directly. An event for this purpose was soon arranged at Serampore College, a Baptist college founded by Danish missionaries in 1818.

The initial plan was that Gopal would deliver the speech. As the day of the event drew near, Gopal and Anandi discussed what he should say and how he should say it. Then there came a point when Anandi suggested that she should give the speech. Gopal readily agreed.

Gopal had come to realize that Anandi was no longer the protégée and he was no longer the mentor. In a Pygmalion-like transformation, she had evolved to exceed his wildest expectations. The self-promoter and iconoclast in him delighted in this opportunity to showcase an Indian woman's eloquence and courage. The practical and tender side of him, the side that worried about sending his young wife alone to an unknown country, knew that this experience would help develop her confidence.

The event was attended by a mixed audience of Indians and non-Indians; men and women, young and old, people who were sympathetic and those who were skeptical and opposed, and the remainder who were just curious. Among the attendees was

an unnamed Indian reporter supported by an anonymous bene-
factor. Thanks to that benefactor, the speech was published in
its entirety in *Native Opinion*, a Bombay newspaper. Another
notable attendee was Colonel Mattson, who would later mail
copies of the speech to Anandi (care of Theodocia) in America.

Anandi spoke to those gathered in English, a language she
was more accustomed to reading and writing than speaking.
And she spoke publicly—a first in a society in which women
were hardly ever seen in public, let alone encouraged to form
or express their opinions. Anandi began with these self-
deprecating remarks:

> *I stand here to fail as I am not likely to succeed I am
> however exceedingly thankful to you for the trouble
> you have taken to attend this meeting. You may have
> gathered here anxiously to hear of some interesting
> subject but I am afraid you will be disappointed to
> hear me talking of an uninteresting one. But what
> should I do? There is no remedy. Had it been in my
> power to give you a pleasing address I would have
> done so. The only attempt I have ever made to speak
> in public is this. I have studied but a little while and
> the language which I intend to speak in is not only
> foreign but thoroughly out of command and entirely
> unused. I am therefore liable to make thousands of
> blunders even in grammar. Many of those who are
> present here are mere schoolboys who will rejoice to
> find that I am not equal to themselves, the young will
> laugh and the old will pity my ignorance. I wish I had
> better knowledge of the language.*

Anandi was attempting a balancing act—to be a trailblazer,
while at the same time claiming that she was not particularly ex-
ceptional. If she felt diffident, she had no choice but to soldier on.

What is doubtless true is that Anandi was a genuine "Pandita"—learned as well as wise. Her speech was peppered with apt references from the Bible and from Western culture, as well as from Hindu mythology and the Sanskrit lexicon. As she would have to do for the rest of her life, Anandi spoke persuasively to two sets of audiences simultaneously, audiences possessed of entirely different worldviews and priorities. On one side were the Indians who were inclined to be oppositional and challenging. On the other were Europeans who were curious and sympathetic. All were, to some extent, skeptical.

Anandi outlined the purpose of the event and what she intended to talk about:

> *Our subject today is my future visit to America and public inquiries regarding it. I am asked hundreds of questions about my going to America. I take this opportunity to answer some of them 1. Why do I go to America? 2. Are there no means to study in India? 3. Why do I go alone? 4. Shall I not be excommunicated on my return? 5. What shall I do if misfortune befall me? 6. Why should I do what is not done by any of my sex?*

She answered each question precisely and concisely and, in a few instances, bluntly.

The one-sentence response to the first question was, "I go to America because I wish to study medicine." In describing the background for this desire, she drew attention to an oversight of the few (newly founded) educational institutions that promoted both scientific education and female education. According to her, the institutional blind spot was that Indian women's suffering was being exacerbated by the lack of access to medical care and yet no one had thought to make it possible for Indian women to be fully trained in medicine.

"I do not mean to say there are no means," she continued, responding to the question of whether she could obtain the education within India:

> *...but the difficulties are many and great. There is one College at Madras, and midwifery classes are opened in all the Presidencies; but the education imparted is defective and not sufficient, as the instructors who teach the classes are conservative, and to some extent jealous. I do not find fault with them. That is the characteristic of the male sex. We must put up with this inconvenience until we have a class of educated ladies to relieve these men.*

But the larger problem was the harassment to which she had already been subjected in Bombay as well as in Calcutta, a reality that she saw as inescapable in any part of India. She concluded her response to that question with these words:

> *I place these unpleasant things before you that those whom they concern most may rectify them and those who have never thought of the difficulties may see that I am not going to America through any whim or caprice.*

She explained why she was going alone in a short and simple manner: they lacked the funds for Gopal to accompany her and, more importantly, he had the responsibility of supporting his mother and his younger brothers.

Anandi continued, fearlessly challenging her detractors:

> *I will go as a Hindu, and come back here to live as a Hindu. I will not increase my wants, but be as plain and simple as my forefathers, and as I am now. If my countrymen wish to excommunicate me, why do they not do it now? They are at liberty to do so.*

"Some say that those who stay at home are happy, but where does their happiness lie?" The question she posed about coping with misfortune revealed both Anandi's adventurous spirit, and a desire for learning and personal growth that was exhibited by her determination to venture into the wider world:

> *Happiness is not a ready-made thing to be enjoyed because one desires it. The study of people and places is not to be neglected. Ignorance when voluntary is criminal. In going to foreign countries, we may enlarge our comprehension, perfect our knowledge, or recover lost arts. Everyone must do what he thinks right. Every man has owed much to others. His effort ought to be to repay what he has received. Let us follow the advice of Goldsmith who says: "Learn to pursue virtue of a man who is blind, who never takes a step without first examining the ground with his staff." I take my Almighty Father for my staff, who will examine the path before He leads me further. I can find no better staff than He.*

The final question was not so much a challenge as an attempt to understand the desire to walk on a path that no one of her ilk had walked before:

> *According to Manu, desertion of duty is an unpardonable sin. So I am surprised to hear that I should not do this, because it has not been done by others. Our ancestors whose names have become immortal had no such notions in their heads. I ask my Christian friends "Do you think you would have been saved from your sins, if Jesus Christ, according to your notions had not sacrificed his life for you all? Did he shrink at the extreme penalty that he bore while doing good?" No, I am sure you will never admit that he shrank. Neither did our ancient kings "Shibi" and "Bharadwaj." To*

> *desist from duty because we fear failure or suffering is*
> *not just. We must try. Never mind whether we are vic-*
> *tors or victims. Manu has divided people into three*
> *classes. The meanest are those who never attempt any-*
> *thing for fear of failure. Those who begin, and are dis-*
> *heartened by the first obstacles, come next; but those*
> *who begin, and persevere through failure and obstacle,*
> *are those who win. The greater the difficulty, the*
> *greater our courage. Never let us desist from what we*
> *once begin.*

After the speech, Anandi received a "good many" congratulatory notes. One was from the wife of Rev. Summers, the head of Serampore College who had presided over the event. Another was from Mrs. Anna Thoburn, a missionary and physician who was engaged in finding affordable passage and suitable companions for Anandi on a ship bound for America.

The most significant development was a letter written by H. E. M. James, then the Postmaster General of Bengal. This was akin to a government minister writing a congratulatory note to a mid-level employee:

> *I was very glad to hear that Mrs. Joshee has made her*
> *debut, and has succeeded. Pray give her my congratu-*
> *lations. I wish her every success. In recognition of her*
> *courage and public spirit, permit me to offer the en-*
> *closed check for one hundred Rupees, which may be*
> *useful to her.*

Mr. James went beyond writing a check to the Joshees; over the ensuing months, he urged others to do the same:

> A young Brahmin lady has recently gone to America to
> study medicine, and qualify herself as a medical atten-
> dant for native ladies. In doing this, she and her hus-
> band have made great pecuniary sacrifices, and her

income barely suffices for necessaries. Going alone among strangers, though treated kindly, she has had to encounter many obstacles which she has bravely faced. In recognition of her courage and public spirit, it is desired to raise a sum which will pay her tuition fees, and relieve her from pecuniary anxiety during her absence. Mr. James, No. 2 Camoe Street, Calcutta, will be happy to receive subscriptions.

The Viceroy, the highest official of the British government in India, responded to James' call, as did the lieutenant governor and several other high-ranking British government officials. The resulting "James Fund" would eventually grow to cover a substantial portion of Anandi's expenses during her stay in America.

Col. Mattson sent a report about the speech and a photo of Anandi to *Frank Leslie's Sunday Magazine* in America. He characterized her as a "leader of the women's emancipation movement in India" and alluded to her "heroism":

> When it is remembered that the Brahmin creed forbids a member of the Order crossing the ocean, eating food other than that prepared by a Brahmin or drinking water which has come in contact with non-Brahmin vessels and imposes many other restrictions the violation of which involves the ostracism of the offender with other severe penalties, the heroism of Mrs. Joshee in determining upon the step referred to becomes strikingly apparent and at the same time appeals strongly to the sympathy of all Christian women the world over.

Even though Anandi's speech led to many positive outcomes, numerous other hurdles remained. One was finding affordable passage on a ship and another was finding a helpful companion for the long journey. These searches would follow

the same zig-zag pattern of setbacks and breakthroughs to which the Joshees had by now become accustomed.

6

CROSSING OVER

If you don't go after what you want, you'll never have it. If you don't ask, the answer is always no. If you don't step forward, you are always in the same place.

Nora Roberts

*T*he Joshees sought help from their many American acquaintances, almost all of whom were missionaries and their wives. Even though they had supported the Joshees' quest, when it came to actually facilitating Anandi's travel to America, they seemed reluctant. Not surprisingly, the Joshees found this both confusing and frustrating.

Four years had passed since Gopal's friendship with Rev. Goheen in Kolapore and the resulting awareness of America as a destination for Anandi's education. Goheen's wife and Anandi had stayed in touch. As plans to travel to America began to crystallize, Anandi wrote to Mrs. "Mama" Goheen, her earliest champion. The response was disappointing;

> *I wish now however that I could sit down and talk with you instead of writing because we seem to misunderstand each other or at least not to perfectly understand each other on some points. . . . I did not mean to imply that we would not take you with us in case you chose to wait years before going to America. I think I said, did I not, that "we might not be able to make*

> *the best possible arrangements for you." I meant that*
> *after our absence of ten years we would be like strangers*
> *in our own country. . . . If either my husband's family*
> *or my own lived near the large cities where there are*
> *such schools it [might have worked], but they do not.*

Mrs. Goheen went on to suggest three alternatives: Anandi could wait three years and go to America with the Goheens, she could pursue a course of study in India under the supervision of a woman medical missionary, or Gopal could accompany her to America even though the expenses of two people would be considerably more prohibitive.

In closing, she tried to explain her limits:

> *Our missionary societies at home do not encourage us*
> *to send or bring home native Christians to be edu-*
> *cated. The expense is not the only objection in their*
> *minds. There are other weightier objections. So we*
> *could not look to them for help in this matter but must*
> *seek out other friends.*

Like Rev. Wilder, Mrs. Goheen probably worried that her fellow Americans might not treat Anandi with civility and respect. Another significant issue, likely in the back of Mama Goheen's mind, was how the truth about American society—its treatment of its formerly enslaved people—would reflect on their standing as missionaries in India.

The feedback from another missionary couple echoed the concerns expressed by Mama Goheen. These were Rev. James Thoburn and his wife, Dr. Anna Thoburn. Their advice was that she "join the class that was shortly to be opened in Calcutta under the supervision of Dr. Thoburn." Anandi was not persuaded and told Anna that "it was impossible for me to change my resolution." The Thoburns were genuinely trying to help.

However, having experienced transcontinental sailing, they were more aware of the unsavory and challenging aspects of such travel. Upon learning the name of a steamer that Gopal was considering, Rev. Thoburn cautioned him:

> *The B.I.S.N. Company's steamers are not good. There are rough people in 2nd class and Mrs. Joshee is very young. I do not think it advisable to send her by that steamer.*

Ultimately however, it was the Thoburns who found a suitable companion as well as affordable passage. Anandi would travel with Mrs. Johnson, a missionary wife, and would therefore be permitted to pay the far more affordable "missionary rate" to travel in first class.

Anandi met with Mrs. Johnson a few days before their scheduled departure on the *City of Calcutta*. She showed Mrs. Johnson one of Theodocia's letters and told her that Theodocia had graciously offered to provide her a home in New Jersey. Mrs. Johnson wanted to know more about the woman who had, sight unseen, formed this most unlikely friendship. She asked Anandi the name of the denomination to which the Carpenters belonged. When Anandi was unable to provide this information, Mrs. Johnson's suspicions were further aroused.

She could not imagine a fine, upstanding American *not* having a denominational affiliation; neither could she imagine a good Christian avoiding mention of it. Living far from America for an extended time, and that too as a Christian missionary, Mrs. Johnson was a complete stranger to the winds of change blowing in sections of American society—in particular, those that had given rise to Theodocia's Spiritualism-inspired progressive worldview.

Used to holding herself apart from the heathen natives, Mrs. Johnson was also incapable of imagining, let alone understanding, the deep bond that Anandi and Theodocia had forged. Based on mutual trust and respect, theirs was a relationship in which religious difference was not a dividing force but a unifying one. In Mrs. Johnson's eyes, an American woman could not possibly be an *aunt* to an Indian woman.

She became convinced that Anandi was about to put herself at the mercy of a person who had not been—indeed, could not be—adequately vetted. She tried her best to dissuade Anandi from her chosen course of action. Knowing the Hindus' fear and resistance to conversion, she asked, "What will you do if this Mrs. Carpenter imprisons you and forces you to convert?" She also described the violence and thievery that were present in a segment of American society. She went so far as to offer a referral, suggesting that Anandi consider going to the home of a Mrs. Parker in Boston, rather than to the Carpenters.

But Anandi's trust in her Aunt was unshakable. She remained steadfast, and asserted that she was afraid of nothing and that the Almighty would protect her. The relationship between Anandi and Mrs. Johnson thus got off to a rocky start. In what was probably her first independent decision, Anandi did not share this exchange with Gopal. At this point, she did not want to risk a flare-up of her husband's temper, possibly leading to yet another delay.

Anandi sewed *bandis* (vests)—the only cold-weather garment that she could rustle up in oppressively hot and humid Calcutta. She packed grains and spices in quantities sufficient to tide her over until she could figure out a vegetarian meal plan in America. Her correspondence with Theodocia had given

Anandi a sense of the curiosity with which Americans were likely to greet her, so she packed silver and brass objects used in devotional rituals. Last but not least, she carried with her letters of reference provided by Col. Mattson.

Finally, the day of departure arrived. Gopal's satisfaction about how far he and Anandi had come was drowned by tender worry. He wanted to request that Mrs. Johnson look after Anandi "as a mother would." However, before he could utter those words, Rev. Johnson asked him if he had provided adequate funds for Anandi to use during the journey. Gopal responded that although he had arranged what he could, he hoped that his wife would be able to travel as economically as possible. Rev. Johnson's response was extremely upsetting to Gopal—"if she expected to travel with Mrs. Johnson, she should be prepared to spend money on the same scale as her."

A part of him wished he could cancel the trip, but that momentary thought was quickly replaced by caution. Not only would Anandi be terribly disappointed, but the funds already spent on both the ticket and other preparations would be wasted. Who knew how long it would take to arrange another voyage, what else might be required of them, and how much more it might cost?

Gopal decided that it would be unwise to share the details of his exchange with Mr. Johnson with Anandi. He did not want to undermine her confidence or prejudice her against Mrs. Johnson. So, he devised another approach—he urged Anandi to be as self-sufficient as possible during the journey. Considering it his duty as her protector, he reassured her that he would join her in America at the earliest possible opportunity.

As for Anandi, she surely felt sorrow at the separation from

her husband. Yet her heart was also full of anticipation at the prospect of finally meeting her Aunt Theodocia.

With all hurdles removed, Anandi set sail from Calcutta on April 7, 1883.

Although steam-powered ships had been in use since the early decades of the nineteenth century, even by the 1880s, they were far from practical. For longer voyages, most of the cargo-carrying capacity of the steamship was consumed by fuel storage. As a result, steam-powered vessels were used primarily for shorter journeys and for "packet boats"—small, regularly scheduled boats designed for the specific purpose of speedily transferring mail and bullion between countries, and between Britain and its distant colonies.

Thus, the *City of Calcutta,* a wind-powered sailing vessel transported Anandi and her fellow passengers from Calcutta to London. The *City of Berlin,* a steamer, took them from Liverpool to New York. At each port of call, they eagerly received letters from family and friends that had been delivered by packet boats.

Anandi had lived in more locales than most Indians—especially women—typically did. She had interacted with a wide range of people—varieties of Indians, Americans, and the English. The first days on board the *Calcutta* exposed her to an entirely new range of sights and sounds. No longer tied to the routines of housework or studies, she used her time to record all that she saw and experienced. Over the course of her correspondence with Theodocia, she had already developed the skills of observation, analysis, and reporting. Anandi now employed those skills in her letters to Gopal.

She described the ship's passage by the coast of Ceylon thus:

We saw from a distance of about one-and-a-half mile the rocks and mountains and hills of Ceylon. Now it was the close of the day. The sky was perfectly clear; the sea was quite serene; the sun had spread his beautiful garments over the lovely sea; the beautiful golden rays of the sun peeped into the dense cocoanut trees, which enhanced the beauty of Ceylon. Though I have not seen it myself, I venture to say that Ceylon must be a handsome place.

She wrote about her first sighting of Africans at the ship's first stop in Aden. At the next stop, Suez, she drew a word picture of the Egyptians who came on board "to sell fruits, shells, bracelets, corals, large beads, photos, silk and golden clothes, pots, etc."

The stops in ports were the only pleasant interludes on her journey. The unceasing heaving movement of the ship caused her severe bouts of seasickness. Soon, other challenges emerged.

It is quite difficult to fully imagine the hardships of being a vegetarian in a meat-oriented society. This was especially true on-board a ship without access to fresh fruits and vegetables. Anandi's only choices were "old vegetables, stalks, and half-rotten potatoes." The ship's staff lacked the will and the imagination to devise adaptations and alternatives. The "coarse cooked rice was too hard to be eaten."

In addition, Anandi's companions simply could not—or would not—comprehend the source of her dietary preferences:

Sometimes my companions pressed me to partake of meat, and when I refused to have it, they used to make fun of me in whispers. For about a fortnight I had

been a source of amusement to all.

Being in close proximity to the other diners—both the smells of the food they ate and the mere sight of the "long long bones"—added revulsion to Anandi's discomfort. As she plain-tively wrote in a letter to Gopal, "It required a stronger stomach than mine to retain an appetite for such kinds of food." Anandi settled on eating "two or three potatoes"—presumably per meal. Not surprisingly, she was soon "well nigh on the point of starvation."

Anandi's companion, Mrs. Johnson, tried to distance herself from Anandi in ways that bordered on cruelty. On one occasion, she insisted that Anandi leave the sofa on which she was seated and go out on the deck. Alone and unsupported, Anandi "got up without saying a word." Noticing this interaction, a stew-ardess cautioned her, "You are not used to this climate, I am sure it will kill you. Do you like to go to the hospital in London, where, I am quite sure, you will not like to stop a minute?" Too exhausted by her experiences, Anandi "made no reply."

On the following day, Anandi took a stand against Mrs. Johnson. As she wrote to Gopal, "Being Sunday, Mrs. — asked me to go to the service. I said I would rather sit with the *ayahs* than with those who think less of me than even the *ayahs* . I am not ashamed to sit with *ayahs* , because I am sure they will not think less of me than themselves." The ayahs were the "native" Indian maids and nannies employed by Europeans in India. Thus, it was that a woman, whose Brahmin privilege would have required her to distance herself from people of lower castes in India, chose to be in the company of those same individuals.

Anandi reclaimed her dignity, even if only in her own eyes, by refusing to cooperate with Mrs. Johnson in her own humiliation.

Anandi's final challenge on the voyage was her health. She suffered from swollen gums during the latter part of the journey:

> *It hurt me to eat, to speak, to laugh or to do anything else. Day by day the pain became severer. It made my head ache. My stomach was still worse. For three days I could not stand, nor sit, nor sleep. This state of things lasted for nearly three weeks, when I thought I had better consult a doctor.*

The ship's doctor diagnosed her pain as caused by the emergence of her wisdom teeth. When summarizing her experiences in a letter to Gopal, Anandi expressed deep sadness that, during the month-long journey, her companions had no inkling of either her pain or her near starvation. "I leave it to you to imagine what must have been my condition on this occasion."

Given that civil company was lacking on the ship, and considering the countless hours to be passed, a person was likely to feel bored at best, or maudlin and homesick, at worst. Indeed, according to Anandi's own admission, "I have had my repose disturbed a hundred times by the feeling of painful separation from home." Fortunately, she found a fine alternative to help her pass the time, one which also made it easier to remove herself from the company of her disagreeable fellow passengers:

> *I had chosen an excellent companion that helped me*

> *to pass time quietly and pleasantly. I mean a book, I*
> *never felt lonely while reading. I read seven books on*
> *board the City of Calcutta.*

After crossing the Suez Canal, the ship took another two weeks to cross the Mediterranean Sea and sail around the Bay of Biscay and through the English Channel to London.

Back in Calcutta, Gopal shared Anandi's letters with the journal published by the Theosophical Society. Describing Anandi as "the willing martyr to her noble thirst for Reform and Science," the editor wrote:

> We see no mortal reason why the S. S. Co. should have
> any more the monopoly or right of starving its pas-
> sengers, than that of drowning them, whether they be
> Hindu or European. ... We sincerely hope that Mrs.
> Joshi [sp] will find truer and better friends in democratic
> America than she has found on the aristocratic British
> steamer, whose Company takes apparently people's
> money but to starve them whenever it can do so with
> probable impunity.

The editorial was just as blunt on the topic of Anandi's mistreatment by her fellow passengers:

> The unmerited insult of seeing herself made fun of and
> especially the humiliation she received at the hands of
> one, calling herself a lady and probably a Christian, is
> too disgusting and revolting.

In keeping with the Theosophical Society's respectful view of Hindu history and culture, the editorial went on to assert:

> Were it worth the trouble, a comparative genealogical

tree might be profitably drawn, showing the respective lineage and the list of ancestors of the Brahminee Indian lady and of both the arrogant European females who used to "make fun" of her "in whispers," and the one who sent her off on deck. It is to be feared that while the forefathers of Ananda Bai (sic) would be found stretching back into the night of that prehistoric age when the Aryans first crossed the Himalayas in their migration from the North, the ancestors of many of the former would be soon traced to some paltry shop in one of the back lanes of Oxford street. It is revolting to read of such snobbery in women.

It is unlikely that such muscular editorializing by a niche publication had much impact on the shipping companies themselves or on centers of British power. However, it surely had an effect on its Indian readers. Through its bold reports and editorials, the magazine was creating an alternate narrative that challenged Western hegemony, and was doing so while asserting that Indians deserved civil treatment and Indian civilization deserved respect.

When he returned home after seeing Anandi off on the *City of Calcutta*, Gopal found himself feeling rudderless and without purpose. The home in which she had been a sweet and energetic presence now felt like a body without a soul.

In his first letter to Anandi, Gopal poured out his heart, describing his tears and anguish. He worried that he had abandoned her much the same way that Ram, the protagonist of the Hindu epic Ramayan, had abandoned his wife Sita. He worried about Anandi's well-being, especially the inadequacy of food and unsuitability of her attire on board the ship. He prayed for her health while reassuring her to not worry about his.

This was a reversal of their usual roles. Anandi, who had hardly ever ventured out on her own, was now doing just that. Soon, she would meet new people and experience new ways of being and doing. Gopal, on the other hand, would be on the outside looking in. Only too aware of this, he repeatedly reminded her to write to him about all her experiences, both good and bad.

It soon became Gopal's turn to face social criticism. One person suggested that Anandi had left him because of marital discord. Another called him a fool for letting her get away, especially considering how useful she was for tending the home. Others characterized him as heartless for sending his wife alone into an unknowable world.

Although he received kudos from his few progressive friends, Gopal no longer had someone with whom to share these experiences. Over all the years of their shared struggle, Anandi and Gopal had been partners. Secure in the bubble of their commitment to both their cause and to each other, they had commiserated and withstood strife together. "I feel like a widower," he wrote to her.

The incident with the Johnsons just prior to Anandi's departure continued to torment Gopal. He referred to it indirectly in a heartfelt letter that he wrote to Benjamin Carpenter the day after Anandi set sail:

> *My wife sailed yesterday morning by the City of Cal-*
> *cutta in the company of many ladies who were*
> *strangers to her. . . . She was not introduced to the*
> *ladies with whom she was to travel until she reached*
> *the ship and even then her reception was cold indeed.*
> *Although at the eleventh hour I advised my wife to ex-*
> *pect nothing from them but to trust to Him who has*

made us both. My dear sir I took good care of her until
her departure and now I hand over this precious charge
to you and your worthy wife.

After sailing over eight thousand nautical miles in thirty-two days, the *City of Calcutta* docked at London's Victoria Dock on May 9, 1883. Victoria was London's largest dock, and had been constructed specifically to accommodate large ships.

The passengers were directed to the London Lodging House for their weeklong hiatus. After weeks spent in a shared cabin with a prickly companion, Anandi was relieved to have a room of her own.

Yet, it was here that Anandi experienced her first minor crisis of confidence. She avoided going out, afraid that people would laugh at her attire. Although used to being around non-Indians, Anandi was now a lone outsider experiencing an alien culture. Being surrounded by an ocean of people completely unfamiliar with her context was far different from being among Western missionaries in India.

Unfortunately, Anandi's worries were not entirely unfounded. On one occasion, when walking to the train station along with several fellow shipboard passengers, a group of Irish bystanders noticed her. Curious about the strangely dressed, small-figured woman, they initially just stared at and followed her. But soon, their numbers swelled to several hundred and the mob became rowdy. It was a relief to Anandi, as well as to her companions, when they finally boarded their train.

In the aftermath of this event, it is easy to imagine the panic Anandi must have felt when wondering whether a similar reception awaited her in America. Her companions, more familiar

with Americans' attitudes toward nonwhite people, probably shuddered at the thought of what lay in store for her.

Still, Anandi did not dwell on her challenges. In her letter from London, she described her wonder about the English people's love for sunshine. Their joyful proclamation, "Sometimes we even get to see the sun!" was an entirely new perspective for Anandi, considering that she had just left the hot city of Calcutta and was quickly finding that the same May warmth was not quite warm enough.

The *City of Berlin* was built in 1875 after steam technology had become commonplace. Just a few years earlier, it had won the Blue Riband—an unofficial shipping accolade—for crossing the Atlantic at record speed. The ship typically completed the voyage from Liverpool to New York, a distance of about three thousand nautical miles, in just eleven days.

Anandi's Atlantic crossing on the *City of Berlin* was quite uneventful, especially compared to the previous leg of her journey. She had recovered from her health woes and knew what to expect regarding meals and companions. Amazingly, her erstwhile tormentors had undergone a change of heart. She wrote to Gopal:

> *I had to suffer all sorts of inconveniences for the first four weeks or so. After that, they all became so fond of me that they were quite unwilling to part company with me. They seemed very much interested in me. So a few days before our arrival in New York, Mrs. —— said to me, "Mrs. Joshee, your husband has given you in my charge, and Mrs. Carpenter cannot claim you*

*from me; but you are married, and if you are not will-
ing, I cannot keep you." In New York when they bid
me goodbye, they kissed me over and over again.*

When publishing her letter in *The Theosophist* magazine,
the editor remained skeptical about her companions' change of
heart:

> The kisses 'over and over again' in the presence of re-
> porters and other witnesses could obliterate but little,
> and atone still less for the sufferings caused in the early
> part of the voyage.

Thanks to the telegraph, the expected arrival times of ships
could be known with a fair degree of accuracy. Updates about
the voyage of the *City of Berlin* were published in the Marine
Intelligence section of the *New York Times*. Thanks to those,
Theodocia was present just as the *Berlin* docked in New York
Harbor.

This was an era when arriving passengers were processed at
Castle Garden. The Statue of Liberty was yet to be built and
Ellis Island had not yet been turned into an immigrant
checkpoint. At this time, a visa was not required to enter the
country. Instead, there were stringent health checks to make
sure that those who might have contagious diseases were quar-
antined or refused admission. To ensure orderly processing of
the large numbers of passengers pouring in, ships typically
docked some miles from shore. Groups of passengers and their
belongings were transported to land on tugboats and barges
only after they had passed the initial health check.

First and second class passengers underwent only a cursory

inspection. Because they could afford more expensive tickets, it was assumed that they were less likely to be sick. Having traveled first class, Anandi was eligible for this consideration.

Theodocia went on board the *Berlin* to meet Anandi. Even though Anandi would be easy to spot, she carried the photograph that Anandi had sent when they first started to correspond. Her excitement about finally meeting Anandi may well have been laced with a frisson of apprehension. In what ways would Anandi's arrival affect her everyday life? Might there be unexpected difficulties? She probably reminded herself that she knew Anandi as well as it was possible to know another woman without having previously met her. Theodocia may have drawn strength from the knowledge that she and Anandi had a noble and selfless purpose, and that together they would overcome anything.

Finally arriving to the land about which she had dreamed, minutes from meeting the woman who had made it all possible, Anandi experienced intensely powerful emotions. As she wrote to Gopal:

> *Mrs. Carpenter having come on board the steamer to receive me. . . I saw all the letters waiting for me, and burst into tears. My heart was heavy, and my eyes swollen. I passed a few minutes in this state when I at once started. I blushed at the display of my own weakness at a time and place like this. I blamed myself and said "Is my courage so small that I should sit weeping? No never." I got up, and took the letters, and stepped down [to] where Mrs. Carpenter was sitting.*

The June 5, 1883 edition of the *New York Times* announced the arrival of the *City of Berlin*. Needless to say, "Anandibai Joshee" was listed as one of the passengers arriving by first-class.

Anandi was finally in America! She had successfully crossed the thresholds—of distance, of social and religious barriers, of health and financial challenges—and was ready to embark on the next chapter of her life.

The crossing of a threshold carries a special significance in Hindu Marathi culture. After the wedding when the bride goes to her groom's home (which is also the home of her new in-law family), she crosses the threshold and steps into *her* new home. In theory, this is where she stops being of her birth family and becomes of her "real" family.

In biology, "crossing over" refers to the process in which two chromosomes pair up and exchange segments of their genetic material. This results in new combinations of genes that are different from those of either parent, which is what creates genetic diversity.

Anandi's journey from India to America was a *crossing over* in the sense that her future experiences would be the co-mingling of two distinct philosophical and cultural systems. The journey made by one individual and aided by another was the first small step in the creation of a new cultural awareness, both in America and in India.

The term "crossing over," also used to refer to life after death, is a meaning in line with Theodocia's Spiritualist beliefs—in the sense that she believed that the soul lives on. Anandi's crossing over from India to America was the end of her organic Indian self and the birth of a new worldly self. She would no longer be merely Gopal's protégé, but was already becoming her own person and a representative of an ancient

and a little-known culture. Anandi would always have Indian roots, but she was also to soon sprout American wings.

In this moment, Anandi's *crossing over* was akin to the high-wire trapeze acts featured in circuses, with their drama and risk, adventure and precarious balance. At one end of the tightrope was Gopal—Anandi's mentor and champion, pushing her into the open space of her journey—and at the other end was Theodocia, Anandi's nurturer and generous aunt, pulling her to safety and committed to helping her achieve her purpose.

SUMMER OF JOY

*All in all, it was a never to be forgotten summer — one of those
summers which come seldom into any life, but leave a rich her-
itage of beautiful memories in their going — one of those
summers which, in a fortunate combination of delightful
weather, delightful friends and delightful doing, come as near to
perfection as anything can come in this world.*

L.M. Montgomery

On a beautiful sun-filled day, June 4, 1883, the *City of Berlin*
docked in New York Harbor. Minutes after Anandi was
united with Theodocia and Benjamin, Mrs. Johnson
approached them. She had developed a fondness for Anandi,
having watched the lone figure on the ship, sitting quietly
reading a book, trying to make do with the meager food she
was provided; somehow this had stirred maternal feelings in
Mrs. Johnson's heart. As she would later write in a letter:

> *On the voyage I became exceedingly interested in her,
> and she was very frank in her statements of her hopes,
> aspirations, and opinions and circumstances. I admire
> greatly her courage and self-poise. . . . Very few girls of
> 18, blessed with the early advantages of American
> training, would show the quiet determination that she
> does, to carry out the purpose of her being useful to her
> own sex. . . . She has conducted herself with great mod-
> esty and propriety.*

She now considered it her responsibility to ensure that

Anandi would be in safe hands and that nothing untoward would happen to her. Unaware of the complex undercurrents, Theodocia graciously invited Mrs. Johnson to her home in Roselle, and Mrs. Johnson was only too happy to accept. It was decided that the visit would take place in a fortnight.

Anandi and the Carpenters reached Roselle early that afternoon. Thanks to Theodocia's standing in her community, Anandi was received as a respected guest. It was no surprise that "visitors began to pour in" right after the trio reached the Carpenters' home.

The visitors greeted Anandi with flowers; they embraced and kissed her. The reaction was so exuberant that one person suggested that "the sun was so bright that day that we never saw anything like it." Finally, sensing Anandi's exhaustion, Theodocia decided that additional visitors would need to wait until the next day to meet her. Anandi wrote to Gopal:

> At last Mrs. Carpenter was obliged to shut the windows, so that no one could see in; and so I escaped visitors! It was a happy day.

The Carpenters had two daughters, Helena, about seven, and Eighmie, about nine. Because Anandi and Theodocia had been corresponding for over three years, the girls had grown up knowing of Anandi and of their mother's connection to her. During the following months, they would find a playmate in the eighteen-year-old Anandi, but for now they were on their best behavior, hushed and formal.

Those who are fortunate enough to make a quantum leap beyond their challenging circumstances typically feel great ap-

preciation for their new environs. Their encounter with each new object and positive experience spurs feelings of wonder, appreciation, and gratitude, and it was with such zest that Anandi summarized her first day in America:

> *Since I left you, I have had nothing but kindness. Everybody is kind to me. We have hot weather, green grass, loving trees, pleasant breeze and flowers, cool wind, kind friends, and comfortable rooms.*

And yet, those same people also look back and remember those they left behind as well as their recent acquaintance with the lack of opportunity, formidable difficulties, and unceasing worry about potential setbacks. So the closing words in Anandi's first letter to Gopal recalled the resolve needed to soldier on:

> *Do not be discouraged. Remember the good old maxim. Let patience have her perfect work.*

Mrs. Johnson and her sister visited the Carpenter home in the second half of June. After the visit, she promptly sent a letter to Anna Thoburn in Calcutta:

> *The lady, with whom she is stopping, is very agreeable and cultivated. They have a pleasant home, a home thickly shaded with trees, not grand or elegant, but very comfortable. They have two very dear little girls, about seven and nine, so that Mrs. Joshee's opportunities for improving in English are very good.*

Mrs. Johnson closed her letter with words of praise for Anandi:

> *If she were not well-balanced, her head might be turned by the numerous newspaper notices. We are a news-loving people, and the novelty of the arrival of a Brahmin lady to study medicine has attracted a good*

deal of attention, but she receives it all very quietly.

Anandi, too, had changed her mind about Mrs. Johnson and was "very happy" to see her. The woman who had been a difficult traveling companion was now the single person in America with whom she shared a direct connection to her homeland.

Once Anandi was settled in her new home-away-from-home, she began an energetic exploration of American life. She joined her aunt in daily activities and even attended church with her; by this time, her confidence in Theodocia's disinterest in converting her to Christianity was so complete that she did not feel any of the old fear of zealous missionary ladies' "blindness to the feelings of others."

A popular pastime of the era was the creation of a "mental photograph"—answering a list of about forty questions of increasing depth. It tells us that Anandi's favorite color was white, that her favorite flower was the rose, her favorite fruit was the mango, and her favorite fragrance was jasmine; that she would choose the Bhagavad Gita to read for an hour and that her favorite trait of character was sincerity.

A striking feature of Anandi's responses was the agility with which her mind weaved through Eastern and Western cultural signposts. She was able to name Indian poets and thinkers (Muktabai and Janabai, Manu and Kalidasa, and Chiploonkar Shastri) as easily as Western ones (Pope, Goldsmith, Macaulay, and Addison). She considered both Indian and Western names beautiful (Rama, Tara, and Annie).

The "mental photograph" also revealed Anandi's deep com-

mitment to social good. Her response to the question, "What is your aim?" was short and simple: "To Be Useful." In three simple words, in a language not her own, and on the spur of the moment, Anandi concisely expressed her highest aspiration. This, together with her "favorite occupation"—to do "whatever is necessary to the common comfort"—reflected an unequivocal articulation of her life's purpose.

When she named "slavery and dependence" as her "bête noire," she was referring to the lives of Indian women. While still residing in Bhuj, she had written to Theodocia:

> *I am led to believe that man and woman should be self-protecting & that one should not depend upon the other for maintenance and other necessaries of life. Then & only then all family discord and social humility will cease.*

Anandi may also have been referring to the fact that her country was ruled by a foreign power. She and Gopal, even as Brahmins, were all too aware of their lower status relative to the British in their own country.

By naming *The History of The World* as the book that she "would part with last," she underscored the value of the books Theodocia had sent her. The books were like a promissory note from Theodocia, and Anandi's presence at that time in the Carpenter home—just months away from enrolling in medical school—meant that the note had been redeemed.

Anandi's presence expanded Theodocia's world as well. Though she had not initially thought Anandi "very beautiful," she soon came to see her as "radiant." At her suggestion, she and

Anandi together hosted a traditional Indian feast for neighbors and friends.

On the appointed day, Anandi greeted the arriving guests with a sprinkle of rosewater from a silver *gulabdani,* and a dab of *attar* perfume on their wrists. In the hot and humid Indian climate, this was (and still often is) a ceremonial way to welcome guests. On a summer afternoon in America, the gestures were a unique sensory experience with the promise of more to come.

The women guests draped themselves in saris and wore items from Anandi's jewelry collection. Some even painted a red dot on their foreheads.

When the eighteen guests entered the Carpenters' dining room, they found it completely transformed. The dining table, chairs, and other furniture had been put away. The resulting large empty room had place settings arranged along the edge of the floor. In this manner, the guests were seated on the floor in a rectangular formation.

Substituting for the large leaves of the banana tree that were used as disposable plates in India, Anandi sewed together leaves of the buttonwood tree. On these "plates," she arranged the various food items in their customary positions—a pinch of salt at the top, salads and condiments on the left half, and vegetable curries on the right half; small mounds of rice and hand-rolled and pan-roasted whole wheat bread (*poli* or *chapati*) were placed in the center of the leaf.

In recognition of the festive nature of this meal, Anandi drew an intricate *rangoli* around each place setting.

> *The powders had been brought from India. The red was first applied in a broad band and then the white was sifted over it from a brass cylinder perforated with*

small holes in a pretty pattern. The effect was like that
produced on ladies' dresses by a band of white lace ap-
plied over crimson silk.

When all the guests were seated, Anandi offered a prayer in
Sanskrit and explained its meaning. Her guests found this part
of the meal similar to their custom of saying grace. Following
Anandi's lead, they ate with their fingers:

> *Anandabai would pick up a morsel bring it a few*
> *inches from her plate and then with a dexterous twist*
> *of her fingers toss it into her mouth. It seemed to fly*
> *magically to the right spot. "To miss," she said, "would*
> *be vulgar."*

After dinner, the company moved to the parlor, which had
also been transformed to evoke an Indian sitting room. A large
mat was spread on the floor and huge cushions were arranged
for people to recline against, the better to stretch out after the
meal. Having heard that "Oriental dinners were wont to con-
clude with song," the guests urged Anandi to sing for them, and
she obliged by singing several songs in her native Marathi.

The planning, cooking, and decorating had taken up several
days. Anandi had improvised because of the lack of availability
of all necessary ingredients, and, during the event, had been
kept busy answering the guests' many questions. Theodocia had
done her part, offering her friends interpretation and context.
Both women felt a sense of accomplishment in this perfectly
executed first-of-its-kind cultural exchange.

Another first-of-its kind event had occurred just six months
before Anandi's arrival. An electrical generator had been set up
in the center of Roselle. It had "sent power through overhead

electric wires to a store, the railroad station, about forty houses and one-hundred-fifty street lights." Roselle had thus earned the distinction of being the first village in the world to be lighted by Thomas Edison's incandescent light bulbs.

It now added to that the distinction of welcoming and providing a home base to the first Indian woman who would become a doctor.

Both events would prove to be harbingers of fundamental changes in society—one material and economic, and the other social and cultural—over the coming decades. The residents of Roselle could hardly have imagined the scale of the changes that had been set in motion by the two "firsts" they had been privileged to witness.

Theodocia and Anandi visited Tiffany's, the iconic store that, since 1847, had been selling luxury goods ranging from sterling silver, jewelry, and crystal to fragrances, watches, and stationery. In 1883, the store was located at Union Square West in New York City. It was so fancy that the New York Times had described it as a "palace of jewels." Even though Anandi had neither the financial wherewithal nor the interest in making a purchase there, she was shown the most opulent merchandise, and particularly items originally acquired in the East. Both Theodocia and the salesman were astounded when she correctly identified the origin of a piece of artwork that was shown to her. Considering her a distinguished connoisseur, Anandi was "urged to prolong and repeat her visit."

The family also went on a picnic to Highland Park. Anandi felt intensely aware of the unique confluence of season, place,

and people that made that spectacular day possible. Knowing that a day would come when she would want to relive this moment, she asked if a group photograph might be taken. Theodocia immediately sent for a photographer, and the resulting photo became one more bead in the growing rosary of connection between the two women.

It is no surprise that Anandi thought of the summer of 1883 as the happiest period of her life. For the first time, she was free of the many forces that constrained her—husband, family, and community. The intense regimen of study was behind her, and she was free to indulge in leisure pursuits and simple play with Theodocia's daughters. Most important, she was "with those who really loved her and who asked no greater privilege than to aid her in her plans."

However, the human heart is a fickle thing, often craving just that which it cannot have. So it was that even when ensconced in the bosom of her nurturing American family, Anandi sometimes felt melancholy. Theodocia noticed that when letters from India were delayed, Anandi would be "silent till the next mail day." When the letters did arrive, Anandi's face "would light up like a child's and for days after she would go humming her sweet tunes about the house."

Although Gopal was her primary correspondent, she received letters from other family members and from Indian and European friends and acquaintances in India. In addition, Gopal sent her magazines and newspapers, allowing her a greater connection to events back home.

Not all letters from India were pleasant. Gopal wrote about her mother's anguish at the thought that the Brahmins would not accept her upon her return from America. A letter from her

brother shed light on the curiosity and concerns of ordinary Indians about her stay in America. Some of the questions were naïve or mundane—How often does the sun rise?—and indicated how little even literate Indians knew about geography. Other questions were far more serious.

> *Did Gopal-rao force you to go or did you go willingly? Is he sending money from India? What is your living situation? . . . Did you have to convert after reaching there? Try your best not to mingle with people of other castes. Remember the saying: it is okay to convert the hand, but never convert the bone.*

Even though he asked for her forgiveness for asking these questions, Anandi's brother closed his letter with relatively stern words that he wrote in English for added emphasis:

> *Mrs. Anandi-bai Joshee, you have done no right because India is your native place.*

Although Anandi was too committed to her chosen path to be perturbed by such criticism, she could not help feeling misunderstood and saddened by such correspondence.

The academic calendar in American colleges had not been a factor when choosing the date when Anandi set sail for America. More practical matters, such as affordable fare and suitable companions, determined that. As a result, Anandi arrived in America four months before the start of the next academic term. This was fortunate for her, as she needed time to spend with Theodocia, learn American manners and customs, and develop adaptations for everyday life.

When it came to attire, her Marathi saris would be inade-

quate cover in cold northern American winters. Although nine yards long, saris were fashioned of thin fabric, designed to deal with the hot, humid Indian climate. More importantly, the sari was worn like a "shawl passing between the legs." Although this "produced the effect of Turkish trousers," in practice, it often left the calves covered with just a single layer of fine gathered cloth.

Anandi was aware that her choice of attire would be judged by Indians as well as Europeans in India. She knew that Americans too would scrutinize her mode of dress. As she had written in one of her letters to Theodocia,

> *If I put on a different dress, I will, I am afraid, expose myself to ridicule and contempt and laughter of those whose dress I have imitated. There are many natives who have adopted European dress for themselves and their wives but are looked down upon by the gentry and the Europeans in general. A native in English dress looks like a butler. Besides I am reliably informed that even in America, people give respects [sp] to pure blood and not to mixed classes such as Eurasian and half caste. If I were to appear in America with English dress on, I am informed I shall not be admitted in high circles. Is it true, Aunt, that your people have such prejudices?*

Mindful of the need to find a balance, she wore a sari, but in a modified style. By draping the sari around her body, but not passing it between her legs, Anandi managed to retain her Indian look. She shielded herself against the unaccustomed cold temperatures by wearing several layers of flannel skirts and blouses underneath the sari. Finally, Anandi switched to "warm woolen or cotton stockings with buttoned boots." Her entire outfit was topped with a shawl that could double as a head-cov-

ering, when needed.

Even though Anandi had adopted these changes out of sheer need, she eventually came to see the sari as inconvenient clothing for a working woman. And the teenager who had once loved wearing jewelry became a critical thinker who questioned even its underlying meaning:

> The longer Anandabai lived in America the less she liked to wear her ornaments or rather those ornaments which like the ear rings and the nose ring recalled a savage condition of society.

Anandi and Theodocia considered two medical colleges that served only women students: the Philadelphia-based *Woman's Medical College of Pennsylvania* and the *New York Infirmary for Women and Children*. Another option was the college of medicine in Boston which was a co-educational institution that specialized in homeopathy. All of these colleges were keen on admitting Anandi as a student. The primary reason they welcomed Anandi lay in the history of women's higher education, and particularly medical training, in America.

Educating females through the high school level, in publicly funded schools, was already quite widespread in late-nineteenth-century America. However, women's higher education, particularly the kind that led to a professional practice and commensurate prestige—law, medicine, and the church—was not at all commonplace.

In 1874 (less than a decade before Anandi's arrival in America), Charles Eliot, the president of Harvard University, called coeducation,

a thoroughly wrong idea which is rapidly disappear-
ing...... the stress could prove so severe that the women
might fall ill and destroy their chances of good mar-
riages; ... a woman's future was so different from a man's
that there was no point in educating them together.

Eliot also deplored the effect that women would have on
their fellow male students. The men,

...might fall in love, which could produce disastrous,
socially unequal marriages; women would have trouble
keeping up with the academic pace and hold up instruc-
tion for the men.

Both reasons were grounded in prevalent ideas about the
primacy of men's interests and women's more limited "appro-
priate sphere of influence and action," i.e., the domestic sphere.
Thus, any pursuit that compromised women's commitment to
their "natural environment"—such as education—could be jus-
tified only if it could extend their roles as caregivers and nur-
turers. As such, it was somewhat easier to make a case for
empowering women to provide medical care to women and
children.

However, there was an entire set of different objections
when it came to training women to become doctors: women's
presence at the anatomy table and the resulting embarrassment
that it might cause *the men*. When Elizabeth Blackwell was at-
tending Geneva College in 1847, her professor asked that she
remove herself from "any anatomy lab that might prove embar-
rassing for mixed company." Indeed, just three decades before
Anandi walked the gauntlet of jeers in Bombay, Dr. Blackwell
faced very similar reactions while attending medical school in
Geneva, New York.

> *I had not the slightest idea of the commotion created
> by my appearance as a medical student in the little
> town. Very slowly I perceived that a doctor's wife at the
> table avoided any communication with me, and that
> as I walked backwards and forwards to college the
> ladies stopped to stare at me, as at a curious animal. I
> afterwards found that I had so shocked Geneva pro-
> priety that the theory was fully established either that
> I was a bad woman, whose designs would gradually
> become evident, or that, being insane, an outbreak of
> insanity would soon be apparent.*

It was experiences such as these that led to the establishment
of the Woman's Medical College of Pennsylvania in 1850. A
few years later, Dr. Blackwell founded the New York Infirmary
for Women and Children. These colleges provided a haven
wherein their female students could pursue medical studies
without having their presence challenged or their aptitude and
fortitude to study anatomy questioned. In these colleges, stu-
dents were trained and mentored by women as well as men who
supported their pursuit of a credentialed medical education.

Not surprisingly, this separate arrangement came at a price.
Even two decades after the Woman's Medical College was
founded, and even though it had its own small hospital, "its
meager resources ... could not match the majestic surgical fa-
cilities or distinguished surgical faculties of the renowned major
hospitals of Philadelphia."

However, by 1869 the tide turned somewhat. After years of
efforts, the college gained permission for its students to attend
Saturday clinics on surgery at the larger Pennsylvania Hospital
(also in Philadelphia). More importantly, the coarse and insult-
ing reaction of the college's male students, in which they "as-
sailed the young ladies, as they passed out, with insolent and

offensive language, and then followed them into the street, where the whole gang, with the fluency of long practice, joined in insulting them," was met with criticism from the managers of the Hospital as well as by major newspapers in the Northeast. Indeed, just a year after this incident, August Gardner, a New York physician, published a *mea culpa* in *Leslie's Illustrated News*:

> A woman who feels an irresistible impulse to study med-
> icine so strong as to overcome her natural timidity, or
> to be willing to take the obloquy and covert, if not open,
> insults from the world in general, and very often her
> own family and friends in particular—she will make a
> better doctor than a stupid lout.

Dr. Gardner could never have imagined that his words would one day provide an apt description of an Indian woman on the other side of the earth—a woman whose desire for a medical education had been burnished in the harsh crucible of orthodox religion and superstition on the one hand, and the loss of her baby on the other. When he wrote that the "great limitations of women come from society, and are not from essential inferiorities of the sex," he challenged every reader who believed that their gender made women unfit for an existence equal to men. His words also indirectly exhorted women who held such aspirations to assert, and where necessary, prove, their intellectual equality with men.

Only too aware of their hard-won battles, the leaders of the women's medical colleges welcomed every opportunity to shine a light on their successes. As Marie Mergler would write in 1896, "For with them it meant much more than the success or failure for the individual. It meant the failure or success of a grand cause."

The aim of women's medical colleges was not just to provide medical training to women, but also to solidify a woman's right to be trained as a doctor and to practice medicine. Because women doctors were the primary providers of medical care to both women and the indigent, women's medical colleges were also fighting on behalf of such patients.

And so, the colleges in Philadelphia, New York, and Boston were eager to admit Anandi. Her high profile would attract favorable attention, and her command of the English language meant that she would be a wonderful spokesperson. Finally, both her biography—a citizen of British India, married at the age of ten, homeschooled by her husband—and her purpose—to provide medical care to women who had none—made her an exemplar of the mission of these colleges.

Anna Thoburn, with whom Anandi had become acquainted in Calcutta, was a recent graduate of the college in Philadelphia. She sent a letter to the dean, Rachel Bodley, alerting her to Anandi's impending arrival and recommending her to the college.

> *She will be a great curiosity. No doubt the first Hindoo woman who has ever set foot on American soil. I trust my native land will deal kindly with her. . . . She is a bright little woman—speaks English fairly well-and writes it better than I do. . . . She will no doubt appear dull at first as she will find it difficult to understand but I think she will get on well after a time.*

Interestingly, she mentioned Theodocia in the letter, albeit mischaracterizing her as a missionary and misunderstanding the nature of her relationship with Anandi.

Some Presbyterian Missionary lady has encouraged Mrs. Joshee and I think will help to provide means to meet her expenses. I judge from the letters she writes her that she knows the little woman well, and she seems to be a woman capable of judging wisely. (I mean the missionary lady.)

Theodocia also sent a letter to the dean:

I have in my care Mrs. Anandibai Joshee, a Hindoo lady of high caste. She has come to America to study medicine that she might serve her fellow country-women in the capacity of surgeon and physician. Hearing from many sources that the Female College of Pennsylvania is the best and the most thorough in its main points, and believing from some things that I have heard and seen in print that steps have already been taken to secure for my ward the advantages of your college, I write to ask you to please inform me what arrangements, if any, have been made; also, if Mrs. Joshee would need to attend lectures now before the close of this term?

She also offered to "begin her studies at home with me and continue them through the summer, taking up such as you deem necessary for the beginning of a thorough course." A secondary purpose of this question was a desire to avoid "incurring the expense of a trip to Phil. before Fall," for "her means are very limited and the ways to obtain the end is not yet clear."

Theodocia then set up a friendly competition between Philadelphia and New York.

We are in correspondence with the Deans of several colleges and shall form plans for Mrs. Joshee with care and deliberation. Believing that you or other eminent Philadelphians had already taken an interest in her

> *before her arrival, I feel willing and glad to respect that*
> *interest by asking your advice at the outset and what*
> *preparations if any have been made for her and what*
> *her advantages will be in going to Philadelphia rather*
> *than to New York?*

Finally, she reiterated her personal commitment to this endeavor:

> *It would suit our convenience better to have her in the*
> *latter city, but we have her best good at heart and seek*
> *only that.*

Now it was Dean Bodley's turn to make as compelling a case as possible on Anandi's behalf. She wrote to the bursar, Arthur Jones, enclosing Theodocia's and Anna Thoburn's letters, and mentioning the calls and letters that she had been receiving from reporters.

> *A half-dozen reporters of the city press, representing as*
> *many city papers have been calling upon me and writ-*
> *ing to me in regard to her during the last month, so re-*
> *markable do they regard her coming to be.*

She also mentioned a clipping from a missionary newsletter. Rev. and Mrs. Gracey had spent several years in India as missionaries of the Methodist church. This clipping provided an unbiased and glowing testimonial from a person who knew India but not Anandi.

> The sacrifices this woman makes we here can scarcely
> appreciate. ... That she breaks away from all her associ-
> ations, social and religious, to seek advantages in a land
> among strangers, and with a people so unlike her own

in all their habits and customs, shows remarkable force
of character.

The last sentence in the account evoked universal sisterhood
among women regardless of where they may live, as an aspect
of Christian charity and kindness:

> While in Calcutta before sailing, she was the recipient
> of much kind attention, and we bespeak for her here, in
> this Christian land, the sympathy and affection of all
> women who have at heart the uplifting of women in all
> countries.

In her note to Bursar Jones, Dean Bodley summarized her
appeal for financial aid:

> *Would it be possible for your committee to perform the
> graceful act of awarding her a scholarship? This wd
> [sp] at once distance all the competing institutions and
> make her sojourn with us certain. Her talents and
> learning would immediately qualify her for a scholar-
> ship.*

So great was the interest of the reporters and of the general
public that Bodley felt certain that "money for her medical edu-
cation could be speedily raised" by the public. However, her
preference was that the college provide for Anandi's education
and, by so welcoming her, preclude her reliance on public
largesse.

A final appeal was received by Bursar Jones from Anandi
herself. She started her letter by stating the amount of money
that she could afford to pay—seventy dollars in hand, plus
about twenty that Gopal would be able to send each month.
Next, she wrote about her educational background:

> *I have been once through English Grammar, have*

> *studied through Arithmetic in my own language, and*
> *as far as Division in English, and I am now pushing*
> *forward in this as fast as I can. I have read the histories*
> *of England, Rome, Greece, and India. I have learned*
> *to read and speak in seven languages—Marathi (my*
> *own), Sanscrit, Bengali, Gujarathi, Canari, Hindoos-*
> *tani, and English.*

Given her "exceptional and peculiar" circumstances, she requested that the college be "obliging and merciful" even if she did not meet all of the entrance requirements. Just as present-day students write in their college application essays, she described the hurdles already overcome and her selfless higher purpose.

> My health is good, and this with that determination
> which has brung me to your Country against the com-
> bined opposition of my friends & caste ought to go a
> long way towards helping me to carry out the purpose
> for which I came, i.e., to render to my poor suffering
> countrywomen the true medical aid they so sadly stand
> in need of, and which they would rather die for than ac-
> cept at the hand of a male physician. The voice of hu-
> manity is with me and must not fail. ... My soul is
> moved to help the many who cannot help themselves,
> and I feel sure that the God who has me in his care will
> influence the many that can and should share in this
> good work, to lend me such aid and assistance as I may
> need. I ask nothing for myself, individually, but all that
> is necessary to fit me for my work I humbly crave at the
> door of your College, or any other that shall give me ad-
> mittance.

The letters from Anandi and her supporters succeeded in their mission. Even though a student had to be between the ages of twenty and thirty to receive a scholarship, an exception was

made for the eighteen-year-old Anandi. The Woman's Medical College of Pennsylvania awarded Anandi a scholarship of six hundred dollars to cover the three-year program.

The biggest hurdle—paying for her education—was thus overcome. Anandi was finally ready to start the education for which she had been preparing almost her entire life.

COLLEGE LIFE

Empowered women empower women.
Unknown

On September 28, 1883, Theodocia and Anandi boarded a train to Philadelphia. Theodocia planned to stay a couple of days—long enough to introduce Anandi to the dean of the college and to help her get settled in her new home.

Anandi packed for a temporary sojourn away from "home." She took most of the grains and spices she had brought from India as well as the cold-weather clothes that she and Theodocia's cousin had sewn over the summer. A treasured possession Anandi brought with her was an alarm clock that Theodocia's husband, Benjamin, had given her. She left behind items that she might not need right away or hardly at all, such as some of her dressier saris and her warm-weather clothes.

As the train glided out of Roselle station, Anandi lost herself in thought. She knew she would be just eighty miles from Roselle, a small hop compared to the distance she had already traveled from Calcutta. However, in some ways, this was the more difficult journey. When she had moved within India, she had always been with her husband. Then, when she left India, she knew she was going to be with an "aunt" and champion. Now, she was on her way to a place where she knew no one.

In addition, Anandi knew she would be embarking on a course of study the likes of which she had never undertaken before. Her only experience of attending school was during the year she lived in Bombay. That class offered instruction for achieving only basic literacy. Now, she would be studying scientific subjects—and that in an environment not tailored to an unschooled student like her. The other students would be studying in their native language, but she would be studying in a language that was, at best, her second language. Would she be able to comprehend her lessons? Would she be able to keep up with her assignments? So much was riding on her academic performance. Failure would be a public disgrace, both in America and India.

Although Anandi had always managed the household while attending to her studies, now she would have to do that while shouldering a newly rigorous study schedule. Last but not least, she was also worried about the availability of fruits and vegetables, especially during the winter months.

Theodocia pondered a mostly different set of worries. Having become familiar with the patterns of Anandi's moods—her anxiety when letters from India were delayed, her simple joy when playing with Eighmie and Helena, and her reliance on Theodocia herself for emotional support—she wondered how Anandi would fare alone, removed from all the sources of support and pleasure that had provided her a stable foundation. It was comparable to wrenching a caterpillar from its cocoon. Yes, a butterfly usually emerged; but Theodocia was concerned about the challenges in the in-between period.

The cold weather was only a few weeks away. Would Anandi be able to make a fire and keep it lit? Would her adapted Indian clothes provide adequate warmth and protection? In Roselle, Anandi had received a kind and generous reception. Aware that this was largely due to their family's standing in their small community, Theodocia worried that Anandi's path might cross with people more like the Irish mob that had chased her in England. Even though Philadelphia had a reputation as an open and progressive Quaker city, Theodocia did not want even a single negative experience to cloud Anandi's American experience. The silver lining in this cloud of worry was that the college had only female students and the professors were known to be committed to women's medical education. At the very least, Anandi would be spared the resistance of skeptical professors and the mockery of male students.

Dr. Rachel Bodley, professor of chemistry and Dean of the Medical College, lived with her mother in a house just across the street from the college. The Bodley home was the first stopping point, and, when needed, the first home in Philadelphia for many students who made their way to the college from places as far away as Maine and North Dakota and now, from India. Theodocia and Anandi went directly to the Bodley home and spent the first night there. Bodley would later describe her first sight of Anandi with feeling:

> From childhood I had been familiar with the statements concerning the condition of the native women of India. My sympathies had always been with them, and my annual offering to the treasury of missionary societies

which worked among them, had never been omitted; but in September, 1883, there came to my door a little lady in a blue cotton saree accompanied by her faithful friend, Mrs. B. F. Carpenter, of Roselle, New Jersey, and since that hour, when, speechless for very wonder, I bestowed a kiss of welcome upon the stranger's cheek in lieu of words, I have loved the women of India.

Arrangements had been made for Anandi to live as a renter in the home of a woman named Mrs. Hallman. As the house was close to the college, it would spare Anandi long walks on windy days and on snow-covered or icy streets. Theodocia helped Anandi unpack and arrange all her possessions. Because Anandi had never used a fireplace, Theodocia taught her how to tend a fire so that it stayed lit all day long. Anandi was still blissfully unaware of how brutal the winter would be, but Theodocia knew only too well. Upon noticing that the fireplace did not get sufficient fresh air to allow it to keep burning, Theodocia became alarmed. She immediately fetched Mrs. Hallman and convinced her to have it fixed.

Bodley had assigned a third-year student, Miss Florence Sibley to familiarize Anandi with the neighborhood and with college procedures. Upon witnessing Miss Sibley's kind and helpful nature, Theodocia's anxiety about leaving Anandi on her own diminished somewhat.

Until Anandi's arrival there, a steady source of international students at the medical college had been limited to the daughters of American and English missionaries serving overseas, or native women in those locations who were converts to Christianity. This meant that the *foreign* students were, in reality, not too foreign. They had familiar Western names, ate the same food, and wore the same attire as their American peers.

Most importantly, since they were Christians, they managed to assimilate into the local community quickly. They presented neither a particular challenge nor a dilemma to their American hosts and peers.

Because Anandi intended to maintain her religion, vegetarian diet, and traditional attire, Bodley knew that Anandi would be the first truly "foreign" student to enroll at the College. Mindful of both the skepticism and the curiosity that many Philadelphians were likely to feel and the isolation and loneliness that Anandi was likely to experience, Dean Bodley hosted a reception in Anandi's honor the day after she and Theodocia arrived in Philadelphia.

On a late September evening, Dean Bodley stood alongside Anandi in the parlor of her home. As members of Philadelphia's professional class—the College's alumni and professors, prominent businessmen and their society wives, and church leaders—streamed in, Dean Bodley introduced Anandi to each of them.

The guests were aware of the broad outline of Anandi's story—that she belonged to the Brahmin caste (the "highest"), that she was only eighteen years old, and that she had journeyed alone from India with her husband's full support and despite "great opposition from both the priesthood and my friends." Over the course of the evening, they came to understand that the young woman had come to America because her country did not believe in educating females and that she needed to become a women's doctor because custom did not allow the few doctors, all of whom were male, to treat women.

Anandi stood out among all the guests because of her petite

form and honey-colored complexion. Her crimson *pitambar* sari, gold jewelry, and the red dot on her forehead made her look exotic and distinguished. She was calm and collected, and a gentle smile rested easily on her lips. Although this was only her fourth month in America, the presence of her Aunt Theodocia allowed her to feel secure and confident.

One of the guests, Caroline Dall, had come all the way from Washington, DC. She was a feminist, a founder of the American Social Science Association, and the author of an impactful book, *The College, The Market, and the Court: or Woman's Relation to Education, Labor, and Law.* Her father, Mark Healey, had been a successful India merchant, banker, and, later, investor in railroads; she had been born into privilege. However, as the wife of a Unitarian minister who had moved to Calcutta over two decades previously, she had had to develop her own means—writing books and giving lectures—to support herself and her two children. Dean Bodley had invited Dall because of her feminist beliefs and her interest in matters pertaining to India. She hoped that in Dall Anandi would find a knowledgeable and engaged ally.

There were undoubtedly some skeptics among the guests, and their first impressions of Anandi reinforced their low expectations. Dall's diary entry about the reception is telling:

> *She looks like a stout dumpy mulatto girl not especially interesting.*

Even though she admired Anandi's candor, she observed that she had "…good reason to think that this is not a common Hindoo trait." Dall's thoughts offer a peek at the doubts that lurked behind some of the smiling faces at the gathering. A notice in the *Austin Weekly Statesman*, although published a few

weeks later, insinuated that Anandi's local practice of medicine would lead to numerous deaths and would provide fodder for the *Philadelphia Ledger's* "obituary poetry."

However, through her intelligence, grace, and articulation, Anandi soon changed the hearts and minds of most people who came to know her. As Dall continued,

> *There is hardly a flaw in pronunciation or construction. If I had not known, I should have thought her born in this country. As time went on, I grew familiar with what had at first disappointed me, and saw the fascinations [sic] of movement and manner that others felt so deeply. . . . In one respect from first to last, she was herself alone, in the sweetest truthfulness, the most entire candor that ever belonged to a mortal.*

Anandi was unaware of the undercurrents swirling in the minds of the guests. It took all her concentration simply to keep up with the whirlwind of activity and conversation. She drew energy from the positive reactions she elicited. In her letter to Gopal, she summarized the event by stating simply, "...the people in these parts are very good-hearted indeed."

By the time the evening came to an end, Anandi and the residents of Philadelphia had entered a covenant of mutual respect and acceptance.

Back in India, Gopal continued to share Anandi's correspondence with *The Theosophist* magazine. An account of the reception in her honor was published in the December 1883 issue. The editor's note expressed both alarm and glee at the number of clergy members present at the reception:

We cannot help shuddering when we find the long string of Reverends among the citizens who greeted our little friend in the Quaker city. What a rush of candidates there will be to save a "heathen soul" from eternal perdition! What sweet persuasions and eloquent oratory are in store for the poor unwary victim!

The morning after the reception, Theodocia and Anandi arrived at the station just as the train for Roselle was about to leave. Theodocia hastily jumped aboard with the help of a couple of nearby passengers. The lack of a proper goodbye—reminders to take care, promises to write to each other, talk of when they might next meet—made the separation, despite being an anticipated one, feel much like an abandonment to Anandi. She made her way to her room in Mrs. Hallman's house, overwhelmed by loneliness that bordered on despair. In her letter to Gopal, she described her next few days as *shunya-kar*—a "zeroness" or complete emptiness. She burst into tearful sobs and lost interest in food and drink, in reading and writing, "in life itself."

On the train back to Roselle and during the first few days back home, Theodocia continued to worry about Anandi:

> *My heart is heavy tonight as I think of you in your loneliness. I know you feel it unless the Spiritual Comforter has come to you and filled you with inward joy such as I, nor any other earthly friend, could give. Our parting was so sudden as to be almost violent....*

She requested Anandi to convey her thanks to Miss Sibley and Mrs. Hallman. Out of respect for the Dean's busy schedule, she refrained from writing a note of thanks to her. Instead, she

asked Anandi, "… if you do see her, please give her my hearty love and good wishes."

The letter also contained reassurance and gentle advice—the former to uplift her niece's spirits that she knew were sagging, and the latter to help her be more independent:

> Perhaps we may be led to see the wisdom of my leaving you so early against your wishes and my own. Your early need of a friend may be responded to by one whom God shall raise up who shall serve you not only in my stead for another day or two, but for all winter and it may be longer [sic]. You are a child of Providence and He will not see you want for anything you really require. He will help you do much through your own powers to accomplish. You have chosen the mission of ministering to the sick and in that calling there is required great self-sacrifice and self-reliance with reference to others help than God. It may be that this is your first lesson in the cause before you, and that you began it when you set all alone from India and today you turn to the second chapter. I hope you will find it easier as you go on and will always feel an unseen staff supporting your steps.

Like a true well-wisher, Theodocia gently discouraged Anandi from leaning on Bodley for support:

> As the Dean is so fully absorbed… I suppose you will see nothing of her till after the "opening." Surely you will not like to intrude unless it was a matter of greatest importance.

Theodocia also included news about her cousin Charlie and an upcoming visit from her sister. By sharing such small, seemingly inconsequential updates, Theodocia gently wove Anandi

into the life of her family. She closed the letter with words of care and support:

> *All the dear ones of our household are in bed and asleep and I hope you are too. Tell me if your bed lies any more comfortable for the change we made. Tell me everything that concerns your comfort and discomfort. I hope you are feeling better and will be "all right" when I hear from you. I shall try to write to your husband tomorrow and will send him one of the papers I bought this morning. Good night, and I will send love enough for all.*

In the postscript, Theodocia expressed regret that she had forgotten to give money to Miss Sibley for Anandi's return trip to the college. "I hope you thought to do it. But it was my place and would have been my pleasure had I done it." With these words, Theodocia once again expressed eloquently how unreservedly she saw Anandi as her own and how completely she had found her own purpose in looking after her niece.

During the weeks leading up to her move to Philadelphia, Anandi's letters to Gopal had become shorter and less frequent. Gopal's initial reaction to these changes was to worry—about her physical health, her ability to cope with being on her own, and her ability to keep up with her studies. But soon his worry morphed into something darker.

The explanation that made the most sense to Gopal's distraught mind was that, in her short time in America, his wife had become proud and conceited. He became convinced that she was doing fine, without him by her side. Indeed, Gopal mistakenly concluded that Anandi had come to see him as super-

fluous and irrelevant in her new, exciting life. He wrote her a highly critical letter, which reached her just as she was becoming accustomed to college life.

Gopal began by charging that Anandi appeared immodest in the photograph taken at the picnic in Highland Park. He castigated her for writing short letters and threatened to write short letters in turn. He sarcastically insinuated that this was because he did not want to bore her by writing longer ones. He accused Anandi of becoming Westernized, and even speculated that she had started eating meat.

Anandi was devastated. Like all Indian girls of that era, she had been raised to think of a husband as akin to God. It was unthinkable for a Hindu woman to challenge her husband's authority. And so, Gopal's letter was much more than a mere reproach; Anandi felt that she was being wrongly accused by an unjust god who would allow no appeal.

Her initial response was conciliatory. In a letter written on October 15, 1883, she apologized for having caused Gopal worry and anxiety. The only clarification that she allowed herself was brief—that her photograph had been a simple one-shot deal, the intention to pose or provoke completely absent. Anandi described her very busy days. She confessed that the long hours of classes and homework, along with cooking meals, exhausted her and sometimes made her think about "dropping everything." She also mentioned the large volume of letters she received and the time it took to respond to each one, even if only briefly.

Wanting to also acknowledge the positive, Anandi thanked Gopal for the money he sent each month. Combined with the scholarship awarded her, it allowed her to live free of financial

worries. Closing the letter with a plea that Gopal take care of his health, Anandi urged him to write often and in detail, and to continue to pursue his efforts to join her in America.

During her stay in Roselle, Anandi had been visited by Bhaskar Vinayak Rajwade, an Indian man who had come to America to study glassmaking. His goal was to bring knowledge of advanced glass manufacturing to India. Even though Anandi and Rajwade hailed from the same Indian province and spoke the same language, Anandi found him distasteful. As she wrote in a letter to Gopal, she disapproved of his Western attire. In addition, Rajwade asked her many questions about her preparation for college; these made her feel as though she was being tested, if not challenged. The last straw, in her view, was his suggestion that she accompany him to a play.

Anandi's reaction exemplified the collision between old ways and new ones. Even though she believed in women's education and their empowerment, she was not yet prepared to cross other boundaries, such as interacting socially with a man who was not her husband. Rajwade's invitation was likely meant merely as a gesture of friendship, but it was not received as such.

Completely unaware of Anandi's dislike for him, Rajwade visited the Carpenters again, a few weeks after she moved to Philadelphia. Since he lived in Clayton, New Jersey, just twenty miles from Philadelphia, Theodocia surmised—disapprovingly—that "... he flattered himself he could call on you very often."

> I would not give him your private address. . . told him
> you were not situated so that it would be proper to re-
> ceive gentlemen at your home and that the Dean

would not allow you to have company to interfere with your studies. I could not avoid however giving him the address of Dean Bodley; so you will doubtless hear from him soon if not already.

So concerned was Theodocia about the peril he posed, that she advised Anandi at length about steps she should take to shield herself. Did Rajwade's conduct go against American ideas about the friendship between a married woman and a man who was not her husband? Or, was Theodocia acting on her understanding that such interactions were forbidden in Indian culture? Either way, she sought to protect Anandi's interests:

We must not offend him while, in the most gentle and positive manner we must compel him to keep his distance. Unless this is done, I feel certain that he is destined to give you a great deal of trouble. I beg of you not to allow him to call on you at your home nor encourage much correspondence. Leave out all personality that you can and treat only on abstract principles both in conversations and correspondence and you will command his respect without danger of attracting or offending. . . . Let him stand on the foundation he shall establish for himself in this country. You do not need his support nor that of any other Brahmin man in America. ... Let it be distinctly understood that you have chosen your path alone and will follow it alone unless your husband joins you.

She closed the letter with words of benediction:

Trust only in the Supreme Being who has led you in the past. If any annoy you or give you trouble, ask God to deal kindly with them and shield you from their darts. All will be well. I hope, dear niece, that you will feel to relieve any little pain of body or mind by con-

fiding in me or Prof. Bodley if she can better relieve
you. Do not carry any burdens. . . keep your heart
light and cheerful.

The course of instruction to receive a medical degree was
three years long. During the term that Anandi was about to
start, students were required to attend lectures in chemistry,
anatomy, physiology, *Materia Medica*, general therapeutics, and
obstetrics. They were also expected "to dissect one or two of the
usual divisions of the cadaver, to attend the daily clinics of the
Woman's Hospital." The students would have examinations at
the end of the term, and their admission to the chemical and
physiological laboratories depended on the degree of proficiency
shown.

Classes or clinics were held six days a week. The first class
commenced at 9:30 a.m. and the last at 5 p.m. A two-hour
break in the middle of the day gave the students time to walk
to their rooms and back, cook and eat lunch, socialize, and catch
up on homework assignments.

By October 5, Anandi had become engrossed in the college
routine, which lifted her spirits. In a letter written that day at 7
p.m., she listed all her activities over the course of the day:

> *I sit down to write a few lines to you (hungry & tired*
> *as I am) while my rice is on the stove. I just came home*
> *from College. I went to the College at 10 AM, bought*
> *my matriculation ticket, went to the lecture on chil-*
> *dren's diseases, went to the hospital and saw two surgi-*
> *cal cases. One of the new students fainted. . . . I went to*
> *the lecture on obstetrics. Next physiology, then anatomy.*
> *The first two lectures and the last one I understood per-*

*fectly though they were quite new to me. I could not
understand Phy.*

And, just two weeks later, she sounded confident about her
studies, though worried about dissections:

> *I do not find study very hard nor do I take much time
> to learn my lesson. . . very soon I will have to dissect if
> I am strong enough to bear the odour. I am afraid I
> will be sick.*

So busy was she that, in response to an Indian correspon-
dent's question about her study regimen, she wrote, "I cannot
say just how many hours I devote to study each day. Every free
moment not spent in sleep, classes, cooking, eating, or writing
letters is spent in study."

Anandi first noticed Charlotte Abbey, a student from Birm-
ingham, England, because of the striking combination of her
pale white skin and jet black hair. As the two became friends,
Charlotte shared her family background with Anandi.

Charlotte's great-grandmother was the daughter of a
wealthy Hindu family. Her great-grandfather, a man named
Alexander Hamilton, was in Calcutta in the employ of the
British East India Company. After his wife's premature death,
Alexander Hamilton returned alone to Britain, where he raised
their baby son. The son had two daughters, one of whom was
Charlotte's mother.

Charlotte took great pride in the fact that Arya (noble
Hindu) blood coursed in her veins, and she felt a bond with
Anandi from the moment they met. Indeed, so keen was
Charlotte to reclaim her lost Hindu connection that, upon

graduation, she planned to serve as a doctor in India.

Charlotte's family's founding story took place nearly a century earlier. It sheds light on the fluidity of relations between the British rulers and their Indian subjects during the early part of their encounter.

Alexander Hamilton (Charlotte's great-grandfather), along with Judge William Jones, one of the founders of the Asiatic Society in Calcutta, was one of the earliest scholars of the concept of Proto-Indo-European languages. In 1806, he received an appointment as the first Sanskrit professor in Europe (at Hertford College). Thus, Charlotte's story also draws attention to a remarkable, mostly forgotten, aspect of the British presence in India—that is, the keen interest that some officials took in unearthing and documenting ancient Hindu scriptures, languages, sciences, and philosophies.

Interestingly, this genealogy is connected to a significant piece of American history as well—Charlotte's great-grandfather, Alexander Hamilton was a first cousin and namesake of America's founding father.

Dean Bodley considered it her duty to keep a watchful eye on her students. She noticed Anandi's low spirits and identified them as resulting from loneliness. She also knew that Anandi was struggling with the meager vegetarian food available to her. During the reception for the incoming class, held two weeks after the start of the term, she asked a student to keep an eye on Anandi and make sure she had eaten some food. After the guests had left, Dean Bodley invited Anandi to spend the night in her home. During the night, she looked in on Anandi and

found her weeping.

The childless Bodley soothed Anandi with "motherly tenderness" and immediately invited Anandi to move into her home. However, this was not an easy offer for her to make. "As an earnest Christian she debated much with herself as to what her duty was towards Mrs. Joshee." Should she give shelter to a non-Christian? Could Anandi, despite her stated intention of remaining a Hindu, be convinced to accept Christ? Ultimately, compassion and generosity won out, strengthened by a long view of the prospects of conversion:

> If the observant, shrewd and criticizing nature saw aught
> of inconsistency between the precepts of Christ and the
> practice of His servants living there, it might deter her
> from accepting Christianity.

Thus, Dean Bodley decided that "she [Anandi] should have perfect freedom to go where she would and read what she chose." According to Dr. Kane, one of the professors at the College, "the love and patience she showed the little stranger were the surest fruit of Christianity." Anandi lived in the Bodley home for the next three years—the remainder of her time at the College—but for the periods during which she went *home* to Roselle.

By early November, Anandi was passionately engaged in her studies. Her studious nature drew her toward a comparative study of Hindu and Western medicine.

In a letter to Gopal, she requested that he send all available Indian medical reports, books, and discussions relating to the disease called *devi*, or small pox. She also requested small packets

of medicinal formulations prescribed by *vaidyas*—practitioners of traditional Hindu medicine. She asked that these packets be labeled in Marathi script as well as in English. She explained to her husband that, with these medications on hand, she planned to investigate the similarities and differences between the Ayurvedic and the allopathic treatment modalities, thereby developing a better understanding of the Hindu approach. Reading her letter (written in Marathi) creates the impression of a scientist who was also a nationalist. Anandi was seeking to apply a Western approach to centuries-old indigenous knowledge.

So focused was she on her studies that the newspapers and periodicals that Gopal continued to send began to seem like a distraction and a burden:

> *I don't feel good about asking you to stop sending me these materials. However, I do not like to neglect my studies. In fact, I have become so devoted to the lectures that nothing else interests or satisfies me.*

Soon it was Diwali—the festival of lights. It is the biggest celebration in the Hindu calendar and occurs in late October or early November. The holiday signifies the triumph of light over darkness, good over evil, and knowledge over ignorance. It is celebrated by lighting lamps, cooking special foods, and buying new clothes.

A unique aspect of the Diwali celebration—*Bhau Beej*—takes place on the fifth and final day. Its purpose is to honor the bond between brothers and sisters. Implicit in this celebration, is the brother's covenant to watch over his sister. This is the day on which brothers visit the homes of their married

sisters, bringing them special gifts. Sisters honor their brothers by performing an *owalni* worship and preparing a special meal for them.

Although Anandi's massive correspondence from India brought her many Diwali greetings, a particularly meaningful one was a series of three letters in quick succession, sent by Gangadhar-punt Ketkar. Even though he was a cousin of Gopal's deceased wife, a warm and nurturing quasi-sibling relationship had formed between Ketkar and Anandi. So, his letters honoring their bond on *Bhau Beej* put Anandi in the Diwali spirit, albeit a month after its actual observance. In her response, she wrote "Upon receiving your *owalni*, I leave it to you to imagine my boundless joy." Despite her busy schedule, Anandi made the time to send him a warm, detailed response.

In glowing terms, she wrote of Americans in general and of Dean Bodley in particular. She went so far as to say that she felt neither alone nor a stranger in a foreign land. The Marathi word *upkaar* suggests a spiritual debt incurred by the recipient of great generosity. She said the *upkaars* of the Americans were such that she would never be able to adequately repay them. "This is not because I am good, but because they are. Just like your *upkaars* towards me, and I hope you will continue to show me the same affection that you always have," she added.

Knowing that Ketkar would be interested as well as sympathetic, she wrote a stirring description of the contrasts between India and America:

> On one side there is prosperity and growth, on the other breakdown and disease. There is wealth in both places. But in India it encourages sloth, tolerates poverty, dismisses industry and promotes ignorance. What a sorry state of affairs. . . but with whom can I share this per-

spective? Those who have the means are greedy and the penniless folk like me have ideas that we can do nothing about. . . . I felt great joy and happiness from the day I set foot in this College. But, when I think of the [dire state of the] Indian people, I feel twenty times the despair. Even while I feel grateful for my good fortune and the many opportunities I have received, I am haunted by the millions in India whose lives are so desperate that they cannot even dream of such ideas and such progress.

As Christmas approached, Anandi managed to hit a stride in her studies. The adaptations for food and attire were finally working, and her feelings of loneliness had abated.

On December 6, 1883, Benjamin wrote Anandi a letter, addressing her as "My Dear Niece." Although it was primarily about acquiring a skeleton and mailing it to Philadelphia, it ended on a very warm and touching note:

> *As the Holiday season is coming, we are beginning to anticipate your coming. I hope soon to hear how long the vacation will last and we shall want to arrange.*

Anandi too was excited about returning to Roselle:

> *Perhaps you would not know, dear Aunt, how delightful it is to get ready to go home!*

Theodocia's heartfelt desire to have Anandi home for Christmas was apparent in the variety of pick-up options that she offered in order to allow Anandi both flexibility and convenience:

> *I received your letter and now am anticipating another or a postal telling me just when to meet you at Eliza-*

> *beth station. If you leave 9th and Green Street at 1:15*
> *pm, you will arrive at a time most suited to my con-*
> *venience. But if by arriving by another train you can*
> *have the advantage of company, some of us will be at*
> *the station at your arrival. Cousin Menina is going to*
> *E Saturday before noon. Should she find you at the*
> *depot on her return she will bring you home. If not, I*
> *will go down to meet you on time.*

Her final words made explicit her eagerness to be reunited with Anandi:

> *How I longed to be with you… Every hour brings us*
> *nearer. We shall be only too glad to welcome you back.*
> *Your aunt, T.E.C.*

And so it was that Anandi's first term at the Woman's Medical College of Pennsylvania came to a close. She had worked hard and was enjoying her studies. She had suffered from ill health, faced hunger and fatigue, and endured her husband's harsh words. She had made a few good friends and had benefited from Dean Bodley's thoughtful generosity. Soon, she would be among people who cherished her and offered her much-needed rest and renewal. She would soon be, truly, home for the holidays.

A Life of the Mind

I didn't come this far to only come this far.
Unknown

*A*nandi's return to Roselle for the Christmas holidays was her first American homecoming. She experienced snow for the first time, enjoying a snowball fight with the Carpenter girls. She rode in a sleigh, or, as she called it, the "wheel-less cart." Being enveloped in Theodocia's loving attention restored Anandi's spirit. Newly re-energized, she returned to Philadelphia eager to resume her studies.

Rev. Royal Wilder and his wife Eliza Jane lived in Princeton, New Jersey—only about thirty miles from the Carpenters' home. It had been more than four years since Wilder denied Gopal's request for help in educating Anandi. When he read local newspaper accounts discussing Anandi's enrollment at the medical college in Philadelphia, Wilder felt irritated and upended. Not only had the young wife managed to come to the United States, she had accomplished this with the help of *his* newsletter.

Early in January, Mrs. Wilder wrote a letter to Theodocia,

to which Theodocia promptly responded. Theodocia enclosed Mrs. Wilder's letter in her next letter to Anandi, indicating that she "would like to have [it] returned." So nervous was she about the letter that she urged Anandi to not show it to anyone. Unfortunately, the actual contents of Mrs. Wilder's letter, and Theodocia's response to it, are not known.

At about the same time, Anandi received a letter from Grace, the Wilders' daughter. Anandi responded to her in Marathi. Starting with, "To my very best friend Miss Grace Wilder, I offer my namaskars [Namaste greeting]," she expressed joy in receiving the letter and offered apologies for the delay in responding. However, Anandi's closing remarks indicated that she was not particularly keen on meeting Grace:

> *I am very eager to meet you, but considering my work*
> *and the weather, it will not be possible at this time.*

The elder Wilders served as missionaries in Kolapore beginning in 1853. Because her parents administered Marathi-language schools for Indian boys and girls, it is no surprise that Grace had mastered Marathi.

It is likely that Grace spent some time under the care of Rev. Goheen, who succeeded her father at the Kolapore Mission. Because Goheen had come to know of Gopal's interest in America, he was likely responsible for introducing Grace to Anandi. Because Grace was just four years older than Anandi, and thanks to her command of English as well as Marathi, Anandi must have found in Grace not only an English tutor, but a friend as well.

Grace left Kolapore to attend Mt. Holyoke, a women's college in Massachusetts, from which she graduated in 1883. The entire Wilder family remained passionate missionaries. Grace

and her younger brother Robert established the Student Vol-
unteer Movement that was instrumental in sending hundreds,
if not thousands, of missionaries to foreign lands. After Rev.
Wilder's death in 1887, Eliza Jane and Grace returned to India,
serving there until their deaths.

Unfortunately, no additional information is available about
the Wilders' interactions with the Joshees or the Carpenters.
The single letter in Marathi offers a tantalizing glimpse of the
unique cross-cultural friendship between Anandi and Grace.

January 1884 brought both snow and a type of bitter cold
that Anandi had never before experienced. In a letter to Gopal,
she characterized it as a kind of enslavement that all stoically
endured. She described at length the treacherous ice that caused
people to slip and fall. Acknowledging that it was a crazy idea,
she wished she could bottle up the snow and send it to Bombay
and Calcutta to provide the people there a break from the swel-
tering heat. Used to violent tropical storms accompanied by
lightning and heavy lashing rains, Anandi was struck by the
quiet advent of snow. "Fresh snow is like sugar," she wrote. "But
the rain converts it to ice, and makes it hard and transparent
like a lens." Even as she wished that Gopal could be with her to
experience the snow, she corrected herself—

> *I want you to be able to share my joy, but not my hard-*
> *ship. It is better that you are in a milder climate, sur-*
> *rounded by friends and good people.*

Unfortunately, Anandi's equanimity shortly began to wane.
In a letter written on January 29, she explained to Gopal that
she had parted her hair at an angle to disguise her thinning hair

and cover a growing bald spot, not for fashion or on a whim. One cannot help but wonder if this was an early sign of Anandi's weakening immune system, brought on by a shortage of nutritious vegetarian food. In February, she contracted diphtheria, a contagious bacterial infection that caused a sore throat, fever, swollen glands, and physical weakness. Her recovery was slow, and her doctors insisted on a gradual return to her activities. She missed many days of classes, which caused her much worry.

Letters written during 1884 were peppered with mentions of sicknesses. "I have to often stand for five or more hours. When I am tired, my hands and legs start to shake." There were fevers, headaches, and backaches. "Every bone in me is aching and I feel very feeble."

A few weeks after her recovery from diphtheria, Anandi received a letter from a "bitter enemy." Neither the specific content nor the author of the letter are known, but given her intense reaction, "My face was clouded by my indignation. My friends said my color changed from red to blue and [they] thought I was sick…," it is likely that the content of the letter struck at Anandi's greatest vulnerabilities.

One of the reasons for the Hindu community's objection to Anandi's travel to America was the fear that she might convert to Christianity. This is why she had publicly proclaimed in her Serampore speech that she would "go as a Hindu and return as a Hindu." However, it is very likely that Anandi's assertion was insufficient to fend off speculation and gossip. Another possibility is that the letter contained charges relating to her marriage— either that she was no longer faithful to Gopal or that Gopal was thinking of abandoning her. It is easy to imagine accusations such as these shaking Anandi to her core.

A person living among strangers is in a weakened position, but is rendered weaker still if abandoned by her family or community. And so, Anandi had to fall back on her own internal resources—her imagination, her faith in her purpose, and her will to thrive:

> *All at once a beautiful young lady with a sweet voice came and sat down by me, and pressing my hand with her own, said, — "Dear child, do not despond. Providence is just and merciful, and means you no harm. Have courage to endure many more such things. Do you not remember how I was persecuted in the presence of my husband the king? Be true and faithful." Then she seemed to disappear. I felt her presence though I could no longer see her, and was comforted.*

Anandi also received a distressing letter from Gopal, in which he expressed anger about a photograph taken during the reception in Philadelphia the previous October. He was upset that Anandi had not informed him that she had changed her style of draping the sari. Gopal charged that Anandi had become overly proud and insinuated that she might no longer be faithful to him. So ugly and disproportionate was his reaction that Gopal seemed to have entirely forgotten that he had given his wife permission to alter her attire, and even her vegetarian diet, if conditions necessitated such changes.

An immense gap had opened between Gopal's heart and his head. On a cognitive level, he had facilitated Anandi's education and her independence. However, his heart had not fully come to terms with the side effects of granting his wife such agency. He appeared not to recognize that since Anandi was living on

her own, she needed and deserved to have the freedom to use her own judgment. Because Gopal was not on the scene, he could not possibly have the necessary insight and wisdom to understand Anandi's challenges and choices. Because she had not shown by word or action that she was being swept off her feet by American norms or by ideas of her own power and esteem, Gopal needed to trust Anandi's judgment. And finally, as her champion and protector, Gopal's new role was to champion and protect his wife's right to make decisions for herself.

A charitable explanation for Gopal's conduct would be that his criticisms were intended to preempt those of others. He might have been trying to control Anandi's behavior in order to ensure her good standing within their community. However, if this was indeed Gopal's motivation, a more even-tempered and compassionate person would surely have found a gentler way to achieve his purpose.

Gopal's accusations were the proverbial straw that broke the camel's back. Although he had written a similar letter once before, it had not had the same effect on Anandi. Since she was living with the Carpenters at the time, she had found support as well as distraction, and this had softened the blow. Indeed, having seen the effect his letters had on Anandi, Theodocia had taken it upon herself to write to Gopal, requesting that he be more restrained and compassionate in his letters to his wife.

In contrast, Anandi was now living alone in Philadelphia, and was also dealing with multiple challenges—studies and cooking, brutally cold weather, and ill health. With Gopal doubting her best intentions and deepest striving, Anandi reached the point of a "nothing left to lose" attitude. No longer meek and compliant, she defended herself in a reasoned but

more muscular manner. So beset did Anandi feel by Gopal's letter that she composed this uncharacteristically forceful response:

> *I do not consider you equivalent to other husbands, and you should not consider me equivalent to other wives. I have not yet changed my vegetarian diet and it is unlikely that I ever will. I changed my attire to protect my health, not to be American and not for reasons of frivolity or fashion.... I want to request that you keep calm and stable, and do not see false meaning. If you do not do this, you will devastate my heart and soul.*

She then reminded him of the physical and emotional abuse to which he had previously subjected her:

> *It would be difficult to decide whether the way in which you treated me in the past was good or mean. If you ask me, I would say that it was both good and bad. If I think of the outcome of those actions, it seems to have been for the good. But, if one were to consider the effect on the mind of a child—with fairness and justice—then it was undoubtedly harmful. . . . At the age of ten—really at a very young age—the little body was hit with wood; at the age of twelve, chairs were thrown, books were flung, and threats to leave and abandon were hurled [at me]; at fourteen, various other [awful] treatments were meted out [to me]. All these were too inhumane and extreme for the body and mind of the girl [I was] at those ages.*

It was a prelude to reminding him that she had not left him despite his cruel treatment:

> *At the young age, the body and mind of the child have*

*not matured. So, what I did in that stage of under-de-
velopment is well-known to you. If I had indeed left
you at that young age, what would have been the out-
come? I would have been lost (there are plenty of in-
stances of girls leaving their homes due to ill treatment
at the hands of their husbands or mothers-in-law). The
only reason I did not do the same was that my thought-
less (impulsive) action would have damaged my father's
name and reputation. I did not even consider leaving.
I cannot help wondering what made me so mindful
given my young age.*

Anandi's anguished letter continued:

*In fact, I pleaded with you to kill me. Whatever binds
husbands and wives together, it is ever against the
women. That is why, even when you were breaking
chairs on me, I had no choice but to stay mum. Hindu
women do not have the right to speak up or to offer
words of wisdom or advice to their husbands; rather
they are expected to let the husbands do what they will
and keep quiet. Hindu men could learn a thing or two
about patience from their wives. (I do realize that I
could not be the person I am today but for you; and
for this I am ever grateful. But, you cannot deny that
I was always calm and patient.)*

It is not possible to know the full extent of Gopal's physical
aggression toward Anandi. It is only through these letters—
provided by Gopal himself to Kashi-bai Kanetkar, the Marathi
biographer, that we know of it. So, Anandi's American friends
almost certainly had no knowledge of this aspect of her life.

Despite the bitter memories that Gopal's letter brought
forth, Anandi closed the letter with her characteristic patience:

> *I could not have imagined that you would accuse me*
> *of disloyalty. It is very unfortunate that I wrote one*
> *thing and you read something entirely different. I did*
> *not mean to suggest that either I or you have changed.*
> *It is my hope and wish that you continue to look after*
> *me and guide me when I err. I can tell you with cer-*
> *tainty that your wife is exactly as she was when you*
> *and she were separated. The only differences are a*
> *slight change in her attire and a big change in her en-*
> *vironment.*

Anandi came to regret this letter almost immediately after she sent it. Her concern was further amplified after reading Gopal's next letter, which he had sent before he received her defensive one. So Anandi wrote him another, more conciliatory letter, one filled with love and encouragement:

> *I was very moved by your loving letter and was grati-*
> *fied to read of your resolve to face all challenges with*
> *courage. Your previous letter had caused me a great*
> *deal of worry, but it has been assuaged by this letter. I*
> *feel like a traveler who is exhausted by journeying in*
> *the hot sun when he comes upon a large tree offering*
> *shade. And the life-giving spring of water for such a*
> *traveler as me is your letter. You are ever in my thoughts*
> *and I am eager to be reunited with you. . . . I regret*
> *the letter I sent you for I know that it was quite harsh.*
> *Even though I did not intend to hurt you, I am sure it*
> *caused you a great deal of pain. If I am lucky, the letter*
> *will get lost in the mail. I cannot ask you to forgive me,*
> *and I am willing to accept whatever punishment or*
> *repentance you wish to assign.*

Given the fact that Anandi's many American friends and acquaintances had no knowledge of the dark underbelly of her marriage, they often spoke of Gopal in glowing terms, going so

far as to find their own husbands lacking. And so, in an attempt to further calm her husband and to remind him of the better angels of his nature, she wrote:

> One woman remarked that you are a better husband than typical American husbands. Another woman went so far as to say that if her husband even suspected that she might exceed him by learning a new business and earning accolades, he would not let her get started.

She concluded, "I am proud that I have a husband such as yourself."

Gopal's two back-to-back letters—one harshly critical and the other loving—had the effect of leaving Anandi wary of Gopal's mercurial personality. She well knew his reactive and impulsive nature, but when they lived together, she was able to manage his moods through her own words and actions. Living so far away, she was at risk of being grossly misunderstood. Letters could not adequately convey context, and Anandi could not know or control Gopal's interpretations of her letters. And so, her letters to her husband followed something of a feast-famine pattern—the expression of love and admiration, alternating with caution and pleas to remain calm and patient.

"Do these dry letters convey my love?" she wrote to Gopal. In other letters, she discussed plans for when they would be together again, going so far as to offer to sell her gold jewelry to pay for his journey. Gopal proposed to give her a new name—Saraswati (the Hindu goddess of learning), which was deeply meaningful and gratifying to her. It reflected the respect and devotion she was sure he felt for her, even if only in the moment.

Overall, the notes of appeasement in Anandi's letters were

those of a person consciously laboring to keep the lid on an explosive situation and to keep matters from sliding out of control. The particulars of her pleas suggest that Gopal continued to be highly reactive and restless, and not only with regard to her.

Alarmed by a letter in which he wrote of his hatred of religion, Anandi wrote a long response defending the truth and moral clarity inherent in all religions. While she praised his rejection of pretense and the false religious beliefs of others, she sought to explain that the flaws in religion resulted from the corruption of the adherents of those religions, rather than from religion itself:

> *Divine Creation loves all its children regardless of whether they are Hindu or Muslim or Christian. Only the ignorant believe that if they don't understand something it must be untrue!*

When Gopal expressed his hatred of other peoples or countries, again her response was a thoughtful and energetic message of love for all humanity:

> *There can be no social improvement with hate. It is hatred like this that turns countries to ashes. Hating others can be of no benefit to us. Just as Hindus are children of God, so are the French, the Irish and the English. Hatred is a mean animal that resides to some extent in all hearts. Let us hate hate, instead of succumbing to the contagion of hate between peoples. Let us call out the hate that divides nations, rather than the nations that we are inclined to hate.*

After reading of his disagreement with his superior, Postmaster General H. E. M. James, Anandi urged Gopal not to impulsively resign from his job, but rather to act with wisdom

and forethought:

> *Always conduct yourself with honesty and truthfulness.*
> *That is God's way. Remember "Satyam Eva Jayate,"*
> *Truth shall always prevail. ... If we do something bad,*
> *despite knowing that it is so, it is like insulting God.*
> *And when this happens at the hands of someone I love,*
> *I feel especially sad.*

In one of his letters Gopal floated the idea of staying on in
America after her graduation. Her response was a reasoned and
impassioned argument in favor of returning home:

> *As you well know, I do not wish ill for any country in*
> *the world. But, if God wants me to be useful in the*
> *service of humanity, I am likely to be much more useful*
> *in India. I know well our customs. I know the con-*
> *dition of our women better than any outsiders. I know*
> *the challenges presented by our religion and I know the*
> *language. If a medical college for women is not in the*
> *Almighty's plan, I intend at the very least to teach*
> *Hindu women about health care. I am prepared to use*
> *my time to give public lectures.*

In another letter, Anandi stated that she felt she had been
chosen or nominated by Providence to serve India. However,
Gopal continued to dwell on the topic of remaining in America.
Exasperated, she finally wrote:

> *If you do not wish to return, it is better that you do not*
> *come at all. I will manage. What message will your re-*
> *maining here send? Only of selfishness. . . a trait that*
> *is not a good one and that is not respected by people of*
> *good will. (Maybe you have written this intention to*
> *make me happy, but I am happy already.) We need to*
> *set a good example, and the place to do that is not*

America, but India.

Given the extent to which Gopal had misread her letters, Anandi was alarmed that her letters could easily be misunderstood or misinterpreted by others. After all, other people could not know her nature as well as Gopal did, and they could not possibly understand her circumstances. She repeatedly requested that Gopal not share her letters, and not publish them in newspapers or in a book. She even suggested that they be burned:

> *I could become a laughing stock. Although there are many who praise my efforts, there are many more who criticize. Also, we are not doing all this for show or publicity. People who want to shine their own lamp to impress others may do so; for me, there is no glory in such conduct and I find no purpose in using my time and energy for such purposes.*

She made just one concession:

> *Please forgive me for writing in this way. If you must, it is fine with me if you collect all my letters in a notebook. Or, if they are hard to read [as written], you may write them out [in your hand].*

Despite her many hardships, Anandi persisted in living a passionate life of the mind. "I am drawn to many topics as if by a magnet," she wrote. In another letter, she hinted at the tug of war between her interests and her duties:

> *I observe hundreds of things, and my mind dwells on and analyzes many of them. This is but natural. But I do not have time to write a book. My every second is accounted for. If you were in my place, you would*

have felt the same.

Perched at the intersection of two different cultures and belief systems, she always found much to ponder. Although her medical education remained her highest priority, leaving her little free time, Anandi still pursued a wide range of interests. She collected specimens of wild flowers and leaves, cataloging their properties. She attempted to study both French and Greek, although she dropped these because of lack of time. And she engaged, whenever possible, with Dean Bodley in a dialogue about Sanskrit—the ancient Indian mother language.

Having become aware of the debates about Darwin's theory of evolution and Christian objections to it, Anandi pondered how Hinduism might regard the issues and wrote about this to Gopal:

> *It is not God's intention that this world should forever remain in its original state. Similarly it is not His purpose that this world should be a stranger to Truth. Man's intelligence has developed over time and it will continue to develop until it reaches its full potential. Material change is an aspect of Nature; any being that achieves a new state will continue to achieve other newer states. As time goes on, everything undergoes change—as can be seen from your very example. It is not that we need to work to make this change happen, it is that it occurs due to the laws of Nature.*

She even arrived at a Hindu underpinning to Darwinism.

> *The Hindu dashavatar—ten avatars—are a manifestation of just this process, the process of 'utkranti'— evolution. Life has evolved from Fish to Man and it was not at all like directly jumping from the lowest rung of a ladder to the highest one. The whole world*

ought to learn this concept from Hindu teachings. Isn't it a matter of importance and astonishment that this concept which has been integral to Hinduism for eons has been universally accepted only now in the nineteenth century? The concept, that the Westerners believe they have recently invented, was set forth by our ancestors ages ago. The Westerners should note as well as acknowledge only that it is true and that they have accepted it [but not that they are the first ones to come up with it]. . . . It is hard to determine just how and where the change occurs—regardless of whether the change is physical, spiritual or mental.

Suddenly aware of her own extraordinary passion, Anandi ended on a more collegial note:

This is my concept and understanding. You may call it dry or foolish. I have presented it to you just as it appeared to me. Do let me know what you think of this topic. As you know I am fond of intellectual discussions. As much as I ponder such issues by myself, I wish to have someone with whom to discuss them. When I am unable to satisfy my questions and curiosity on my own, I try to quench my thirst on the fountain of others' intelligence.

Anandi became familiar with the mission of nearby Girard College to provide for orphans and empower them to become productive members of society:

There are 1,100 students in this school. They are between the ages of six and eighteen. They receive food and clothing as well as housing and board. No clergy are permitted to enter the grounds. This is because differences in opinion relating to religion often lead to conflict. The students are treated with affection and

are taught useful trades.

So impressed was she by this college that a few months later she wrote to Gopal urging him to consider establishing orphanages in India:

> *We should open schools for orphans instead of dharm-shalas [building devoted to religious or charitable purposes, especially a rest-house for travelers]. I will help in this cause after I return. There are many dharm-shalas, but there aren't sufficient schools for orphans. If I am asked to sacrifice my life for orphans, I will gladly do it. I pray to God that you too will have the same resolve.*

A visit to a school for the blind introduced Anandi to another aspect of American ingenuity. She was as astounded by the idea of teaching blind persons to read, write, and work as she was by the ability of the blind to benefit from such instruction. This experience, too, provided new ideas to be implemented in India:

> *The American people use their ingenuity very well. It is because of this that their country has become so rich. When our country achieves prosperity, you too will feel inspired.*

Finally, her work at the Norristown State Hospital introduced her to the practice of "humane" treatment for psychiatric patients. To the extent permitted by a patient's condition, she or he was not necessarily restrained. Such patients were permitted to work on the farm and in the stables, the kitchen, the laundry, and in trades.

Given Anandi's predisposition to be of service, exposure to these institutions provided her much inspiration and many

ideas to implement in India upon her return.

Women's Christian missionary societies had been in existence in America since the early 1800s. Since women were typically not permitted a role outside the home, these societies gave them a way to come together and work for a higher purpose. Despite the biases of church and society, they eventually gained respect, especially that of the missionaries in the field who came to rely on their donations and prayers.

The Annual Assembly of the Philadelphia branch of the Church Missionary Society took place on April 29–30, 1884 at the Tenth Presbyterian Church. Three sessions were held each day, with the two daytime sessions being exclusively for women. Given the Society's interest in foreign missions, Anandi was invited to address the gathering. The audience probably expected that she would paint an authentic picture of the many hardships faced by women in India.

Anandi chose "Child Marriage" as her topic, though her talk was *not* especially a denunciation of the practice. Instead, it was a more balanced view, informed by her own experiences.

Having known and witnessed the suffering of girl-brides, Anandi was not altogether a fan of the practice of child marriage. Given Gopal's unflinching opposition to the custom, she was predisposed to criticizing it. However, the seemingly endless questions repeatedly posed by Americans had created in her an impulse to resist the barely veiled criticism. As she wrote in a letter:

> *I am often surprised by the ignorance of the people here. They ask me utterly foolish questions about child marriage. They ask me about other strange practices that I*

> *have never before seen or heard. . . . They even ask me*
> *about the supposed widespread killing of girls imme-*
> *diately after they are born. How horrible is this idea?*
> *I did not know that India is such a barbaric and evil*
> *place until I met these people. We should not be sur-*
> *prised if they see Indians as somewhere between ape*
> *and human. All these questions, sometimes coming at*
> *me from all four directions, make me very sad. I do*
> *not feel ashamed. I think it would be best if I were to*
> *provide them more accurate information.*

Thus, she chose the topic of her speech in order to speak directly on this matter and to counter Americans' wide misconceptions about her society.

Anandi was born in 1865 and was married off at the age of nine. Her early marriage is quite a bit less outrageous when considered alongside the norms for marital age prevalent at the time in Western Europe, especially considering their greater progress in matters relating to women.

European nations began to enact age of consent laws in keeping with the emergence of an Enlightenment concept of childhood, which introduced a distinct phase of early development and growth. This novel view cast children as different in nature from adults, and as particularly vulnerable to harm in the years around puberty. But even so, the age of consent was *increased* in France to only thirteen in 1863. In England, the age of consent was raised to thirteen in 1875. In the United States, each state determined its own laws relating to family life. So the American age of consent ranged from ten to twelve years of age. Even with the shift in English law, American laws did not follow suit.

In middle class or well-to-do American families, it was considered improper for a young couple to marry until the husband could support his wife in a well-appointed home. As a result, the average age at first marriage, as reported by the US Census in 1890 (based on data collected starting in 1880), was 23.3 years for white females.

Members of the Missionary Society typically belonged to these classes and so were accustomed to women marrying in their twenties—well after obtaining a high-school education and reaching a level of emotional and physical maturity. In addition, owing to their close association with missionaries in foreign lands, they were well-acquainted with the ills of those societies, such as child marriage and opposition to widow remarriage. The combination of this awareness, belief in human progress, familiarity with Enlightenment ideas, and Christian compassion predisposed them to have no sympathy for child marriage.

It is no surprise, then, that there was shock and bewilderment when Anandi chose *not* to entirely denounce the custom.

Dean Bodley and Caroline Dall, two of her most ardent champions, were taken aback by her speech. It became an important coordinate in their understanding of Anandi and, later, in their memories of her. It is a credit to both women that, although they disagreed with Anandi's rationale, they refrained from criticizing her. Instead, they made genuine efforts to understand Anandi's mindset.

In her biography of Anandi, Dall wrote:

> I think it tried the patience of those who were interested in her very severely. I have never seen any abstract of her remarks, but if she favored early marriages was it strange?

> She had been married at nine years. All the happiness of
> her life had flowed from the instruction of her husband
> and from that liberal sympathy which she supposed to
> move him in assisting her to come to this country.

In her foreword to Rama-bai's book on high-caste Hindu
women, Bodley wrote:

> If there are any who still cherish the feelings of dis-
> appointment and regret engendered that April afternoon
> let them. . . learn how absolutely impossible it was for a
> high caste Hindu wife to speak otherwise.

And yet, Bodley did not see Anandi's talk as the automatic
response of a powerless victim of the Hindu social order. She
understood that Anandi's unwillingness to criticize the practice
of child marriage was her way of staying true to the speech she
had given in India. In Bodley's view, keeping the promise to "go
to America as a Hindu and return as a Hindu" required that she
refrain from criticizing her religion among non-Hindus. In ef-
fect, Bodley's empathy and code of honor allowed her to respect
even what she perceived as Anandi's unsavory views.

In reality, Anandi was motivated by a simple desire to use
the speech to offer a fuller and more balanced response to the
seemingly unending questions and strange assumptions about
the custom of child marriage. What she intended to convey was
this: although the custom could be regarded as barbaric overall,
there were still bright spots in practice. For example, many mar-
ried girls continued to live with their birth families and were
sent to live with their husbands only after attaining puberty;
many in-laws were kind and nurturing to their young daugh-
ters-in-law; and in the manner of American girls, young wives

were typically allowed to engage in play and pastimes in the company of other girls and young women.

Most important, a revolution was already under way within India with more and more husbands—like Gopal and his friends—actively resisting the custom and/or insisting on gentler treatment and education for their young wives. By mentioning these examples, Anandi may have hoped to replace her audience's confusion or disdain with sympathy and hope.

In a letter that she wrote to Gopal the day after the event, Anandi mentioned that there had been over two thousand women in the audience and that she had received an honorarium of ten dollars. However, she seemed completely unaware of the furor she had caused. Instead, she felt energized by the opportunity to publicly speak her truth. In the very next sentence of her letter, she mentioned her plan of preparing a talk on "Hindu women." She wrote that she would "…speak based on my own thoughts and personal experience." She reassured him that this would not come in the way of her studies. "I receive many invitations, but I decline them all because my studies are my main focus."

Anandi was growing in confidence and was starting to spread her wings beyond her learned preferences. It was a remarkable paradigm shift to start seeing Indian society from the stance of an independent thinker—no longer as the dissident who delivered the "Why I am going to America" speech, nor as a compliant and oppressed adherent of a conservative religion.

THE YEAR OF CULTURAL EXPLORATION

We do not see things as they are.
We see things as WE are.

Talmud

*A*nandi spent part of the summer of 1884 in Roselle. As during her initial stay with the Carpenters, their mutual acculturation project resumed with enthusiasm. Her letters to Gopal during these months paint a picture of loving kindness and full acceptance.

> *Please don't worry about me. I am continuing to ad-here to our food and attire. God is looking after me and he will direct me only towards the good. I never eat American food, but I occasionally cook Indian food for the family. [Theodocia's little girls] Helena and Eighmie, as well as family guests delight in wearing Indian saris and wearing the red dot on the forehead. Even the dolls ask for Indian saris! I have given every-one Indian names. Helena is Tara, Miss Stuart is Sa-guna and Eighmie is Pramila. And, I just call Theodocia mavshi [the Marathi word for maternal aunt]. Everyone uses namaskar [the Hindu greeting] instead of "Good morning." Mavshi often says that we are gradually becoming more and more Hindu.... Mavshi and her husband send you namaskars and re-*

*quested I write these two sentences: the one from whom
you are parted has been received by us, and for this we
are grateful to God. Anandibai's presence with us
makes us very happy.*

Even though Anandi was not open to converting to
Christianity, she regularly attended church in Philadelphia. It
is likely she was comfortable doing so because, while in Roselle,
she had often attended church with the Carpenters. In her often
lonely life, Anandi may well have found solace in a spiritual
worship service. However, her reason for choosing a Unitarian
church remains unknown.

One possibility is that Anandi was already familiar with
Unitarian beliefs from her and Gopal's acquaintance in Calcutta
with Rev. Charles Henry Appleton Dall, a Unitarian missionary
(and husband of Caroline Dall). Rev. Dall's open critique of
British rule in India had alienated many in the European com-
munity. By contrast, he was active in liberal Hindu circles and
was not focused on converting Indians to Christianity. Dall had
also established several schools in Calcutta, including two for
girls. As a result, Anandi may have expected to find among Uni-
tarians kind, curious, and open-minded individuals, paticularly,
ones who would not attempt to convert her to Christianity.

The minister at the Spring Garden Unitarian Church in
Philadelphia was Rev. Charles G. Ames. He was passionate
about "anti-imperialism, woman's suffrage and the prohibition
of alcohol." In addition, Ames was an abolitionist and, together
with his wife, had founded several charitable organizations for
the care and education of orphans. With beliefs so closely akin
to hers, Anandi felt very comfortable in his church.

Indeed, so regular was her attendance that she gradually developed a close relationship with Rev. Ames and several members of the church. Dall described Anandi's relationship to Ames thus:

> *Between him and her there was no "need of words."*
> *She entered into his spirit, and it was her greatest delight to listen to his preaching in Spring Garden Street.*

In turn, Ames described his feelings about Anandi in a letter to Dall:

> *She was often at the church and showed her interest by lingering long at the close, and accepting with sweet and gracious silence, and hand pressure, all the greetings of the people. It was not customary for her to initiate conversation, but once engaged, she talked remarkably well, and generally on serious subjects. She was a guileless and genuine person who knew her own mind and saw clearly "the path." Her capacity for self-direction, coupled with rare and generous justice, promised a career of great usefulness in her native land.*

Rev. Ames' sermons made a strong impression on Anandi. In a letter to Gopal, she juxtaposed Hindu and Unitarian beliefs. She regarded Hinduism as an evolving religion, one with millions of gods at its outset, then progressing through a trinity of gods, and onto the final stage of a single divinity. She saw Christ as a *sadhu* or a *rishi*—not very different from the sages of ancient Hinduism. She saw obvious parallels between the Christian Trinity (Father, Son, and Holy Ghost) and the Hindu Trinity (Brahma-Vishnu-Mahesh—Creator-Preserver-Destroyer). And finally, Anandi observed the essential similarities between the Unitarian belief in a single god and multiple Vedic Hindu teachings. "Love is what binds us all," she concluded. "Love is

the core of all religions."

Anandi's inquisitive and observant mind continued to identify new opportunities for her husband and for her country. Noting Americans' enjoyment of it, she saw a market for Indian tea in America.

> *Mavshi [Aunt]'s husband thinks that you should bring Indian merchandise here for sale. My view is that you should bring tea. Americans have developed quite a taste for tea. The only tea available here comes from China and it is not very pure. One of the gentlemen here received tea from his brother who lives in India. He gave some of it to me. Those of my friends who have tasted this tea absolutely love it and go to the stores in search of it. Unfortunately, there is none to be had.*

From there her mind leaped to the potential for trade between the two countries:

> *My view is that there should be trade between India and America and this will be very good for India. . . . The only other source is India. If the tea is of good quality, people will be willing to pay high prices for it. We can start with tea and then determine which other items can be sold here. Even though the tax is high, I am convinced that there is potential for a great deal of profit. I am also sure that one who conducts business honestly will do well here. It is important to lay a sound foundation for such a business venture. . . . I feel that Aunt's husband will be willing to help. He believes that there should be more trade between India and America.*

Gopal wrote exploratory letters to some traders in Poona,

but unfortunately did not get much of a response.

During the summer of 1884, Anandi spent a few weeks in Saratoga Springs, New York, with the family of Mrs. Bartow, Theodocia's cousin.

Saratoga Springs was well known as a destination for "health and horses." The carbonated mineral-rich springs were believed to have medicinal properties, thus drawing many visitors. The racetrack was the first of its kind in America, and attracted the wealthy and fashionable from New York City and beyond. It is no surprise that reporters were a fixture of the summer season. They dutifully reported on the well-known personalities, their horses, and their events and galas.

The August 3, 1884 edition of the *New York Herald* carried a story entitled, "A Hindu Critic of American Life." There were the usual descriptions of Anandi's satin wrap and scarlet petticoat, and the silver and pearl rings in her ears and nose. She was described as "the observed of all observers as she looked for the first time in her life upon 'the dance of modern society.'"

When a reporter asked Anandi her opinion of the dancing party, it was probably disappointing that she neither gushed nor criticized. Calling it a "butterfly party," Anandi only allowed that she "enjoyed the dancing of the children, they were so graceful." Intent on a flashier story, the reporter characterized Anandi as a *critic* of American life.

This newspaper account conveys the tightrope that Anandi walked whenever she ventured beyond the protective cocoon of Theodocia and her family. Her attire always branded her an "outsider," even while its richness conveyed an impression of

distinction. An expression of the gentlest disagreement or dissent never went unnoticed. Anandi had already learned to summon her patience and good humor to cope with such situations.

While Americans observed Anandi's attire, she observed theirs. In particular, she questioned American women's custom of wearing corsets. It concerned her that corsets were worn so tightly as to make breathing difficult. Anandi likened this practice to Chinese custom of women's foot-binding. She thought it ironic that the Chinese custom was considered *backward* and the Chinese *ignorant*, whereas the American custom was merely considered *fashionable*, owing to the otherwise more developed state and self-regard of American society.

A high point of Anandi's visit to Saratoga Springs was the opportunity to become acquainted with a young Native American woman. We do not know the extent of her knowledge of Native Americans and why they were called Indians—that Columbus had set out to find a route to India and, not realizing that he had landed on a different continent, had mistakenly referred to the natives as Indians. Nor do we know if Anandi was aware of the connection between the colonizing impulses of Spain and Portugal (the financers of Columbus' voyages to America and of Vasco da Gama's to India) and her country's rule by the British at the time:

> In one young squaw she took a great interest, talking with her about manners and customs, and receiving from her several friendly gifts.

So warm was the meeting between the two "Indian" women that, in addition to exchanging gifts and handicrafts from their respective cultures, Anandi bought a few items to take home to India. One special purchase was a beautiful box that she gifted to Theodocia, which her aunt would later use to store her collection of Anandi's letters.

At the end of the summer, Anandi returned to Philadelphia for the fall term. By now she had been exposed to a range of a technological inventions and made it a point to write to Gopal her fascination with them.

A year earlier, she had described in detail the mechanism of the alarm clock that Benjamin Carpenter gave her. She had already written about the modes of transport she had experienced in New York City—the elevated railroad, the elevators that effortlessly whisked people seven stories up, and the soon-to-be-built underground train system.

Another notable innovation of the time was Electricity. As with any new technology, the spread and adoption of electricity were slow. The associated fire hazards led to resistance from insurance companies. Many people were comfortable with the prevalent gas lights and did not see any need for electric lights and their cumbersome wires. For Thomas Edison and other evangelizers, marketing was as big a challenge as the development of the technology.

The Edison Electric Company received permission in 1881 to light a section of Philadelphia's Chestnut Street at no charge for one year. By 1882, the Wanamaker department store, the office of the *Public Ledger* and the Post Office were all lit using electric power. Arriving in Philadelphia just a year later, Anandi

had likely heard of some of these places and may have personally seen electrical lighting.

The 1880s were a time of rapid technological change in Europe and America. Many European capitals had hosted expositions to show what electricity could do and, just as important, what their engineers and innovators could do with it. In 1884, Philadelphia's Franklin Institute organized America's largest such exhibition. It boasted the added distinction that it was "entirely electrical in character." It was a way to introduce ordinary people to the wonders of electricity, inspire schoolchildren, and demonstrate to the world the "new ideas and new applications" of American inventors, workshops, and laboratories.

Anandi and her friend Frances Coleman Smith were two of the three hundred thousand people who visited the exhibition. Touring the Gothic-spired hall that had been constructed just for the occasion, they saw conduits and railroad switches, sewing machines and pipe organs powered by electricity, and an egg incubator warmed by electric current. Twice each evening visitors were treated to a display of an illuminated fountain whose streams of colored water created a prismatic spray. Over one hundred years later, a promoter's description of the event as "but the threshold of the coming electrical era" reads like a gross understatement.

A letter that Anandi wrote to Theodocia in October 1884 contains only a passing reference to her visit to the exhibition— "I enjoyed it very much." The brevity of her remark may have resulted from the fact that she and Theodocia had already together experienced electric-powered lights. Another possible explanation is that Anandi had very little free time for non-essential tasks.

P. T. Barnum was well-known, mostly as a showman and as the owner of the eponymous Barnum and Bailey Circus, which billed itself as "The Greatest Show on Earth." Many are also familiar with Barnum's cynical belief that "there is a sucker born every minute." During its heyday in the 1870s-1880s, Barnum's circus showcased the "midget" General Tom Thumb, the Bearded Lady, and the Siamese twins. It also featured sideshows based on human "specimens" brought to America from the farthest corners of the world.

The Ethnological Congress, as that display of humans was oddly named, promised a thrill by collapsing the boundaries between humans and animals.

> 100 Rude and savage representatives!
> Fanatical and Pagan idolaters!
> Bestial and fierce human beings
> Ignorant and warlike barbarians

The exhibition included the famous Chinese giant Chang Yu Sing, fully armed Afghan warriors ("as difficult to control as a lot of imprisoned bandits or caged wild beasts"), Zulu Braves ("symmetrical and graceful... literal demons in carnage"), and later, whirling Dervishes, Australian boomerang throwers, and Cossack horsemen. The violence inherent in these "specimens" was tempered somewhat by the inclusion of Burmese priests, "High Caste Hindoos" and finally, "short-headed, broad-skulled, ... flat-faced Buddhists."

Notwithstanding the recently emancipated slaves, the United States was a mostly homogenous (white Christian) society. There was little appreciation of the humanity and inherent

dignity of the persons so exhibited. In the shadow of Darwin's Theory of Evolution, Barnum claimed to be "completing the work of scientists by providing the collected examples they required to properly illustrate the findings of their research into the natural history of man." The program for the 1884 show proudly listed the spectacles on offer:

> Roman chariot races, Asiatic dromedary races with mounted Nubians, jockey races, grand female pedestrian races… and the picturesque Indian chase for a wife.

Having heard her friends' breathless descriptions of the circus, and having seen the posters and newspaper notices, Anandi was quite repulsed by the prospect of going to the circus. The mere idea of gawking spectators reawakened her feelings of helplessness and humiliation when she had been jeered at in Bombay and Calcutta. Worse yet, people from India, who looked and dressed like her, were included in this *freak show*. It felt stingingly like a mockery of her hard work, her belief in progress, and her people's need of and right to respectful treatment. Being the only one of her "kind" in her milieu, Anandi had no one to turn to, no one who would understand her or with whom she might commiserate. Equally, she had no platform from which to protest or express dissent about what Barnum featured and how the whole spectacle made her feel.

After her friend, "Miss B," repeatedly invited her to the circus, Anandi relented. In a letter to Theodocia, she allowed only that it gave her "no pleasure whatsoever." Whatever other painful feelings her circus visit engendered, Anandi kept those to herself.

One of Gopal's friends in Calcutta was Govind Sathe. He was an accountant who, like Gopal, was employed by the postal service. Govind and Gopal (both names for the Hindu god Krishna) belonged to the same Konkanastha Brahmin caste and, as such, shared both mother tongue and culture. Also, like Gopal, Govind had lost his young wife and had a child who was being raised by family members.

But the two men shared much more than these basic co-ordinates. Each had gravitated to Calcutta, then the capital of British India, out of a "desire to enlarge his experience." Like Gopal, Govind was a free-thinking Theosophist and believed in the "forming of a nucleus of universal brotherhood; the pro-motion of the study of Aryan and Eastern literatures, religions, sciences, and the investigation of unexplained psychical powers in man and physical laws of nature." Most importantly, he sup-ported Indian women's education. As one of the Joshees' closest friends in Calcutta, he had supported Gopal during the first days of utter emptiness after Anandi's departure for America.

A little over a year after Anandi's sailing, Govind decided to head for America. Knowing how well Anandi had been received, he decided to "see for himself what the country offered." Equally, with a restless spirit that chafed against the limited prospects for a "native" under British rule, he sought a freer existence, even if only temporarily.

Govind wrote to the Carpenters who graciously provided him his first foothold in America. Benjamin met Govind upon his arrival in New York and his first impression of the man was positive:

*He is learning navigation. . . . He evidently has
abilities and would make an excellent businessman.
He showed me several letters showing his past experi-
ence and may well be [justified to be] proud of his
record.*

Thanksgiving was the very next week, and "sit here and study" is all Anandi planned. However, learning of Govind's arrival, she could not resist making a quick trip to Roselle. This would be her first opportunity in over a year to be with someone *from back home.* Anandi's anticipation of joy was enhanced by the fact that Gopal had sent saris, blouses and foodstuffs for her, and gifts for every member of the Carpenter family.

Over the course of the sixteen months she had so far spent in America, Anandi had not had a single occasion to speak Marathi, her mother tongue. Not only was she completely immersed in an English-only society, she had made every effort to make sure she used the language impeccably. Although she carried on a large correspondence in Marathi, the total break from use of the spoken language temporarily impaired her fluency; worse, she was quite unaware of this change.

What a shock it must have been to her when, upon meeting Govind, she attempted to converse with him in Marathi and words failed her. What an even bigger shock when, witnessing her unease, Govind flew into a rage. Viewing her disability as permanent and of her own volition, Govind accused Anandi of no longer loving her country. He went so far as to express the sentiment that she was no longer fit to return to India and that it would be best if she never did.

Govind and Gopal were educated and thoughtful men; they were capable of critical thinking about their religion and society. Though both were champions of the cause of women, both

were still reactive and judgmental when interacting with a woman whom they should have had every reason to respect. This small incident demonstrates the magnitude of change— of heart, not just of head—that would be needed before a theo- retical recognition of women's equality could become a reality.

In the moment, Anandi had no choice but to silently endure her hurt and humiliation. Like a slow-burning fire, her reaction to Govind's harsh criticism did not kindle until four months later. When it did, it unfortunately led to further conflict with Gopal.

About a month later, on December 26, 1884, Anandi took a train to Washington, DC, to spend a few days with Caroline Dall. Over a year had passed since their first meeting in Phila- delphia, on the occasion of Dean Bodley's reception for Anandi. The two had remained in touch and had formed a close bond.

Dall's interest in Anandi was of a different nature than Theodocia's. Theodocia strongly resonated with Anandi's desire to do good in the world; in helping Anandi pursue her goal, she had found her own purpose. She also derived great satisfaction as the aunt who looked after her young niece. In contrast, Dall's interest was of an ethnological nature. She planned to encourage Anandi to talk about "the antiquity of her nation and of her family record, which she asserts is two thousand years old."

Dall met Anandi at the station and had engaged a carriage for the two-mile ride to her home in Georgetown. However, the train was so late that the carriage had already left. As a result, the two women had no choice but to take a horse-car, a form of public transport. Dall was sensitive to "the attention she [Anandi] could not fail to attract," and was therefore deeply ap-

preciative of:

> . . . the calmness with which she endured the curious
> gaze of our companions, and the courage with which
> she bore her burden and encountered the necessary fa-
> tigues. She was a striking contrast to the English ladies
> who came over to Philadelphia with the British Associ-
> ation that same year.

Dall's home was decorated with many Indian artifacts. She noted that "it pleased her [Anandi] to steal quietly about my house, taking up and touching the various articles that had been sent from India."

We can only wonder about the thoughts that ran through Anandi's mind as she saw and felt so many objects from her country. Did she feel a "shock" of familiarity? Did she marvel at the unique style, materials, and texture of the objects, and how different they were from the American home furnishings and accessories? Did she ponder the similarities between her journey and that of those objects—the parallels between the cu-rious gazes that both she and they attracted?

During Anandi's stay, Dall paid great attention to Anandi's attire and jewelry. Although the first sight of the nose ring that Anandi had worn in Philadelphia had "disappointed" her, she had come to regard it as an item of delicate beauty:

> Tonight she wore a close satin vest embroidered with
> gold, and a white camel's hair shawl or saree deeply bor-
> dered with gold; also her collars and necklaces of jewels,
> and for the first time, at my request, her nose ring. It is
> very effective, much prettier than ear-rings, and looks
> as if she were holding a spray of flowers between her lips

Dall took Anandi "to all the public buildings [including the

White House], to a service at a nearby Unitarian church, and to private lunches and receptions." They were invited to dinner at the home of Commodore James Walker, the chief of the Navy's Bureau of Navigation.

Another distinguished person that Anandi met was Major John Wesley Powell, the second director of the US Geological Survey and one of the founders of the National Geographic Society. Given his interest in anthropology and linguistics, Maj. Powell and Anandi shared a wide-ranging conversation. With Dall's input, it was arranged that Anandi would carry some specimens of North American pottery back to India and that she would, in turn, send some to him upon her return to India.

To preserve a sense of the swirl of activity in which Anandi was immersed, Dall journaled, "[On Dec 29 they] had fifty-two callers and in the evening gave a light supper to thirty." The guests were amazed by Anandi's knowledge of a wide range of topics:

> She talked in an earnest and excited way about the religions of the world, showing a profound intelligence as well as scholarship. Then, for a while in a very entertaining way about jewels and costumes.

And, they were charmed by her personality. One guest recalled:

> I cannot report anything that she said, but I remember wondering when I realized how soon the foreigner and the lion I went to see, was lost in the sweet and cultivated woman with whom it was a pleasure to talk.

CAUGHT IN THE MIDDLE

How much easier it is to be critical than it is to be correct.

Talmud

\mathcal{B}y the time a year had passed since Anandi started her studies in Philadelphia, she had hit her stride as a doctor-in-training. In October 1884, she wrote to Theodocia:

> It was a charming lecture, useful and interesting to every individual, the subject being Practical Hygiene. . . . I have to attend all the lectures except those on Materia Medica and Surgery, which I take up next year. I work from fifteen to sixteen hours daily. . . . I enjoy my studies more than ever.

The following month she wrote:

> I have commenced to dissect my third & last part. It is the head. It is getting to be so interesting that I often think it would have been a great deal nicer had I not been so often tormented by hunger & weariness.

The warmth of summer was long gone. The biting cold wind offered a taste of the miseries that were just around the corner. Putting in fifteen-hour work days and dealing with the resulting weariness was hard enough, but the fact that she was

also "tormented by hunger," took her suffering—and
determination—to a whole new level.

Meanwhile, in Calcutta, Gopal continued to make plans
for his voyage to America. Over the course of the year, since
Anandi sailed for America, he saved as much money as he could.
In addition to purchasing his ticket, he wanted to ensure there
would be sufficient funds to cover Anandi's expenses after he
left his job.

There was a possibility that he might earn money in
America. Dean Bodley had offered to help find him a position
teaching Sanskrit at an American university. However, the need
to make financial provisions was amplified by his plan to travel
via Singapore and Japan to San Francisco, and then overland
across America. This would require more time and funds than
a direct westward sailing.

Because Gopal did not expect to return to India in a short
time, he dismantled the home that had been his and Anandi's.
He sent their few belongings to Gangadhar Ketkar, his friend
and former brother-in-law. Shedding his identity as a
postmaster and householder, he donned an orange robe and
gave up footwear. Oddly, he seemed to want to garner attention
as a mystical Hindu; his reasons for that decision would become
apparent over the coming months. And so, on June 20, 1884,
Gopal boarded a ship, along with several hundred workers from
Calcutta, to Rangoon, the capital of Burma.

It is said that wherever the British expanded their empire,
they took Indians with them to operate their enterprise. These

workers ranged from menial laborers and shopkeepers to traders, lawyers, and other professionals. As a result, there were significant settlements of Indians in locations as far away as South and East Africa, Fiji, Mauritius, and the West Indies. In particular, Gopal was to benefit from the Indian presence in Burma, Singapore, and Hong Kong.

At most of his stops in the Far East, communities of Indians helped Gopal find room and board, and connected him with useful locals. He earned money, where possible, by giving lectures. In this manner, he managed to pay for each leg of his journey and to obtain letters of reference in order to establish his credentials at the next stop.

Gopal spent the second half of 1884 in the Far East. At each location he sent letters to Anandi and received her responses. He also mailed accounts of his travels to newspapers in India, describing his lectures and the communities of Indians he encountered.

How does a traveler choose what he will write about in letters home? A better question might be, what does a traveler observe when she finds herself in a new environment? Anandi's letters from on board ship had included descriptions of the scenery and of the different races of humans that she had encountered. She had also written about the treatment she received at the hands of her fellow passengers.

In contrast, Gopal's letters contained short descriptions of the Indian communities that he encountered—Bengalis in Rangoon, Marathis in Singapore, and Parsis in Hong Kong. He also wrote about the differences from the Indian norm that he found most impressive—public order and cleanliness, the status of women, and the stress-free relationships between Parsi em-

ployers and their Chinese servants. So impressed was he by the Chinese, that he wrote, "The Chinese need a capable leader. With such a one, they will build a country like no other people." He felt most gratified by the positive reaction of the Parsis of Hong Kong to Anandi's pursuit of a medical education in America.

In Rangoon, he was impressed by the independence of the local women. After visiting the city of Prome, he wrote admiringly that the women there were "as men":

> *Whatever I had been thinking and imagining since many years of what women ought to be able to do—I am seeing all that here. Women are engaged in trade and all other kinds of business. They can swim too.*

He was equally impressed by the cleanliness of the Burmese people:

> *The people here bathe twice daily. Their homes are very clean. If you come live here, you will not want to live anywhere else.*

Dejectedly, Gopal concluded, "I have never before seen people such as these. It is our people who make a mess."

Gopal's next stop was Singapore. He looked forward to going there because, even though it was still under British rule, it was not under the control of the British Indian government:

> *[It is a] free country, a country that has no English influence. It will be liberating to feel the winds of such a land.*

After spending a few months in Singapore and Bangkok, Gopal sailed to Canton and from there to Hong Kong.

In his letters to Anandi, Gopal did not mention that he was earning money by delivering lectures during his journey. Nor did he mention the reactions that those lectures garnered. If she had known about this aspect of his life, Anandi might well have been less eager to be reunited with her husband.

For example, in a lecture he delivered at Temperance Hall in Hong Kong, Gopal criticized Western civilization and especially what he saw as its pernicious effect on Indian society:

> By coming into contact with shallow Western civiliza-
> tion, we have morally, socially, and religiously degen-
> erated. Where before there was unity, there is now
> disunion; . . . where there was sobriety and temperance,
> there is now drunkenness. . . . We were very honest and
> faithful in our dealings and loving as brothers ought
> to be. We have become the greatest of liars, deceitful,
> fornicators and forgers. The civil and criminal courts
> in India will bear testimony to my statement. To tell
> lies and commit fraud is the order of the day.

He also denounced what he saw as the bait-and-switch tactics of Christian missionaries. According to Gopal, the missionaries first seduced gullible youth by offering:

> Golden chains and watches, polished furniture and
> white-washed houses. . . one God, no caste, all alike,
> moral precepts in the Bible, and the missionaries so
> kind and loving that they at times allowed these
> heathen lads to sleep on their own bed and eat from
> their own dish.

However, he claimed, all this changed after a successful conversion. Gopal was familiar enough with Christian teachings to present a particularly stinging metaphor to his Christian audience:

They could not imagine that the missionaries in India were sent by God to do what was practiced on Adam and Eve by that deceitful serpent in the Garden of Eden. Adam and Eve fell by eating the forbidden fruit at the cunning insinuation of a serpent. So these youthful lads were outcastes as soon as baptismal water was sprinkled on their heads. They were immediately told to live in outhouses intended for coachmen and butlers. No more admission to missionaries' dining tables or beds. These converts were then told to cut grass for their livelihood, or do some other drudgery."

If the converts expected to escape their lowly position in the Hindu caste hierarchy and live as equals to the missionaries, they faced a rude shock. Adding salt to their wounds, Gopal reported that the missionaries pressured converts to challenge the customs and traditions of their families and communities:

They were directed on pain of dismissal from the church to enter into the house of their parents and snatch away their wives. They were encouraged to go and defile Hindoo temples. They were advised to go and wash clothes where Brahmins were bathing. The missionaries have set children against parents, brothers against brothers, husbands against wives and vice versa. Converts are deadly enemies of their own countrymen.

The *China Mail* newspaper report chose to ignore Gopal's charges about missionaries. Instead, it offered a defensive response, strongly criticizing the treatment of women in Indian society:

Mr. Gopal is a Mahratta Brahmin, educated and trained in Western principles. . . . So great is his appreciation of

Western civilization that he has sent his wife to graduate at the women's medical college in Pennsylvania. He might have stated in his lecture that the condition of women in India is deplorable. . . . Debarred from the advantages of even the most elementary branches of education, the upper classes of the women are held captive in the harem, while on the lower classes are imposed menial offices and labour in the fields and markets. In no grade of society are the women permitted to eat with their husbands. Until Western civilization stepped in, this conjugal slavery of the softer sex went beyond the grave, for the widows had to immolate themselves with the dead bodies of their husbands.

Finally, given the prejudices of the time, the newspaper attributed Gopal's "withering denunciation" of Western civilization to "the native love of flowery language"—that is, a perceived tendency among Indians to exaggerate and issue emotional appeals.

But the ultimate blow to Gopal's credibility was the fact that, after realizing the hostile reception that the lecture received, he himself "disavowed it in a most singular nature." In a letter to the newspaper, Gopal backpedaled, speaking of the "barbarous condition" of his countrymen, and declaring that he himself did not necessarily subscribe to the ideas he put forth:

> *All that I stated represented the feelings of notable persons of Benares, Calcutta and Poona. I myself share very little of such feelings; but on the contrary I actually live on English ideas. In thought and taste I am Anglicised. In short I owe my present stirring life to English influence and civilization. And yet, I was quite justified in being a faithful representative of my people.*

The brazen absence of consistency in his public stances elicited the most damning indictment from the newspaper—not just upon Gopal himself, but essentially as a characteristic of his entire race.

> Mr. Gopal is enjoying to the full, the benefits of that Western civilization, which he has vigorously denounced one day and lauded the next, in a way peculiarly Asiatic.

Gopal went "viral" as a result of his inflammatory lecture and his public about-face. Many newspapers in a variety of countries featured the story over the coming weeks. Under the title, "As Others See Us," the *Straits Times* of Singapore made an effort to read Gopal's arguments more objectively and to understand his arguments from his perspective.

Conceding that he was "alive to the shortcomings of missionary work… and could frame as pretty an indictment against all missionaries in the East (as a body)…," the writer offered an argument in favor of Gopal's charge that British influence had caused the general degeneration of Indian society:

> In the presence of a stronger race, the weaker does degenerate in truthfulness and honor. The feeling that nothing but subtlety can steal a march on the European induces constant deceit.

However, in a final analysis, the *Straits Times'* indictment of Gopal's lecture was almost as harsh as that of the *China Mail*:

> The native falls back on two broad facts: that a hundred years ago his fathers were happy in their own way: and that now he can only be happy according to European ideas. … It is useless to tell him that order and justice have taken the place of desolating wars and fearful injustice. He does not want our order and justice, and in-

finitely prefers to take the chance of great success or great failure, in the old barber-who-rose-to-be-vizier style. Mr. Joshee is no doubt wrong; but how are we to convince his fellow countrymen of the fact?

At the start of 1885, Anandi returned to Philadelphia after spending the Christmas holiday in Washington, DC. She felt energized by the warm reception that she received from the many distinguished people that she came to know. However, the cold winter months again presented serious challenges.

She remained so "sensitive to the extremely cold spells" that she felt "somewhat timid to go out." In the interest of her health, and given the fact that the shortage of suitable foods often left her feeling hungry, she began to eat eggs.

Although not all Hindus are vegetarians, members of Anandi's Konkanastha Brahmin community were strict lacto-vegetarians. Milk products and honey were an integral part of their diet; however, they did not eat eggs or any kind of meat. Anandi may have allowed herself to be persuaded that unfertilized eggs did not violate the intent of Brahmin vegetarianism—to eschew consumption of the flesh of beings that had once lived.

Continuing to apply herself diligently to her studies, Anandi found that she studied best at night. Even so, she often fell asleep from sheer exhaustion. She learned to be patient with herself when she found herself struggling:

> *I only strive for all within my reach but do not struggle for what I could not digest or what my undeveloped brains or insufficient strength could not retain. For, everything must have its time. Prematurely born babes*

> *seldom live the longest, nor are the prematurely ripened*
> *fruits the best.*

Working tirelessly late into the night meant that Anandi was sometimes late to wake up in the morning. Dean Bodley, in whose home she was already living for more than a year, was displeased when Anandi was late to arrive at the breakfast table. When the "dear Prof." gave her "quite a sharp scolding [one day]," Anandi felt unfairly judged. Unable to offer an explanation to the dean, she offered it to Theodocia instead:

> *I do not care for any style, nor for vanity, but her word*
> *touched my pride, for I am always prompt & regard it*
> *as my pleasure as well as duty to be so. Besides it was*
> *Sunday & I did not hear the bells.*

Her need to vent assuaged by writing these words, Anandi quickly reverted to her habitual humility and discretion:

> *Please do keep it a secret & destroy this letter if you*
> *please for I do not wish to say anything against her.*
> *She is kind & loving to me.*

Bodley's irritation about Anandi's tardiness to breakfast was rooted, at least in part, in a different, more difficult disagreement. This was the issue of religion, specifically, Anandi's continued refusal to convert to Christianity.

When she first invited Anandi to live in her house, Bodley struggled with the question of where her Christian duty lay. Should she offer a home to someone who had publicly announced she would never convert to Christianity? Ultimately, Bodley extended her hospitality because she believed that if anything could change Anandi's mind, it would be her

experience of Christian generosity and kindness. After nearly eighteen months' time, there was no indication of the hoped-for change of heart. And so:

> *Prof. Bodley has commenced a few weeks since to talk*
> *to me on that "most serious" subject, "the Religion."*

With respect to Christian conversion, Dean Bodley's concern was not limited to Anandi. It extended to others who, although white and therefore *expected* to be Christian, seemed to have an "at arm's length" relationship to Christianity. These included Frances Coleman Smith of Warrensburg, Missouri, and Charlotte Abbey from England—the two women who were Anandi's closest friends at the college. Also of note, Bodley was not seeking a conversion "conquest" in the style of many of the Christian missionaries of the time. She felt genuine "pain and sorrow," wishing the best for her students; in her view this "best" meant accepting Christ. Bodley "never spent a Sunday without shedding a tear" for Anandi and her non-believer friends.

However, Bodley considered Frances and Charlotte beyond her sphere of influence, so she concentrated her efforts on Anandi. Bodley and her mother had conversations "too numerous to mention" with Anandi. Though Anandi felt irritated by this onslaught, she continued to engage in civil dialogue on the topic. Eventually, the issue came to a head when Bodley charged that Frances exerted a "bad influence" on her:

> *I asked her if she has observed any change in me and*
> *if so whereabout. She replied in the negative.*

Bodley's rationale, as she explained it to Anandi, was that:

> *You are taught to regard sacred things as very sacred*

and will understand me better than Mrs. Smith.

Anandi's response to this attempt to find common ground brings to mind her father's nurturing when she was just five:

> *I was first taught to receive the thorough rationale of anything before I accept it. If you give me reason to accept your theory I will be only too thankful to you. . . . After a long talk (no arguing) she asked or begged me to promise her to keep Sundays as long as I live. Of course, I could not do it. I am not prepared to insure my word even for one day, far less "life."*

It is hard to overstate the significance of Anandi's firm defiance in these exchanges. She was a student and an outsider. She was only too aware that she was a member of a club of one. Younger than both Bodley women by several decades, she was also a guest in their home. Though her nature was also to avoid friction and to "keep silent unless there be an attempt made to force an answer out of me," Anandi remained true to her own beliefs. She refused to relent.

Dean Bodley deserves approbation for not taking greater offense at what must have felt like Anandi's intransigence; she remained a gracious host. It is impossible to imagine what recourse Anandi would have had if she had had to confront the dean's wrath or even her withdrawal of hospitality. In a letter to Theodocia the very next day, Anandi wrote:

> *She is a dear loving woman, nor will I ever think of her with anything else but gratitude & love. She told me a day after to stay in bed & Catherine would bring me my break[fast], as I was not quite well. This will show that it was but of little consequence.*

Writing of her frustrations to Theodocia and knowing that

her words would be read with sympathy, helped Anandi weather this storm. Her final words on the topic, after her agitation had melted away, were full of insight: "I fear at times that the Prof. does not understand me as I do her." And, she expressed her love for Theodocia in heartfelt and eloquent words—*give my love to Uncle, Helena & Eighmie, & keep your own full share*—accompanied by flowers (in cold February):

> *I send you some flowers & I hope you will accept them*
> *(not as my love but) with my love for they might dry*
> *or spoil before you receive them.*

By the spring of 1885, Anandi had completed half of her course of study. The letters she wrote during that period attested to her emerging physician persona. She theorized that her cold was "due to the increased metabolism arising from the increased nervous activity. For, the nervous excitation liberates more heat and energy which tends to regulate the temperature by its action on external conditions." And, she diagnosed her own headaches thus:

> *I have a bad headache today My headache comes*
> *from another kind of ache that is to say it is a secondary*
> *affliction. I have taken bad cold in my throat which*
> *has found its way to ear.*

Anandi received a letter from Gopal in the middle of March. He sent it from San Francisco, and reported being exhausted by his very lengthy journey. It was almost a year since he left Calcutta, during which time he had passed through many different countries and cultures, none of which were

friendly to vegetarians. While Anandi worried about Gopal's health, he worried that his presence in Philadelphia might interfere with her studies.

So, once again she wrote to Theodocia. Should Gopal stay with her in the Bodley home? Anandi felt that he should, because her home-cooked meals were sure to help him gain strength. Also, since the upcoming term was expected to have a lighter load, she felt confident that his presence would not adversely affect her studies. Professor Bodley seemed amenable to the idea as well. Ultimately, though, Anandi wanted to know what her aunt thought. She clarified that she was asking only for Theodocia's advice and was not looking for help in meeting the expenses:

> *I am aware of my Bank Book but trust everything will be alright. I don't know what I would have done if I had not my dear Aunt to consult & seek advice from. I shall prize your advice & opinion above all others so do not forget to bestow them upon me. I beg you not to undergo any unnecessary trouble or expenses in this cause. But treat me as you would.*

Money was only one of Anandi's concerns as her reunion with Gopal drew near. She observed from his letters that he had become more mercurial and reactive. She would need to be cautious and mindful to manage his temper.

Even though she confided in Theodocia about almost every other matter, she could not bring herself to do the same regarding Gopal. Perhaps she feared their cultural divide was too great on this subject, even for someone as understanding and sympathetic as Theodocia. Or, Anandi may have wanted

to avoid prejudicing her against Gopal, whom she would soon meet. And finally, she may have hoped that Gopal would present his best side to those close to Anandi, so that her concerns might be unwarranted.

So, rather than discuss these matters with Theodocia, she wrote to Gopal, asking him how he expected them to greet one another when they were reunited. This was the single letter she wrote to him in English, and she offered no explanation of that choice. Was it because the content of the letter could be more easily expressed in English?

> *I will request you to direct me in your next letter how I am to receive you. In this country, even a distant relative such as second and third cousins is received with a kiss among women. Men seldom kiss men, but they do their sisters, mother, cousin, wife or daughter. It will astonish my friends or spectators not to find me kissing my beloved husband after such a long absence and separation from each other as we have suffered from. On the other hand, it might seem immodest for a Hindoo woman to kiss her husband before strangers...*

Anandi was the one with direct experience of American customs. Yet, she had to defer to her husband's judgment, or at least present herself as so doing.

Another issue that worried Anandi was her diminished fluency in Marathi. With the memory of Govind's rage the previous Thanksgiving still fresh in her mind—and only too aware of Gopal's temper—she tried to prepare him for this change in her:

> *I am sure you will feel amused, surprised and even angry. I can no longer speak in Marathi. It is entirely my own fault, of course. But, it was my intense desire*

*to become an expert in English as well as in medical
science. It is not that I have completely forgotten all
Marathi. I can still write in it, and speak and under-
stand. But, over the last two years, I have lost the habit
of communicating in Marathi. I had to focus on my
studies, to the exclusion of all other considerations and
the total immersion in English has almost transformed
my very tongue. Even so, I am sure that in about
twenty-four hours of exposure to my mother tongue [in
your company], my old mastery will return.*

She assured him that she would regain fluency quickly, but
would need his patience and help:

*As you know, I always concentrate my full attention
on whatever I am working on, and set aside that which
I was working on previously. So, if you are calm and
patient and talk to me in Marathi when we are alone,
you will be fulfilling my desire [for re-acquiring flu-
ency]. I hope you will not have the same reaction as
Govind-rao. He did not realize the changes in me and
I was not able to remedy those changes. I need a little
time to once again become fluent in Marathi, but un-
fortunately, no one seems to understand this nor the
need for understanding this.*

Finally, Anandi pondered the question of how best to earn
the money they would need for their living expenses. The
money that Gopal had been sending while employed was re-
duced and they needed to replenish that account. Although
Dean Bodley had expressed confidence that a position as a lec-
turer in Sanskrit might be found for Gopal, Anandi did not
think that this was a good option:

*I don't think it is a good idea to take a teaching position
without prior preparation. To stand up to teach before*

*a class full of students is to open oneself to criticism.
Plus, there is no guarantee that such a position will be
available. So, we must find our own means of support.
It might be a better idea to deliver lectures [about
India] and earn money in that way.*

This was followed by a clarification Anandi felt she needed
to offer:

*I am not asking for money so I can be decked in ex-
pensive jewelry. Rather, it is for the thing that I like
and value the most—my studies.*

Caught between her newer independent self and the
imperative to resume her role as the subservient wife of an
eccentric husband, Anandi was walking a tightrope walk that
she had no choice but to walk.

It took less than three weeks for Gopal's response to reach
Anandi. As she had feared, it was an angry and accusatory
screed. Her response reveals the true measure of her dilemma:

*I feel constantly observed and judged. In particular,
the missionaries see me as a challenge. "Mrs. Joshee is
exactly as she was when she first landed here. If there
is no change in her and she returns to India as such, it
will be a shameful thing for Christianity." This com-
ment by an Episcopalian minister will give you an idea
of how my every action is weighed and interpreted. So,
when I wrote to you about our first meeting, my pur-
pose was only to avoid confusion and prevent blame
from being attached to me. . . .*

She listed the various options for their first meeting and re-
stated her willingness to abide by his preference:

*If you wish me to hold your hand like a foreigner, I am
willing to do that. Or, if you now believe that I should*

do something I never did before—to timidly hang back like a Hindu woman—I am willing to do that as well. Or, if you wish me to be formal and only ask, "How are you? It is good to see you," I will do that. In any and all these ways, if you wish me to act like a subdued and modest Hindu woman, I will quickly retreat to my room and pretend to be no different from that type of Hindu woman. . . . I hope you don't find all these ideas ridiculous. My only thought is to make things easier for both of us.

Making things easier was not about Anandi's personal preferences or her judgment. It was only about her husband's preferences and his uninformed judgment.

It must have been paralyzing to know that any action she took opened her to censure either by Americans or by Gopal. Despite her educational achievements and considerable sacrifices and hard work, her enduring patience and grace, she would likely continue to be denied respect and authority, at least within her marriage.

In the matter of her finances and the decreased bank balance, she first offered Gopal a challenge:

Do you actually think that I have become greedier about money? Because that is the impression I get from your response.

Then, she presented a fuller accounting of their finances:

Previously, you were sending money and that is what opened the way for me to be educated. This is why I never had to ask for money before. But that option is no longer available and so I am forced to think of this issue. If arrangements can be made to pay for my education, I will not need even a single additional penny.

. . . Almost all of the money from the James fund is spent, and I have just $22 left. The scholarship support has ended. I am very careful about spending money. I have yet to pay Prof. Bodley $40 for my board. She is far from wealthy and if I were to not pay her, how would she pay for the food? Dear Aunt has so far not taken even a penny from me. If she had expected me to repay her, how would I have done that? I even thought of selling my gold necklace. But seeing that I would get less than ten percent of its value, I refrained.

Anandi also tried to prepare Gopal for expenses yet to come:

I have this golden opportunity to obtain an education and I am eager to obtain as much knowledge as I possibly can. But nobody will provide this knowledge if we cannot pay for it. I have not yet purchased any surgical instruments because these cost hundreds of dollars, which I do not have. However, I think you will agree that I must have these instruments before I start practicing medicine.

Her final words on this issue expressed a passionate argument for financial self-sufficiency:

Surely you don't think it is better to depend on help from others than to live frugally within one's means. I don't think you would ever prefer that. It may be that you think that my education is costing too much. If that is the case, the only option left is to stop my studies. But, this is something that neither you nor I would consider, even in jest. . . . So, when we stay with the Carpenters in Roselle, it is only right that we pay them for our food. This is because Mr. Carpenter is not that wealthy. I have not discussed this with them even once, because before now we did not have the ability to pay them. Their generosity and kindness have been so great

that we would not be able to repay them even if we
were to live to 200 years of age.

As a lone guest, a niece, and a protégé, Anandi had managed to convince herself that she was not burdening the Carpenters excessively. But she was much too thoughtful and proud to expect to continue in the same fashion after Gopal's arrival. The two of them together created a family and therefore the responsibility to be able to cover their expenses.

She was equally forceful about criticisms—first Govind's and now Gopal's— of her lack of mastery of her mother tongue Marathi.

> *I feel very pained by your mistaken understanding of*
> *my words. I did not intend to suggest that you treat me*
> *badly. I was only trying to tell you that Govind-rao's*
> *reaction was very unfair. He thought I had become un-*
> *patriotic and suggested that I should not bother to re-*
> *turn to India. This criticism was very unfair and*
> *further, I believe that I should now be considered bey-*
> *ond such judgment. . . . You will recall how few op-*
> *portunities I had had to speak in English and how*
> *diffident I was about having to do so. Yet, in less than*
> *24 hours after leaving India, I managed to start speak-*
> *ing grammatically correct English and that too without*
> *stammering or hesitation. So, a transition of 24 hours*
> *should be ample for me to start speaking fluently in*
> *Marathi.*

Unbowed by his dislike of receiving advice from her, she continued to offer exactly that:

> *I am not suggesting that you give up your personal free-*
> *doms. However, I will continue to provide input and*
> *I hope that you will at least consider it. For exam-*
> *ple, in this country, a foreign visitor is always pursued*

by reporters. I am sure you have already experienced this. So, I request that you be very careful about offering your opinions.

Finally, and in spie of these prickly issues, Anandi ended her letter on a positive note:

I do not expect you to meekly accept anything and everything that I, or others, tell you to do. If I see you doing that, I would feel really sad. I respect openness, personal freedom and courage. Without these, nothing else is possible. So, do please, hold on to these traits. I have been deprived of seeing you in this persona for too long. . . . No, I don't want you to stay away until I graduate. Please join me here as soon as possible. All others are eager to meet you as well.

Was her expressed longing rooted in the hope for greater harmony, or was it Anandi's love for the person who had been the primary forcebehind her valuable personal evolution? Only time would tell.

GOPAL IN AMERICA

The moment our dignity is undermined, we get up in arms and want to see our dignity restored - especially if we are humiliated.

Desmond Tutu

*W*hen Gopal landed in San Francisco, his "huge oriental turban of many folds" attracted considerable attention, not least because "he wore it constantly" and because it was "the only thing especially remarkable about his costume." This suggests that he chose a combination of Eastern and Western attire, the better to be noticed while also seeming approachable.

Public lectures became popular in New England beginning in the late 1820s. The Lyceum Movement, as it was called, "spawned adult education in America, with public forums that promoted thoughtful conversation and education about the intellectual and ethical questions of nineteenth-century society." These lectures also disseminated information about the latest scientific innovations. Among well-known Lyceum speakers were Abraham Lincoln, Susan B. Anthony, and Mark Twain. By 1885, when Gopal landed in San Francisco, such lectures had become "a commercial enterprise and [a] desirable platform for celebrities who wished to expand their incomes from lecturing."

So, it was not long before Gopal started receiving invitations

to deliver lectures. He soon had a platform for airing his opinions, enhancing his celebrity, and earning money. Gopal's exotic attire and strong command of English presented an intriguing contrast. That he was the man who defied social custom by supporting his wife's medical education added to his celebrity. Lecture organizers probably expected a speaker who would thoughtfully discuss issues such as women's education and British rule in India; instead they got a speaker who espoused quite different ideas.

A lecture at the Teachers' Institute in San Francisco was "mostly composed of young lady teachers." As reported in the *Domestic Monthly*, in the first part of his lecture, Gopal focused on the status of Indian women:

> He said that his own idea was that ignorant wives were much preferable to educated ones as they made much better slaves; that is, they performed their duties with greater contentment and reliability and were not continually opposing their own views to those of their husbands thus causing the dissension so frequently seen in more enlightened households.

He continued his rant by also offering a critique of American women:

> He thought there would be less of gadding about which he noticed upon the streets here if there was less of this placing women above their sphere. He had especially noticed the great crowds of handsomely dressed ladies constantly promenading on the thoroughfares who seemed to have no care and no thought of home duties or household responsibilities. This was a condition of things that would not be for a moment tolerated in Bombay.

This was too much for one young woman, who challenged
Gopal by asking about his "educated wife now in Philadelphia
studying medicine." If the audience expected a tortured attempt
to reconcile two diametrically opposed positions, they were
disappointed:

> To this he naively answered Yes and joined heartily in
> the storms of laughter that followed.

Through his glib response and lack of embarrassment by
the audience's laughter at his expense, Gopal was establishing
himself as an unreliable and untrustworthy speaker. He
cemented this impression by painting a completely false picture
of Indian society:

> He explained that there were a few very intelligent and
> finely accomplished ladies in India who had received
> their education from the government schools established
> by the English throughout the entire country but he
> thought it was all a mistake.

Worse, Gopal even gave his audience good reason to
question the Brahmin brand that he had earlier tended with
great care. As the writer opined:

> It is very evident that the civilization of the Brahmins
> about which we have been hearing so much of late has
> been woefully overstated.

The *Domestic Monthly* did not react to Gopal's unexpectedly
outrageous views the way the editor of the Singapore newspaper
had. It allowed only that Gopal's address had "thoroughly
entertained" the large audience. But this was the low-grade
entertainment of a freak show, rather than the earnest, high-
minded engagement a thought-provoking, inspiring lecturer

might have provided.

Gopal soon realized that Americans' interest in him went beyond his credential as the husband who had supported his wife's education. They were eager to know about Hinduism, particularly in relation to Christianity. They were curious about his views of British rule and geopolitics. Not beholden to consistency, unfazed by ridicule, and eager to poke the "establishment" in the eye, Gopal accepted lecture and interview requests with gusto and proceeded to voice his provocative, contrarian views.

The April 20, 1885, edition of *San Francisco Chronicle* carried a story titled, "A Brahmin Theologist: A Hindoo Talks Religion and Politics." When asked to describe his religion, Gopal addressed head-on the many arguments used by Christian missionaries to denigrate Hinduism. He asserted that all Hindus were "idolators" and worshiped animals as well. Gopal provided the context for such practices—idols were respected as the images of ancient and wise men who had left behind important records; animals were worshiped for their power (the serpent was the symbol of eternity, whereas the cow was a mother who nursed the newborn with her milk).

Gopal's cogent explanation could have changed readers' minds about Hinduism. However, his blunt assertion that "Our religion is better than yours," could hardly have convinced anyone or won him supporters.

A reporter asked Gopal: "How do the various nations or classes of people feel towards England?" He described Gopal's quite forceful response with the inclusion of a racist idiom of the time—"The dark eyes of the Hindoo glittered savagely...":

It is not possible that we should be friendly. They have

done us no good. Their policy is to rob us right and left.

Gopal added to his list of bitter grievances against the British, including his belief that over ninety percent of the revenue collected in India was remitted to England, and that the rule of law did not apply to the British in India. He pointed out that unlike the Russians who allowed "Turkmen" to become officers, the British government did not allow any "natives" to assume positions of authority. When asked if the Indians would take part in the Anglo-Russian war, Gopal called the British "a nation of bloodsuckers" and said that his countrymen "would choose to be mere onlookers and would be glad if the English got whipped."

Gopal's next important stop was Sacramento, where he tried a different tactic. After patiently answering the questions posed by a newspaper reporter, he assumed the role of the interviewer and asked questions about aspects of American life that he deemed strange. A story was published in the *Sacramento Bee* under the headline, "American Institutions as seen through Hindoo Glasses."

The reporter generously characterized Gopal's questioning as being of a "masterly and approved style" and noted that Gopal "struck him as being decidedly curious." The reporter wrote that Gopal "propounded questions that indicated [that] he was a close observer and possessed of the philosophical yearning to get to the bottom of things."

Gopal's questions ranged from trying to understand the economics of running a newspaper ("circulation, influence, running expenses, salaries of writers, etc.") to the "restless" spirit

of Americans, especially the rich men:

> Your people are so restless. You never stop working, no
> matter how rich you become. I actually know a wealthy
> American who works eighteen hours a day and takes no
> vacation, and he will die working. It seems most extraor-
> dinary. The result of habit, you say? Well, I suppose it
> is. But, it is indeed a most miserable life. I would not
> be a Stanford nor a Crocker and work so hard.

Gopal was referring to Leland Stanford and Charles
Crocker. Stanford later founded Stanford University but, as a
politician and railroad entrepreneur, was eventually considered
by many to be a robber baron. Crocker was a banker who part-
nered with Stanford in funding and running the companies that
built the transcontinental railroad.

Gopal contrasted rich American workaholics with upper-
class Indians:

> They always have happy, peaceful expressions on their
> faces. The richer a man becomes, the less he works. . . .
> The merchant takes life easy, and when he becomes old
> and well-off, he retires in favor of his sons. . . . He
> must... care for relatives, give in charity, etc. or lose
> caste. So he spends his money while he lives and does
> not leave it, as do many Americans, to charitable insti-
> tutions after their death. That is so comical.

Gopal had only been in America a few months. In that
time, he had interacted with a limited cross-section of
Americans. He had acquired a rudimentary understanding of
American society from reading newspapers and being
interviewed by reporters. His perspective on American society
revealed his still narrow understanding of the breadth of
American experience, as well as his strong propensity to judge,

without an awareness of his limited view.

The contrasts between his and Anandi's temperaments are striking. With her arrival just two years earlier, Anandi worked to assimilate (attending church with the Carpenters, playing with Theodocia's daughters, becoming familiar with those in her community), openly shared her culture (the lunch given in the Carpenter home) and adapted to a whole new lexicon of manners and customs (hugging when greeting a friend). Unlike Gopal, she held her frustrations and judgments close, giving them expression only when vigorous attempts were made to convert her or to challenge her customs or culture (such as child marriage).

It is to his credit that the reporter who was interviewed condescendingly by Gopal noted that he had "acquired a great respect for Joshee's abilities as an interviewer." Indeed, the unnamed reporter further suggested, without judgment, that "the Brahmin Joshee could add a most entertaining lecture to his repertoire on American Manners and Customs as Seen by a Hindoo."

Thus, Sacramento was a relatively congenial sojourn for Gopal, without the acrimony he stirred in San Francisco and, subsequently in Salt Lake City.

Gopal arrived in Salt Lake City on June 17, 1885, exactly one year after he set sail from Calcutta. He stayed with Brother Wm. Willis, whom he had come to know during their voyage together between Hong Kong and Japan.

The *Salt Lake Tribune*, the newspaper of record in the Mormon heartland, published a story about Gopal that included the standard coordinates about him—his "high caste,"

his wife being educated in Philadelphia, and his journey through the Far East. However, the account provided an additional data point: that he expected to lose his caste affiliation and was not bothered by that:

> He is of the Brahmin or the highest caste of India, but through sailing abroad and mingling through people who are defiled in the estimation of his race by indulging in a flesh diet etc., he has lost his caste and could never regain it if he were to return to his native country. . . . In India a Brahmin is not allowed to even receive a drink of water from the hand of another caste. This, of course, he has had to do since leaving home. And, by the way, he seems by no means downcast at having fallen in this particular, for he has come to the conclusion that the East Indians go somewhat to the extreme in the matter of class restrictions.

Since he hoped to convert Gopal to Mormonism, Willis found Gopal's misgivings about Hinduism promising. He invited Gopal to stay in his home. But within just a couple of weeks, Willis concluded that a conversion would not be forthcoming. He extended an ultimatum to Gopal—if he expected to remain under Willis' roof, he had to become either a Mormon or a Gentile (a Christian of some other denomination). Ironically, Willis failed to notice that Mormon intolerance of and rigidity toward non-Christians was not so different from Brahmins' attitudes toward non-Brahmins. Of course, Willis could only perceive the former as rationally based.

The *Salt Lake Tribune* account of this disagreement was leavened with open-mindedness and a sense of humor:

> The heathen, the greater Christian of the two said: "Poppa Willis, I came to you as a heathen and a friend.

So far as I am concerned, I leave you as a heathen and a
friend." . . . Small as the Hindoo is, it seems he is too
big a toad intellectually to be swallowed by the Rocky
Mountain viper though he had been well slimed over by
it. . . . To a Tribune reporter, he laughed heartily at the
narrowness of the elder and remarked that it was noth-
ing, simply human nature, for which he was ever tol-
erant and charitable.

There was another story about Gopal in the day's newspaper
titled "The Hindoo Tiger Hunts His Christian Foe." It featured
a lecture delivered by Gopal, titled "The Religions of India,
Contrasted with Christianity and Mormonism," which drew a
large audience.

Gopal opened his talk by praising Mormons for being "near
the truth and universal brotherhood" and noted that, although
they tended to harbor some prejudices, these could be easily
"reconciled." Gopal even allowed that he considered himself a
Mormon in belief. However, he quickly pivoted to bitterly crit-
icizing Christians, particularly missionaries. He railed against
the Mormon founders Brigham Young and Joseph Smith for
"the palaces they had built for themselves and left the poor in
dungeons."

Gopal expressed agreement with the practice of polygamy,
noting that the Hindu god Krishna had "ten thousand wives."
He went on to state that he was also in favor of polyandry—a
woman taking multiple husbands. This shocked some of the
ladies in the audience, who left in a huff. When a suggestion
was made that he speak of something else as "his discourse was
offensive to a large portion of the audience," there were con-
trasting cries of "Go on," "He is telling the truth," and "Free
speech!" Clearly, though some in the audience took offense,

others were keen on hearing an original and irreverent take on Mormon practices. Like the reporter in Sacramento, at least a few people in the audience were not unhappy to be introduced to a new way of looking at their own customs.

Gopal continued to nurture his "brand" like a fine-tuned musical instrument. He figured out just the right mix of pandering and challenge, information and opinion, and humor and modesty to engage, and even titillate, his audiences. As a risk-taker and iconoclast, he gradually freed himself of the need to be consistent, polite, or even gracious. It surely did not appear that the possible effect of his conduct on Anandi gave Gopal any pause.

Back East, when Caroline Dall read the newspaper reports, her view was that,

> Mr. Joshee could have had a very inadequate idea of the interest Anandabai had aroused in this country, and he could have understood very little the character of his wife, if he expected her to be pleased by fun of that sort.

Dall discussed the matter with friends, all of whom were "troubled." They readily understood that Gopal's inflammatory words and flippant attitude would leave Anandi in a bind—she would be unable to either distance herself from him or to reconcile his persona with hers. Dall immediately mailed the newspaper to Anandi, to warn and prepare her for the inevitable reactions and questions she would receive. When she and Anandi met soon after, Dall noted the effect that the newspaper reports had had on her friend:

> The moment we met. . . I knew that she had seen the

paper. A change had passed over her as subtle as that the
hoar-frost breathes over the summer grass.

In the summer of 1885, Anandi returned to Roselle to
spend her vacation with the Carpenters. Awaiting her
husband's arrival, she tried to carry on as normal a life as
possible, burying her anxieties in a corner of her heart. One
afternoon, she was visiting friends with Eighmie, the
Carpenters' older daughter (by now a preteen), completely
unaware that her husband's arrival was imminent. We can only
imagine her shock when, upon returning home, she saw her
husband coolly sitting in a chair reading the day's newspaper.

This is where the camera pulls away. The members of the
Carpenter family left the couple to themselves. All that is known
is this: in that moment, if only for that moment, all the
acrimony between Anandi and Gopal melted away as they laid
eyes on each after a separation of two years.

The rest of the summer was spent in relative harmony.
Gopal was in frail health after the year-long journey. With the
Carpenters' hospitality and Anandi's familiar home-cooked
food, he soon recovered his strength. The hosts took their new-
est guest on picnics and excursions. Knowing his penchant for
criticizing America and Christians, they tried to show him the
best of Christianity in America.

One notable outing was to Brooklyn to visit the churches
of two eminent ministers of the day—Dr. Thomas Dewitt Tal-
mage and Henry Ward Beecher. Both were very successful,
high-profile preachers, whose congregations numbered in the

thousands. Both were known for offering a combination of theater, preaching, and purpose.

Attending Rev. Talmage's sermons was one of the most popular religious experiences of the era. Although the tabernacle had been built to seat large crowds, hundreds were turned away every Sunday. Talmage had a reputation as a reformist and as a crusader against vice and crime. As such, important people across both the United States and Europe called upon him to seek advice. His sermons and lectures were published regularly in three thousand journals and reached twenty-five million readers. In a country with a population of just over fifty million, Talmage's reach could be compared to that of several present-day news channels combined.

Rev. Henry Ward Beecher was the son of the famed minister Lyman Beecher and brother of the famous author of *Uncle Tom's Cabin,* Harriet Beecher Stowe. His Plymouth Church, with a capacity of three thousand seats, regularly had a packed house. It was even a tourist attraction for people visiting New York City. Beecher was a supporter of most of the progressive movements of the time—women's suffrage, abolition, and Darwin's theory of evolution. He spoke out against the Chinese Exclusion Act of 1882, recently enacted American legislation which severely restricted immigration from China. Over time, Beecher even rejected the Christian belief in hell, emphasizing instead God's forgiveness of human sin.

The promise of a spectacle and the chance to participate in a popular cultural and religious phenomenon might have prompted the Carpenters to take their visitors to visit these two churches. Particularly in the case of Rev. Beecher, his views were very closely aligned with their own Spiritualist beliefs, which

might have provided a further draw. The visit may have also been an indirect attempt to show Gopal the best of high-minded and purposeful preaching, with the hope of influencing his energies in a more productive direction.

Indeed, there is some indication that the two ministers already knew of the Joshees and thus personally met them at the conclusion of each service. Unfortunately, as proven by later events, neither the experience of those church services nor the audience with those esteemed ministers had thehoped for effect on Gopal.

The family's final stop was at the vast Green-Wood Cemetery, which is now a National Historic Landmark. Even in the 1860s, its four hundred seventy-eight acres of hills, valleys, glacial ponds and paths, throughout which existed one of the largest outdoor collections of nineteenth- and twentieth-century statuary and mausoleums, attracted more than a half-million yearly visitors, second only to Niagara Falls. Crowds flocked there to enjoy family outings, carriage rides, sculpture viewing, and natural beauty. The concept that people who had passed on should reside in a beautiful abode for eternity made a strong impression on Anandi. It was a stark contrast to the Hindu custom, which did not offer the departed individual the solace of eternal rest in beautiful surroundings. Hindu custom also did not offer mourners or survivors a place to visit the departed, offer respects, or seek comfort.

Anandi returned with Gopal to Philadelphia in late

September 1885. He moved into her quarters at the Bodley home and she resumed her studies. These would be her last six months as a student. Unfortunately, it would prove to be one of the most challenging periods of her American sojourn. Anandi developed severe headaches and a "pelvic affliction." These physical difficulties adversely affected her ability to attend lectures and to study. However, the worst challenge may well have been facing her deteriorating relationship with Gopal.

One Friday, Anandi was in so much pain that she attended only one lecture and then stayed in bed the entire weekend. Unable to sit or walk without significant pain, she came home from school "resting on Miss Abbey's arms." Treatments of "fomentations, Sitz baths, and poultices" brought little relief.

No longer wishing to cover up or excuse Gopal's behavior, Anandi wrote to Theodocia about his acts of both commission and omission while she was sick in bed. "My husband goes out in the morning and comes home at night every day, so he is out as usual." Not only was Gopal not taking care of her in her illness, he also refused to help her catch up with her school work.

> I have to copy a great deal of the lectures I missed during my illness before morning. I requested my husband to help me a little in it but he positively refuses to comply to such indulgences as he calls them.

The long-shared purpose of her medical education seemed to no longer bind Gopal to Anandi. He was telling her through his actions, even if not in words, that she was now on her own.

Gopal's trip to Washington during this time further demonstrated his disregard for Anandi's studies and ill health and his standing in the community. He visited Caroline Dall's home, and as she was out, was met by a friend of hers:

> This lady, who had been greatly attracted to his wife,
> looked at him sharply and said, "Was it you, then, who
> made that speech in San Francisco?" "Yes," replied
> Gopal. "And what did you do it for?" she persisted. "Just
> for a little fun," was the answer. "I thought I would stir
> them up a little."

By mid-November, Anandi's health had barely improved. She reluctantly canceled her plans to go to Roselle for Thanksgiving:

> *The long trip may tire me so much that I am afraid it*
> *will cast off a large part of my pleasure. . . . My health*
> *is improving but I am far from being well yet. I am*
> *trying to save every bit of strength. I am not doing 1/3*
> *the amount of work I did last year. I am simply keeping*
> *up with lectures.*

Fortunately, Anandi had recovered sufficiently by the middle of December to go home for Christmas. But she was in the dark regarding Gopal's plans. Caught between the breakdown of communication with Gopal and her desire to be a thoughtful niece to Theodocia, she chose the latter:

> *I do not know where my husband will be because he*
> *does not tell me anything about his plan in this par-*
> *ticular matter.*

It is not known if Gopal accompanied Anandi to Roselle for Christmas, but regardless, Anandi had a comfortable stay with the Carpenters. She used the time to work on her thesis and Theodocia helped her "correct"—that is, edit—it.

Anandi returned to Philadelphia in early January 1886, anticipating her graduation, which was only a little over two months away.

13

COMMENCEMENT

*The future belongs to those who believe in the beauty
of their dreams.*

Eleanor Roosevelt

Graduating students were required to write theses "on some subject which has direct application to medicine." In keeping with this guideline, students in the class of 1886 chose review topics with titles such as "Clinical study and medical knowledge," "The uterus" and "Some notes on criminal abortion." Other theses focused on investigations of jaundice, "Cholera infantum," and on uses of emerging technologies, such as the clinical thermometer and the ophthalmoscope.

The title of Anandi's thesis was "Obstetrics among the Aryan Hindoos." (In Sanskrit and related Indic languages, the word *arya* means "noble" and is a reference to the roots of Hinduism in the ancient Aryan civilization.) The thesis was an exposition of Hindu beliefs and practices covering everything from the earliest signs of pregnancy to diseases of the newborn. Written in her beautiful cursive, it came to fifty pages—the maximum permitted length. It quoted ancient Hindu sages and medical practitioners such as Dhanwantari, Susruta, and Charak. Anandi included anecdotes and remedies culled from her personal experiences and cultural knowledge. She described

prevalent practices relating to hygiene, diagnostic techniques, and surgical practices. Ayurveda, the ancient Hindu science of life and health, formed the underpinning of much of this medical knowledge.

The thesis described the use of turmeric combined with sesame oil to cleanse a woman's body immediately after the delivery, and to massage the newborn. Other ingredients mentioned for medicinal use were black mustard powder, orris root, honey, opium, asafetida, long pepper and its root, dry ginger, and milk. The minerals used were iron, "copper sulph," "zinc sulph," and mercury.

The use of broth from wild animals (noted as not available to Brahmins), cow's urine, mare's and ass's milk, and powdered deer antler were also noted for their healing properties. Spirits were deemed effective for "general feebleness." Ice was to be employed to aid a woman's fragile pregnancy—ingested for its cooling properties and externally applied as an astringent.

Considering the fact that it never snows in most of India, the mention of ice is startling. The story of an enterprising Bostonian, Frederic Tudor, reveals the explanation. In the 1830s, Tudor figured out how to ship blocks of ice, harvested from frozen Massachusetts lakes and ponds, to places as far away as New Orleans and Havana. When that proved successful, he extended his "sales territory" by shipping ice to cities as far away as Calcutta, Madras, and Bombay. Of the ice houses built at the time in those three cities, the one in Madras (present-day Chennai) remains to this day.

Within a few decades, the use of ice had expanded beyond British officialdom. By the late 1870s, "ice-making technology had improved to the point where it was possible to manufacture

ice cheaply in India" and "new domestic technologies (ice chests) were developed to store ice in people's homes." Soon ice had made its way from cold drinks to medicinal uses, at least for the well-to-do, including some Indians.

Anandi's thesis detailed various strategies employed to ensure hygiene and prevent contagion. Attending physicians and midwives were expected to keep their nails cut short and their hands and bodies clean.

The pregnant woman was advised to avoid eating stale food. In a tropical climate and without the benefit of refrigeration, food spoiled quickly. In addition, food left standing could attract ants and other insects, some of which might carry bacteria or disease. Thus, eschewing stale food was a ready way to potentially prevent food-borne and other illnesses.

Anandi wrote about how the new mother was forbidden to drink milk or water that had not been previously boiled. The reason for this was based on the Ayurvedic knowledge of bacteriology:

> The ancients strongly believed that "the atmosphere is densely populated by germs of infinite variety and minuteness and can never be seen by the human eye. These can be destroyed by heat and fumes of certain resins, hence the boiling process."

A separate room in the house was designated for the new mother, where she remained in relative isolation for four months. The circle of people allowed to visit her was expanded very gradually. And, visitors were required to wash their hands and feet "in certain disinfectant waters" before entering the

room.

Anandi's thesis summarized diagnostic techniques available to the physician using the physical senses of touch, hearing, vision, taste, smell, and speech. Of these, the most interesting one was taste—not the patient's or the physician's, but that of red ants. It was used to detect excess sugar in the body:

> Taste will decide the constituents of the urinary secretion as the red ants are found to be very fond of sugar.

In addition, experienced physicians were known to be adept at reading and interpreting the patient's pulse:

> I have known at least two native physicians positively decide pregnancy from the pulse alone while in one case of my personal acquaintance there was no other sign present.

Finally, the thesis mentioned an obstetric surgical procedure handed down by *Susruta*, an ancient practitioner of Ayurveda. Akin to Cesarean sections, it is as challenging to read as the descriptions of surgeries performed during the Civil War. Performed without the benefit of anesthesia or other pain-thwarting procedures, the Ayurvedic practitioners used "silver or gold wire or silk" to "close the wound with sutures."

When writing her thesis, Anandi relied on several books she had requested from India. Ironically, some of these books were a result of the British presence in India. British doctors, sent to India to care for the British military, gradually paid heed to the practices of Hindu medicine. They concluded that there existed in Sanskrit "many tracts of merit... on the virtues of plants and

drugs and on the applications of them in medicine, the knowledge of which might prove beneficial to the European practitioner."

However, these "scholar-surgeons" gradually settled on a more cautious regard for Ayurveda. Though it was a centuries-old "advanced scientific system," they came to see it as having fallen into some decline due to a tendency on the part of its practitioners to be "satisfied with the knowledge and power acquired in the past," and the superstitious reliance of the ancient texts on "religious sanctions and cultural cosmologies." Thus, the resulting preference of the practitioners to see medical knowledge as a "gift of the gods" —and thereby, essentially immutable, and beyond testing and disproof—doomed many of their otherwise sound, wise findings to somewhat lessened credibility and prevented them from further evaluation and development.

Unfortunately, Anandi's thesis reinforced the validity of some of these conclusions. In the course of extolling Hindu medical knowledge, she uncritically described some practices that were based essentially only on superstition and religious dogma. For example, the thesis contained recommendations that practitioners and patients resort to prayer. And worse, in the event a baby was born with "undesirable traits," the mother was deemed responsible:

> If the mother is emotional, selfish or generous so will be the child. Prayers should often be repeated by the woman. . . for the child's physical, mental, moral and psychical cultures, nay its very existence is dependent on its environment and the mother's condition.

On the other hand, Anandi also included many sensible

"rules" to ensure the well-being of a pregnant woman:

> Woman from the time of conception should be kept
> pure and happy. She should not fast, retch, drag or lift
> heavy things. She should avoid stretching, violent
> exercise, grief, fear and anger. She must not be fright-
> ened, nor hit at even in joke, as it will either produce
> abortion or leave an unerasable mark on the person of
> the baby.

These rules also encouraged parties and celebrations to en-
sure a pregnant woman's emotional well-being. If the rules were
not followed, the result was retribution in the present:

> All these rules. . . must be observed in order to avoid
> any catastrophe and disaster such as making the fetus
> congenitally deaf, dumb, blind or deformed.

as well as in the hereafter:

> The rules are laid down by Manu the great Aryan Legis-
> lator, Susruta and other physiologists. They say, "trans-
> gressing them means committing sin."

In this arrangement, a carrot-and-stick approach backed by
religion was used to encourage a woman's family to prioritize
her health and well-being during pregnancy.

Anandi was about to graduate from an American medical
school. She would soon return to India to practice medicine,
equipped with all the Western medical knowledge she had
acquired at significant risk and with the greatest fortitude and
courage. And yet, she had chosen a thesis topic that extolled the
beliefs and practices of the ancient life science that was
dominant in her country. Recognizing that her professors might
find her choice of thesis topic puzzling, she provided

clarification in the very first paragraph of her thesis:

> Since our study naturally embraces the cause and effect,
> race, habits, climate influences, and means of assisting
> Nature in her operations, we must not entirely overlook
> the history of past ages, and consider the superior
> minds, which labored, with marked success, in the same
> field of investigation, under the promptings of the same
> motives, as far back as 15 century B.C. They may enable
> us to the better appreciation of the science and pay due
> respect to the discoveries, theories & mode of applica-
> tion of remedies of minds of different nations at differ-
> ent times.

She called attention to the "superior minds" and the
"marked success" of her Hindu forbears. She wanted to
"appreciate their science" and "pay due respect" to their
discoveries. Her closing sentence, "I therefore need not
apologize for choosing this subject," was uncharacteristically
assertive.

The Indian Anandi, the one who wrote bold and impas-
sioned letters to Theodocia, would have rejected practices—
such as prayer and assigning blame—that were based in
ignorance and superstition and that therefore led to more suf-
fering. *That* Anandi would have offered a nuanced explana-
tion—for example, that given the low status of women in the
society, this "stick" was necessary to ensure pregnant women
were treated kindly and that they received proper prenatal care.
But, clearly, it was an essentially different, evolved Anandi who
wrote this thesis. What was at the root of this change?

Perhaps one reason was that Anandi was once again in
Gopal's orbit. Given her seriously failing health and weakened
state, as well as his unsympathetic behavior, she may have chosen
a path of lesser resistance. She may also have felt a need to assert

that her culture, too, deserved to be acknowledged and respected for many of its ancient contributions to the world's store of medical knowledge.

In any case, Anandi's thesis is an important historical document that provides at least a snapshot of Hindu obstetrics during the latter half of the nineteenth century. It also highlights the extraordinary internal tug-of-war Anandi experienced in her attempts to acquire modern knowledge, while not mindlessly jettisoning her ancient inheritance.

As Anandi was rushing to complete her graduation requirements, her relationship with Gopal continued to worsen. In her letter of January 14th, Anandi lamented that Gopal had blamed her for delayed letters, even though in her view, it was he who had waited an "undue" length of time to answer them. "I suppose it is all right" she wrote, signifying silent resignation. But, matters were far worse than this instance suggests, for Gopal was not above harshly criticizing Anandi, even in a public setting:

> My husband came to see me at the College this afternoon with the attitude. . . of a severe critic. . . . The criticism I doubt not was rational. . . but I must confess it was too harsh for my sensitive nature.

Gopal was incensed about what he saw as her emergent college-educated personality:

> He said I am in habit, nay am fond of writing or speaking in "College airs."... Mr. Joshee when he finds nothing wrong at present, scolds me for things which certainly will not occur for several years yet & perhaps never.

Anandi surely wrote that letter in a state of anguish and despair. She opened it with the words, "Pardon me for the style of this letter & the objects it is intended to convey. ... I did not wish to utter a word to anyone but [rather] swallow everything as is my practice." Only a few sentences later, overcome by a rush of emotion and, gearing up for what she still had to confide, Anandi sought confidentiality. "I beg to say to you what I wish not to be repeated."

The rest of her letter—through its beautiful language, and the thoughtful ideas and sentiments expressed—ably refutes Gopal's thoughtless charges against his young wife.

Regarding his criticism of her writing style, she conceded that she did not possess the "art" of good writing. Nonetheless, there was a subtle note of defiance in her words. If her relationship with her husband had been even slightly more equal, she might have used them to resist his charges.

> *As to the style it is beyond my power. I was not naturally gifted with it and cannot acquire it by art. Art I love much but that I was not intended for it is the plain solution of the question. It shall always receive due respect from me, but never mourning because I am not the master of it.*

In an attempt to reclaim her self-worth and equanimity, Anandi affirmed her own guiding philosophy.

> *Whether I have much or little to do, it shall always be for the happiness & comfort of those I love. I am bound by duty to be busy whether I say so or not and therein alone lies all my pleasure and happiness. Love and duty are sacred and my own properties. I can always love though I cannot claim to be loved always. So I can always perform my own duty as well as lies in my power*

though I cannot make others do theirs.

Only slightly veiled in her passionate sentiments was a gentle rebuke of the one who was failing to love her back and do his duty. She clarified that her own devotion to duty was intrinsically motivated, not by promises of heavenly rewards or even earthly riches. By articulating this, Anandi was claiming some moral high ground, while trying to simultaneously maintain her sense of self. Her words seem also to attempt to offer herself solace.

> *I do not do them for the promise of any earthly pleasure nor even for those termed Heavenly but for their own sake & my promise to them. Heaven, if it is only for its riches & banquet & no duty has no charm for me for the riches well may fade away but leave us overwhelmed [and] paralyzed in an unacceptable slumber only to make us more & more miserable for the future*
> *...*

Finally, Anandi reminded herself to primarily live in the moment, to focus her energies on immediate priorities, and to not worry about what might occur in the distant future:

> *It is always well to look far in future. Just far enough to guide our steps and prepare for any immediate obstruction which may be in our path & need prudent action on our part. But I think it is foolish if not worse to mourn for the future which is probably to come when the Present claims our care, attention & strength.*

While Gopal had traveled in the Far East, Anandi had written a few strongly-worded letters to him. The brief period between her getting acclimated to American life and his arrival in America may have been the high point of her selfhood and

agency. Sadly, even on the verge of receiving her longed-for diploma, to attain which she had labored for almost half her young life, Anandi was forced to relinquish those hard-won traits at some level.

The man who resorted to physical abuse to force his very young wife to study was now punishing her for becoming an educated woman. Gopal had become thoroughly consumed by a toxic combination of petty jealousies and damaged ego, caring not if he hurt the very person who had bet her body, mind, and soul for his quixotic ambition.

Dean Bodley made grand preparations for the upcoming graduation. Although this was an event that took place annually, this year was to be different because the first "Hindoo" woman would receive her diploma. Bodley decided to *go all out* to make the event a most memorable one.

Bodley sent an invitation to (Pandita) Rama-bai Dongre, Anandi's cousin from Calcutta, who was then living in England. She felt confident that Rama-bai would make a compelling guest because she was a Brahmin and a Sanskrit scholar, who had converted to Christianity. In contrast to Anandi's and Gopal's resistance to Christianity, Rama-bai was a true believer and had found much to admire in the same:

> . . . its message of love and forgiveness; its egalitarian treatment of all people, in contrast to the inferiority assigned by Hinduism to women and [the "low" class]shudras(to the extent of denying them salvation); and the Christian orientation towards rehabilitation.

By inviting Rama-bai, the Dean also hoped to draw favorable attention to the commencement and raise the profile of the

college. Unaware that Rama-bai's star had dimmed in India because of her conversion to Christianity, she also hoped that Rama-bai's presence would improve Anandi's reception in India:

> *My thought in inviting you. . . has been that if the tid-*
> *ings might be sent to India that you braved a wintry*
> *ocean to witness Anandibai receive her degree as Doc-*
> *tor of Medicine, you in a certain sense gave your sanc-*
> *tion to her act.*

Rama-bai accepted the invitation, and she and her five-year-old daughter Manorama reached Philadelphia on March 2, 1886, a few days before the commencement. Anandi and Gopal met them at the wharf, accompanying them to the Bodley home. For the first time in more than three years, Anandi was in the company of another Indian woman. It was particularly gratifying that the woman was also a cousin and an intellectual equal who shared her passion for improving the condition of Indian women.

Despite all that they shared, the two women had been like ships that pass each other in the night. Daughters of Konkanastha Brahmin families of the Bombay Presidency, each had made a name for herself in far off Calcutta. On Rama-bai's husband's death, Anandi had reached out in sympathy and support. But the former had ignored the gesture, grief-stricken and too unsure of her standing among members of her own community. Rama-bai had set sail from Calcutta only a few weeks after Anandi set sail, but her ship reached Liverpool just as Anandi's was setting out for New York.

Anandi wrote to Theodocia about her sympathy for Rama-bai and her joy in having her by her side:

> *[She] ... has passed through too many sorrows for one*

woman. She has filled my heart with the joy of reality which used to be imaginary. I had wished for the pleasure a long time since.

And immediately after, Anandi's heart was filled with the desire to unite the two women who now meant the most to her:

I hope you will like her when you meet her.

In time, Theodocia would indeed get to know Rama-bai and would come to like and respect her as well as eventually help her in her cause.

When Gopal and Anandi first conceived that she should go to America to become a doctor, they paid scant attention to Anandi's employment prospects upon her return. There were risks—she might be shunned by Hindu society and the (British) government might not recognize her credentials. However, at the time they resolutely ignored any doubts that might weaken their resolve. Their faith in the rightness of their purpose gave them the hope that somehow a path would be cleared for a Dr. Joshee to serve the women of India.

Fortunately, as 1885 drew to a close, and only a few months remained until the commencement, their faith was redeemed. Dean Bodley received a letter from Dewan [Prime Minister] Cooverji of Kolapore seeking a recommendation of a woman doctor. Ironically, this happened to be the same province where the seed of Anandi's going to America for an education—just seven years previously and when she was barely fourteen—had been planted thanks to Gopal's friendship with Rev. Goheen.

A major change in governing philosophy had taken place in Kolapore in 1882, in the form of an "installation" by the

British of Jaysing-rao Ghatge as Regent. Widely traveled and tutored by thoughtful English teachers, Ghatge had emerged as an able and progressive administrator of "sound common sense, organisation and energy." He had instituted policies in support of trade, education, and medical care. Only eight years older than Anandi, he was a champion of all that she and Gopal hoped to achieve. It was at his behest that the Dewan of Kolapore had written to Dean Bodley:

> To engage a lady doctor to teach the native nurses and to take charge of the female ward in the Albert Edward Hospital at Kolapore he himself offering to provide a house and to pay the stipend...

Bodley wrote back to say that she had a student who was about to graduate who fit his requirements. Dewan Cooverji then opened a private dialog with Anandi to ask if she would be interested in running the women's ward at the newly completed Albert Edward Hospital. Anandi responded in the affirmative, and a formal offer was sent to Dean Bodley on her behalf on March 10, 1886.

The written offer laid out seven clauses covering everything from monthly pay and promised increments, housing offered, medical and teaching duties, duration of contract, and terms for its termination. The seventh clause addressed Anandi's ability to treat private patients:

> Private practice will be allowed to any extent that will not interfere with public duties. But, no fees are to be charged for attending on the ladies of the palace, or on the wives of contributors to the Hospital Funds.

Anandi's response to this clause was characteristically eloquent and thoughtful.

There is nothing in the seven conditions which you name, that causes me any uneasiness, but if any question were likely to arise under it, I might object to the seventh. Our Shastras [religious doctrines] require us to impart the gifts of healing and of religious truth without pay, and to this practice I shall adhere; but if I ever meant to take a fee from any one, it would assuredly be from those who are rich and powerful, and never from those who are poor and depressed.

Another matter that the Dewan clarified in the letter was the royal court's recognition of and commitment to Anandi's professional standing:

I assure you that the supervision of the Durbar [court] Doctor will be friendly. I feel sure that Doctor Sinclair, our Durbar Surgeon, and Doctor Joshee will pull well together. . . . Mrs. Joshee seems to think that we mean our pupils to be nurses only. Our object is much higher—to enable them to be general practitioners. . . . When the Bombay scheme for Female Medical Education, which has been taken in hand by Lady Reay, the wife of our Governor, has been perfected, it is our intention to have the Kolapore Establishment affiliated to the Central College. . . . Close to Mrs. Joshee's quarters will be provided quarters for the pupils, that they may be under her constant supervision.

Tragically, the person whose energy and financial support had made this job offer possible, Regent Jaysing-rao Ghatge, passed away ten days after the written offer was sent. However, the changes he had set in motion and the growing awareness of the need of medical care for women had been sufficiently normalized so that the offer to Anandi was honored unequivocally.

The final offer included permission to complete an intern-

ship and set sail for India in January 1887, almost a year away.

With this job offer in place, Dean Bodley initiated steps to make sure that Anandi's diploma would be fully recognized by the (British) government of India.

The first American doctor-missionary who served in India was Rev. Dr. John Scudder. He went to Ceylon in 1819 and, after serving there for nineteen years, moved to Madras and started a mission there. He was part of a virtual "dynasty"— forty-two members of four generations of the Scudder family served as medical missionaries in India. All of them were educated at American medical colleges, and there had been no impediment to their ability to practice medicine in India. Of course, all the Scudder physicians were men. The first woman doctor in that family, Ida Sophia Scudder, would only initiate her practice in India in late 1899.

The first woman doctor-missionary in India was an American, Dr. Clara Swain. She went there soon after graduating from the Woman's Medical College of Pennsylvania in 1869. She too had been able to practice medicine in India without any objections from the government.

However, the big difference was that Anandi was neither a Westerner nor a missionary.

And so, Dean Bodley sought assistance from the highest office in the American government. She wrote to Thomas F. Bayard, then Secretary of State to President Grover Cleveland. Mr. Bayard contacted Edward J. Phelps, then serving as the American envoy to the Court of St. James's in London. Mr. Phelps, in turn, reached out to the Foreign Office of the British Government in London. Dean Bodley was wise to set this

process in motion as early as she did, for she did not receive any communication until June 1886, several months after Anandi graduated. The encouraging note that Bodley finally received stated that the college:

> ... *appeared to have been misinformed as to the restrictions alleged to be placed upon private medical practice in India. As a matter of fact, no such restrictions exist. ...*

Bodley thus acquired a written commitment that there would be no hindrance from the government to Anandi's ability to practice medicine in India. The job offer from the Kolapore court opened a path for Anandi to serve as a doctor in India. The letter from the London Foreign Office cleared that path and brought her professional career a step closer to reality.

Looking ahead to the commencement, Anandi wrote to Theodocia.

> *Don't buy me anything for next March. I shall be sorry if you put yourself into any unnecessary expense for it is unnecessary. Your presence will make me a great deal more happy than if you bought me anything for any price. It is not that I have nothing to remember you by, for nothing more can be added as a memento or a keepsake. Again, had you been so troubled by wealth that you knew not what to do with it, I would not hesitate to accept any little thing that you may present me. I hope you will be present yourselves which will be by far the richest of all gifts.*

The letters that she wrote to Theodocia just days before the graduation testified to her physical and mental exhaustion:

> *On the last day of examination I was more tired than*
> *I remember being ever before. In the examination*
> *when I was on the last question & I think on last be-*
> *cause I could not think any more my patience for once*
> *gave vent and I could not write another word on my*
> *paper. I did not stop even to see if I had finished the*
> *sentence. I pinned the papers together and left the room*
> *abruptly not even bowing to the Prof. who was there*
> *and had to bow to me before I did.*

The letter totaled eight pages, with additional words scribbled in the margins. It was as if, at this hour of her triumph, all Anandi wanted and needed was to be with her aunt. Her most poignant words were these:

> *Am so tired that I am hard of keeping my eyes open or*
> *hand under control.... I wish I could see you tonight??*

The 34th commencement of the Woman's Medical College of Pennsylvania was held on March 11, 1886 at the Academy of Music. Built in 1857, it was America's oldest opera house, still used for its original purpose. The *New York Times* had described it as "magnificently gorgeous, brilliantly lighted, solidly constructed, finely located, [and] beautifully ornamented." The theater has been in continuous use since its opening and remains a vital part of Philadelphia's art and cultural life even today.

With a seating capacity of almost two thousand five hundred, the ornate auditorium features an "open horseshoe" designed to provide direct sight lines even from the seats in the side balconies. Its acoustics were the most advanced for its time, designed for optimal sound absorption. The upper balconies,

recessed in a tiered fashion, are fashionably supported by fourteen Corinthian columns.

Friends of the College and members of the Philadelphia elite thronged to the event; so did people with an interest in India, in women's education, and in progressive movements. Caroline Dall came from Washington. The Carpenter family, and Anandi's many friends, came from Roselle. Also present were members of the faculty and members of the board of trustees of the College.

Last but not least, was Gopal. The man who had been the original instigator of this risky, audacious project was present to witness its successful completion.

According to one newspaper report:

> There was not a vacant seat in the Academy when the exercises began. People stood against the walls and under the galleries, sat upon the steps, and filled every aisle and doorway. The students of the College filled the front seats in the pit, and the Faculty with their invited guests crowded the stage.

The organizers seated Anandi and Rama-bai so that they were easily visible to the audience.

The commencement speech was delivered by Dr. Clara Marshall who, besides being a graduate of the College, was also a professor there. Her address hit all the expected high notes—congratulations, inspiration, and encouragement for the next step in the graduates' personal and professional lives, together with reminders of the highest ideals of their new profession.

However, as this was the graduation of a class from a *women's* medical college, even three decades after its founding, there was an awareness of the need to keep making a strong case

for its mission. So, Dr. Marshall strategically touched on several additional points—the depth and breadth of the education imparted, the graduates' responsibility to uphold the name of the College as well as their own personal standing, and the important role of women doctors in providing medical care to women and children. In particular, Dr. Marshall mentioned the dire need of medical care for women as far away as India and the fact that the Queen, too, had been "aroused to an interest" in this cause.

This served as the perfect segue to mention the fact that one of the College's newest graduates would soon return to Kolapore to provide medical care to the women of India. With the "frequent and honorable mention" of her name and the enthusiastic applause of the large audience, Anandi was the "observed of all observers":

> An immense quantity of flowers was distributed at the close of Dr. Marshall's address, and Anandabai had many valuable presents, books, instruments and money, to help her carry out her purposes.

What might Anandi's thoughts have been that day as she received her diploma? Even though her face appeared solemn, she undoubtedly felt a sense of both tremendous accomplishment and relief at this, the conclusion, to her long educational journey.

And what about Gopal? In his resentment of Anandi, had he come to regret his part in her success? Or was he able to set aside his dark emotions and allow himself to feel pride in his wife's achievement and the fulfillment of his original dream?

As for Rama-bai, she was proud and joyful in celebrating her cousin's success. Seeing the place that Anandi had made for

herself in American society and the outpouring of interest in the cause of Indian women's empowerment, she started to think of extending her stay in America in order to raise money for Indian girls' schools.

Not surprisingly, Theodocia Carpenter was the unsung heroine of the day. Sight unseen, she had sent Anandi a letter offering friendship, sympathy, and encouragement. She had opened her heart and home to a virtual stranger, eventually making her a member of her family. We can only hope (for no written record has been found) that Theodocia allowed herself moments of quiet satisfaction, as well as exuberant celebration, for having committed herself with sincerity to such a glorious end.

An auxiliary event took place the next day at which Rama-bai gave her first speech in America. Caroline Dall and Theodocia attended the event and they were just two of the "eighty ladies of the highest social position whom Dr. Bodley wished to introduce to her Indian friends." Rama-bai electrified her audience as much by her personality as by her passion.

> The audience was reverent, struck by the speaker's beauty and awed by her enthusiasm and eloquence. Never shall I forget the hush which followed her appeal when, after clasping her hands in silence for a few moments, she lifted her voice to God in earnest entreaty for her countrywomen. The whole city echoed the next day with wondering inquiry and explanation.

Rama-bai used her high profile to create greater awareness of India. Unlike Anandi and Gopal, she drew an unvarnished portrait of the dire state of Indian women. Also, unlike Gopal,

she offered a far gentler critique of the modus operandi of Christian missionaries. In place of efforts to proselytize, she urged the various denominations to cooperate with each other and harness the "growing sentiment among India's own best-educated people in favor of the emancipation of woman from her present social bondage and ignorance." Even though Rama-bai spoke as a Hindu who had converted to Christianity, the *Philadelphia Bulletin* aptly characterized her as "the Hindoo missionary to the Christian people of America."

Buoyed by her success, she decided to extend her stay in America. Over the following three years, Rama-bai traveled all over the Northeast and eventually to California, giving speeches about India and especially Indian women. She wrote *The High-Caste Hindu Woman*, which, with a foreword by Dean Bodley, described the plight of Indian women in unflinching detail. Sales of the book generated thousands of dollars, which were used to establish girls' schools in India.

Congratulations poured in from Anandi's well-wishers near and far. Anna Thoburn, who had recommended Anandi to Dean Bodley, sent her a warm note:

> *You are beginning to demonstrate what Hindoo ladies can do when advantages are given them. May the day soon come when all of India's daughters shall be blessed with the same freedom that you enjoy.*

Anandi's friend, Dr. Francis Coleman Smith, who had graduated the previous year, sent congratulations along with an invitation to visit her in Missouri.

If Gopal felt any joy about the commencement ceremony, he did not display it and it did not last long. He soon resumed his angry denunciation of American society and his condemnation of Christian missionaries. The high rate of divorce in America became a new favorite topic; he considered it deplorable and used it as a counter-argument against Americans' penchant for focusing on the custom of child marriage among Hindus. He wrote a letter to the Unitarian *Index* on March 14, just three days after the commencement:

> I beg you dear editors never to say a word against my country. We have no confidence in your careless press, unprincipled missionaries, crafty politicians and cunning presidents. The Americans have no shining character to boast of. Why do you go to India for "abominations"? Look at your deeds ignominious as they are. "Save us from such people" is my constant prayer to myself. We don't want your marriage system. We don't want your divorces. We don't want your swindles and frauds. Keep them all to yourselves. We don't envy you. But don't condemn our child marriage system and call us by hard names.

In the face of her husband's rage, Anandi tried her best to carry on. Because most Americans had treated her with kindness, she suffered feelings of shame and humiliation silently. Ever sympathetic and perceptive, Caroline Dall noticed the change in her friend:

> Whoever had walked the streets of Philadelphia in modest peace with Anandabai, could not fail to find a difference when Gopal was added to the party.

In short order, the New England Hospital in Boston offered

Anandi an internship:

> *The Bostonian friends and others at the N. England*
> *Hospital are very kind indeed to me. They had made*
> *special arrangement for me to go there for 6 months*
> *only which is not allowable at all. Besides my applica-*
> *tion did not start until only a few wks since while*
> *others had sent theirs several years ahead. So they filled*
> *the places for "interne" physicians before my applica-*
> *tion reached. Yet they are going to accept me as an*
> *Extra student or interne as they are very anxious to give*
> *me an opportunity of instruction in their institution.*
> *Extra students are required to pay board &c but they*
> *invite me as their guest.*

Anandi and Gopal wrapped up their affairs in Philadelphia. Together with Rama-bai and her daughter Manorama, they spent a few days at the Carpenter home in Roselle. They left for Boston at the end of April 1886.

Months after the commencement, Dean Bodley continued to look for ways to publicize the achievements of the College and its star pupil. She decided to send a letter to Queen Victoria, informing her of the achievement of one of her subjects.

India was well-known as Britain's "Jewel in the Crown." In an acknowledgment of the subcontinent as a key imperial colony, the Queen had assumed the title, "Empress of India." Britain's engagement with India was built atop a foundation of political, military, and trade interests. Beyond that, India was seen as the location of a romance with the exotic; the welfare of Indians was not a priority.

As a result, Dean Bodley's letter could have been seen by the Queen as an audacious attempt to show that Americans were doing the job—providing education to their Indian subjects—that the Queen's own governmentwas failing to provide.

Additionally, the Queen's disdain for the budding movement for women's rights was no secret:

> The Queen is most anxious to enlist every one [sic] who can speak or write to join in checking this mad, wicked folly of "Women's Rights," with all its attendant horrors, on which her poor feeble sex is bent, forgetting every sense of womanly feelings and propriety.

Her objections were based in a particular understanding of God's plan:

> It is a subject which makes the Queen so furious that she cannot contain herself. God created men and women different—then let them remain each in their own position. Tennyson has some beautiful lines on the difference of men and women in The Princess. Woman would become the most hateful, heathen and disgusting of human beings were she allowed to unsex herself.

And then there was the issue of what are now considered "Victorian" ideas about social propriety:

> The Queen is a woman herself [she wrote] & knows what an anomaly her own position is. . . . But to tear away all the barriers which surround a woman, & to propose that they should study with men—things which could not be named before them—certainly not in a mixed audience—would be to introduce a total disregard of what must be considered as belonging to the rules & principles of morality. Let woman be what God intended; a help-mate for man—but with totally different duties & vocations.

What was the likelihood that the most powerful royal in the world would respond to a letter that proudly announced the very endeavors that she disdained? What was the likelihood that she would congratulate the achievement of one of her lowly subjects—an achievement that underscored what her own mighty government had, thus far, failed to provide?

Amazingly, a response from London was forthcoming. And it was a positive one, albeit in the understated and indirect manner of royal communication. The letter was written by the Queen's Private Secretary General, Sir Henry Ponsonby:

> *I am commanded by the Queen to request that you will kindly thank Mrs. [sic] Bodley for having sent her Majesty the account of Dr. Joshee's reception in the Woman's Medical College of Pennsylvania, and to assure you that the Queen has read the paper with much interest.*

A report about this letter was published in the *Public Ledger and Daily Transcript* with obvious glee:

> The Queen of Great Britain and Empress of India for many years holding opinions unfavorable to the recognition of medical women in her dominions, has yielded to the argument of accomplished facts.

In sending a letter to the Queen, Dean Bodley performed two thoughtful acts. First, she registered a gentle dissent of British policies in India that neglected the well-being of Indians. And second, by obtaining an approving message from the Queen, she made it harder for naysayers to obstruct Anandi upon her return to India.

14

PROFESSIONAL WOMAN

We rise by lifting others.
Robert Ingersoll

Founded in 1862, the New England Hospital for Women and Children was the first hospital in New England operated by women for women. It was the second such hospital in the country, the first being the one attached to the Medical College in Philadelphia.

The New England Hospital uniquely combined medical, surgical, obstetric, and pediatric services in a single institution. Their senior surgeon, Dr. Elizabeth Keller, an alumna of the Philadelphia College, attended the recent commencement at the College. She was a top practitioner in her field and had "published case studies of ...operations to remove normal ovaries to cure a variety of gynecological and psychological complaints."

Dr. Keller had personally experienced bitter opposition to women's medical education. She recounted "being greeted by jeers, whistles, groans and the stomping of feet, while some men actually threw stones." Also, like many women medical graduates of the time, "the great medical centers in France, Germany, Switzerland and Great Britain [had] proved quite cordial to women in the last third of the nineteenth century." Thus, she

was committed to doing her part to provide the first American-trained Indian woman doctor the broadest practical experience. At Dr. Keller's urging, the Hospital administrators kindly extended some accommodations to Anandi—they accepted her into the program despite a late application, waived the cost of her board, and shortened the duration of the internship.

Anandi arrived at the Hospital on the evening of May 2, and a full schedule of duties commenced immediately. Her hours were long, her assignments many. In addition, there was paperwork to complete and meetings to attend in order to review patient cases with the surgeons and other interns. Such a schedule would have been exhausting enough. But some aspects of Anandi's living arrangements presented additional challenges:

> *My sleeping-room is on the third floor, dining room on the lowest, patients all over. I have to fill up the papers that belong to my own patients. This is the first time I have sat down. I am so tired! . . . It was so cold in the house that I came out on the lawn to write. It is very sunny, but very windy, so I don't think I shall stay long.*

Not surprisingly, these factors took an unfortunate toll on Anandi's health:

> *You will be sorry to hear that I have such a cold in my throat that I cannot talk, only whisper.*

Even though she was working in a hospital, surrounded by the most skilled doctors of the time, the extent of Anandi's exhaustion and failing health appear to have been missed. "There is a civil war in me," she wrote to Theodocia ten days later. Though her cold was in retreat, her body was struggling

to keep up with the sheer physical exertion that her job demanded:

> *I feel tired because I am not used to these stairs & so many trips in a day. It seems my back could not help showing the bruise, at least it feels so. My heart bellows & my limp is back. . . . My legs rebel at the injustice done to them.*

Nonetheless, Anandi continued to work long hours and attend to as many patients as possible, sometimes seeing as many as a dozen in a single day.

The New England Hospital's promise to give Anandi "the chance to see a great variety of work" was fulfilled in several ways. Dr. Keller personally made sure that Anandi had "ample opportunity to visit other infirmaries and asylums not unfriendly to women." To make time in her schedule for such training, Anandi was spared some of "the care and responsibility devolving upon an interne," such as temperature checks, the changing of bandages, and other routine tasks. Keller also took Anandi with her "to see some of her most interesting surgical cases."

Anandi had the opportunity to treat patients of all ages—from infants to very old women—and to be exposed to new procedures. A paper on the use of electromagnetic fields had been presented at the St. Louis Obstetrical and Gynecological Society just six months earlier. Anandi received training in using cutting-edge technologies—"galvanic and faradic electricity" and "electric baths"—in the treatment of menstrual disorders.

The New England Hospital was also at the forefront of other innovations in the medical field. In a letter to Theodocia, Anandi characterized it as "a fine hospital, much more so than

the good old Hospital of Philadelphia." She was referring to the very professional manner in which she thought the Hospital was being run:

> *The business is carried on on business principles & a*
> *great improvement over the old orthodox Hospital of*
> *Philadelphia. . . . Another important improvement is*
> *that it is free from the overwhelming whims & notions*
> *of <u>old maids</u>.*

The underlined reference to "old maids" was out of character for Anandi. And, even though she realized that Theodocia would find her use of this phrase jarring, she used it anyway, with only an inadequate explanation as to why she used it:

> *I know you detest this term when it is included con-*
> *temptibly but I know you would not when I tell you*
> *the reason why I used it. It is because they are so & also*
> *because it expresses the whole matter in one word*
> *which I could not express in a page.*

On the other hand, this bit of Anandi's writing attests to how aunt and niece had attained that rare level of informality and confidence in one another, such that Anandi no longer felt it necessary to curate her thoughts and feelings when communicating with Theodocia.

By the late nineteenth century, Boston was the American city with the broadest connections to India. These took the form of "missionaries and ice" being sent abroad, with textiles and spices coming back. However, there was an additional dimension to the interchange. As missionaries set out to win souls for Christ, American souls were gradually stirred by the trickle

of Hindu texts that made their way to Boston. At the time, both Ralph Waldo Emerson and Henry David Thoreau undertook a deep study of the Hindu holy texts—the Bhagavad Gita and the Upanishads. Emerson and his circle came to be called Transcendentalists because of their "emphasis on the transcendent oneness of spirit"—a concept to which Emerson was introduced as a result of studying the Hindu tomes.

Thus, it is no surprise that the female student from India was welcomed by a broad swath of Boston society. There were teas at the Woman's Club and at the Woman's Industrial Union. There was an invitation to speak at an event organized to celebrate the anniversary of the Free Religious Association, whose progressive philosophies predisposed them to welcoming Anandi:

> The Free Religious Association (FRA) was formed in 1867 [as a] spiritual anti-slavery society to emancipate religion from the dogmatic traditions it had been previously bound to. It was opposed not only to organized religion, but also to any supernaturalism in an attempt to affirm the supremacy of individual conscience and individual reason. The FRA carried a message of the perfectibility of humanity, democratic faith in the worth of each individual, the importance of natural rights and the affirmation of the efficacy of reason.

Unfortunately, Anandi was unable to accept their invitation because of her duties and increasingly fragile health. Indeed, only four weeks after arriving in Boston, "she decided to give up her studies at the Hospital, and see if perfect rest would not prepare her for her duties."

Intending to spend some time with Anandi, Caroline Dall arrived at the hospital on June 5. She was shocked when she

saw Anandi confined to her room, "lying in bed, pale and quiet." With her usual thoughtfulness and generosity, Dall gave her young friend the opportunity to speak of matters close to her heart. Although Anandi did not "seem anxious about herself," she certainly regretted not being able to work. However, she still looked forward to her future work in India, hopefully with Rama-bai.

Noting her weakened condition, Dr. Keller invited Anandi to move into her home. It was hoped by all that complete rest would quicken Anandi's recovery. (The whereabouts of Gopal during this period are unknown.) This move was somewhat helpful, and Anandi "rallied enough to go to Mrs. Underwood (of the Free Religious Association) for an evening and meet a few friends."

That event was marked by the same wide-ranging conversation that had taken place during Anandi's stay with Dall in Washington. The *Oriental* topics discussed included poetry, vegetarianism, and infanticide. Western topics included Christian Science and American and English scientists. On most of these subjects, Anandi impressed her guests with the depth and breadth of her knowledge, as well as her eloquence. Anandi assertively but respectfully challenged some of their pieties.

Although she "had taken several lessons" in the art of healing as espoused by Christian Science and saw a natural basis on which it might be explained, Anandi declared that having dissected the brain, she found "reason to dispute the claims made by its enthusiastic advocates." In the end, she reserved her most pointed objections to questions about infanticide practiced in India. As Dall recalled:

> In speaking of the mothers who distraught with poverty
> sometimes throw their babes into the Ganges, Dr. Joshee
> said that during her medical experience in Philadelphia
> a large number of newborn infants, either murdered or
> deserted, found their way into the dissecting room, and
> she might as well on her return to India relate this fact
> making it a custom of American mothers to kill or desert
> their children, and adducing it as a result of Christian
> belief, as to charge the Hindu faith with the drowning
> so often reported.

Thus, Anandi held up a mirror to her audience, demonstrating how their society might appear if judgments were made about American society, based solely on the experiences of a physician whose patients were drawn from the poor residents of urban Philadelphia.

Mrs. Underwood's detailed description of Anandi's appearance—"the dark face was round with full lips"—shows, once again, the racial lens through which she was regularly initially perceived. Interestingly, as had been the case with Dall as well as Theodocia when they first met her, reactions to Anandi's looks were quickly superseded by admiration. According to Mrs. Underwood, Anandi spoke "sensibly" of Christian Science and her "acquaintance with American and English scientists was something phenomenal."

At about this time, Gopal spoke at a different event organized by the Free Religious Association. He excoriated Christianity just as he had in the many lectures and talks he gave since leaving India eighteen months earlier:

> *Christianity lacks every noble attribute; that we are*
> *told we must believe as the Christians do, or be imme-*

diately damned; that this is not done by one sect but
by all, including the broad Unitarian. . . . Christianity
lacked justice, righteousness, and humanity; that char-
ity was absent through the length and breadth of Chris-
tendom; that Moses and Jesus imposed upon the
credulity of their followers.

At another event in Concord, Massachusetts, Gopal con-
ceded that he did not wish to speak against Christ and his teach-
ings. However, he continued to rail against Christian
missionaries. His was the rage of a person who lamented the
loss of the pure and noble at the hands of people of ill will, who
nonetheless expected his gratitude:

I have been with missionaries for the last twenty-two
years. The more I look into their characters, the darker
is the dye that stains them. Christians have manufac-
tured all the vices, and exported them to countries
where simplicity and innocence reigned.

Gopal further charged that "the missionaries. . . travelling
to this country with his wife. . . put meat into her plate, to force
her through hunger to break the requirements of her caste."

Some in the audience knew that the Joshees had previously
had at least a few positive interactions with Christian mission-
aries in India. And so, they were perturbed when Gopal failed
to offer anything to balance his denunciations. Dall eloquently
noted:

If there had been a spark of nobleness in Gopal's breast,
would he not have known how to tell his truth without
repulsing his best friends?

Sadly, to the extent that Anandi's health and duties allowed,

she had no choice but to accompany her husband to his speaking engagements. Once there, she had to sit "through his long tirade, silent and suffering." Members of the audience were curious to know her opinions. But Anandi, who had not shied from expressing herself when on her own, now chose silence.

With her return to India on the horizon, Anandi started planning her life in Kolapore. She knew that her employer would provide housing and a monthly salary. She looked forward to being in charge of the new hospital being built and teaching female students. However, she worried about the uncharted territory of reintegrating with her family and community.

She and Gopal were now living essentially parallel lives. While she was concerned about her health, about the long journey, and about the details of her future work and making a home again, Gopal focused entirely on his own trajectory. He was in no hurry to return to India; he toyed with the idea of remaining in America for a few more months, and even fancied a sojourn in Russia on his way back to India.

Gopal's self-centered musings and potentially independent future plans left Anandi more than concerned. What would her status be if she were to return to India unaccompanied by her husband? Would she be regarded and treated as a disfavored or an abandoned wife? Would her virtue be questioned as Sita's had been in the *Ramayan*? How would orthodox Hindus react to her, given that her husband, previously her protector and champion, was not by her side? Would she be shunned for having crossed the seas and for having lived in the homes of non-Brahmins? Would she face rejection by her in-laws, the family

with whom custom dictated she belonged?

With these concerns in mind, Anandi wrote a letter to her mother-in-law in June 1886. The letter was cordial and respectful. She invited her mother-in-law, as well as both of Gopal's younger brothers, to Kolapore so they could all live together, as was the norm, as a "joint" family:

> *Whatever little I earn, is yours. As an elder, I wish that you will live with me and run the household. In your old age I do not wish to make you exert yourself. We can hire a cook and a maid and you can oversee them. However, we can decide these particulars later. . . Please let me know your thoughts. So long as I am living, you will not want for anything.*

In writing this letter, Anandi graciously extended herself well beyond her role as the wife of the oldest son of the family. She also offered to assume the responsibilities that fell to a son—to be the provider and caretaker of his widowed mother and younger siblings. Ironically, while her education freed her to take on responsibilities attributed to men, it did *not* free her of either women's duties or of their need for social approval.

However, Anandi's sharp intelligence and fiery imagination were not to be constrained by rigidly traditional rules and roles. The striver in her had ambitious ideas for the careers of Gopal's younger brothers:

> *I think Appaji [older brother-in-law] should study photography. If he learns to take photographs, he will do very well. Please tell him on my behalf to continue his studies. I will bring a good camera for him. As for Ravji [younger brother-in-law], I think he should study Pharmacy and Chemistry. If he does that, there*

will be at least one Indian pharmacist. He can even
establish his own dispensary.

In closing, she reiterated her commitment to her in-law
family:

> *My return is six months away. I have hardly any*
> *money. Please carry on as best as you can until I get*
> *there. After that, you can stay with me and there will*
> *be no worries. It might be better if you reach Kolapore*
> *after me. That way, I will have arranged the house and*
> *you will be spared inconvenience and uncertainty.*

Unfortunately, this dutiful and generous letter did not elicit
a response. The silence seemed to speak for itself. There would
likely not be any encouragement, appreciation, or welcome. So,
after two months Anandi wrote again, reiterating her earlier
commitments, while also attempting to respond to imagined
accusations:

> *I have not yet received any letter from you, and so I*
> *don't know what has been decided. It remains my ar-*
> *dent wish that Mother-in-law stays with me upon my*
> *return. Please indicate to her that she will not have*
> *any cause to worry because of my "convertedness." I*
> *will make sure not to even touch her. Also, I will keep*
> *all my affairs completely separate. You can engage a*
> *cook (of your choosing). I will conduct myself only per*
> *your wishes.*

In the hope of a sympathetic response, she allowed herself
a brief mention of Gopal's eccentricity and of her own
vulnerabilities:

> *Most likely, I will have to return alone. I am urging*

> *"him" to return with me, but he gives many reasons*
> *why he cannot do that. He is very keen on going to*
> *Russia. And he wants to go to England and curse the*
> *English there. . . . I have had to resign from the hospital*
> *due to ill health. . . . I am very exhausted and have*
> *neither hunger nor energy. This is the effect of working*
> *night and day for a long time. I was given medicines,*
> *but they have done no good.*

Anandi concluded her letter on a contrasting note:

> *So I started taking "our" medicine. This has given me*
> *some relief and has also kept my fever at bay. Even my*
> *cough is less. I expect I will be much better in a few*
> *days.*

Did she include this information to appeal to her in-laws'
national pride by purposely casting doubt on the effectiveness
of Western medicine? Did she, in fact, receive greater relief from
Ayurvedic medicines? If that were the case, was it merely the re-
sult of a placebo effect or were they genuinely more effective?
Only time would provide answers to these questions. It is not
known if Anandi ever received a response from her in-laws. Un-
fortunately, her health continued to decline and this drastically
changed the course of the following months.

Of necessity, the Joshees returned to Roselle on July 1,
1886. After spending the first week of July there, Anandi, ac-
companied by Eighmie Carpenter, left for a respite in the coun-
try at Read's Creek in Delaware County, New York. This time
was to be spent in the care and comfort of the Eighmie and Car-
penter extended families, both of whom had homes there. It

was hoped that the health-enhancing climate of the location, might help Anandi recover.

Anandi and Eighmie went on long walks with Aunt Jennie in the nearby woods and, just like generations of city kids, were disappointed when they did not meet any wild animals or "even a rattlesnake." When they happened upon strawberry fields, they ate "of them heartily." On Sundays, they slept in late and after breakfast headed out again for the woods. Church attendance seems to have been optional.

Her restful stay in the country provided Anandi ample time to work on her "crazy quilt," an art form in vogue at the time. Pieces of embroidered cloth were sewn together in a largely random, "crazy" form that did not require the typical repeating quilt structure or pattern. This perfectly suited Anandi's situation, as many of her friends created individual blocks for her quilt using only their imaginations, without concerning themselves with how the blocks might fit together in the larger whole. Over the course of her stay, Anandi managed to complete her crazy quilt as a wonderful keepsake of the best of her time in America. In a sense, the beautiful crazy quilt that Anandi made with the unique contributions of her many friends, symbolized the *crazy quilt* of Anandi's many unexpected friendships that, despite lacking symmetry and pattern, together made a beautiful whole.

Sadly, even though Anandi had a very pleasant stay at Read's Creek, her health did not improve. She also missed her aunt, even more acutely than before:

> *How I wish you were here. I won't stay here very much longer for I have been ill ever since I came here. I am having chills three times a day & fever. My whole body*

> *is aching. If you do not come here within a reasonable*
> *time, I shall leave this place & go to you. I am afraid*
> *I won't have any visit from you before I go to India.*

The Carpenters, Gopal, and Rama-bai joined Anandi in Read's Creek at the end of July. Anandi seemed to recover from the worst of her health woes over the next few days. So it was decided that she should join Gopal in Rochester. He had been invited to give a lecture there on August 19.

Gopal began his Rochester speech by praising America:

> The Americans are a mighty people who have mastered all elements of nature. . . . Oh, thou, America, the destroyer of kingcraft and priestcraft, liberator of the enslaved, thy glory is brilliant. . . . Even the Goddess of Learning cannot do justice to thy name . . .

However, this proved merely to be faint praise in contrast to his subsequent, more forceful critique of American society. He was deeply troubled by what he saw as the Americans' willing subordination to Britain:

> But alas, America is blind! She sacrifices her honor and dignity that she may be patted by other nations. Her daughters marry for empty titles—insolvent baronets and degraded peers. The English "Dog" has an access to every noble family in America, but when Americans go to England, they are treated as low castes, scoffed and sneered at by the haughty and insolent Britain. They are not welcomed into the high circles, nor are they admitted into first class hotels and clubs.

Believing that Americans were not sufficiently aware of their humiliating treatment by the British, he warned his audience about that using the example of the sorry state of his

own country:

> Beware of one thing—the danger of self-adulation. Nations have come and gone for that very fault. Wealth is the curse of all nations. . . . My country was the wealthiest one in the world; my people were the wisest of all nations; but where is her wealth and wisdom gone now? All gone—gone never to return. We welcomed all foreigners, and feasted them as potentates, but they ultimately became our enemies, and we are now in bondage.

His only explanation of this critical stance—"I am not here to praise the Americans but warn them against the rock of vanity on which their ship is sure to wreck today or tomorrow. What is best in America, I reserve for the enlightenment of my country; and what is worst in her I freely leave behind"—appears to offer the only clue to understanding his rationale.

Continuing, Gopal proceeded to criticize many more dimensions of American life—their society, culture, economy, and market. He described his disgust with Americans' personal hygiene. He was troubled by Americans' relationships with God:

> The Americans do not think of God better than a machine. They pray to God for all manner of things, even for pins and lids.

While earlier in his speech, Gopal conceded that he "received kindness and hospitality at all hands in America," nearer to the end, he eclipsed that praise with harsh criticism:

> In Kansas City I could not get a bed in a hotel, because of my complexion. In Chicago barbers did not shave me because of my color. The other day I was in Ocean Grove, the seat of Methodists, where I was not allowed to speak on any subject. . . . When these crank Meth-

odists go to other countries and shout loudly like mad-
men against their etiquette, why should they object to
other nations coming here and explaining their own sys-
tems?

Gopal's speeches illustrate the frustrations of a nineteenth-
century Indian man seeking to protest his powerlessness in a
sometimes unwelcoming foreign land. He expressed that dismay
by frequently calling attention to the unworthiness of the
powerful. Thus, the closing words of his address were in favor
of another powerless group:

> [America] has reached the culminating point where she
> will stand forever or fall for eternity. . . . America should
> hand over her administration to women who alone can
> save her from destruction. Woman is a powerful admin-
> istrator. Woman will be the savior of future generations,
> as she has been of the past, but if man encroaches upon
> her rights and independence, down will go America.

Gopal's strange, seemingly contradictory speech in Roches-
ter almost makes sense at another level. He was worried for
Americans—for whom he had some respect and affection—and
was thus trying to warn them in his way. For this proud, emo-
tional Indian man, offering up praise to America—even for as-
pects he believed were praiseworthy—would be hypocrisy. And,
though praise would have served him much better, it was not
what Gopal believed a *good friend* ought to do.

Anandi spent ten days at the beginning of September 1886
in the Woman's Hospital in Philadelphia. This was one more
attempt to achieve a breakthrough in her failing health—one
that might allow her to remain in America for a few more
months. Unfortunately, no treatments were successful and

Anandi's health became dismal.

Seeing Anandi's dire condition, the consensus of all her well-wishers—Rama-bai, Dean Bodley, and the Carpenters—was that she should return to India as soon as possible. Being in her native climate would spare her having to face the approaching bitter cold. Having access to plentiful vegetables and staples, as well as longed-for home-cooked food, would provide her comfort and help her rebuild her physical strength. Being reunited with her family members would, hopefully, also lift her spirits.

And so, Anandi returned to the Carpenter home for a final stay. She was surrounded by all the people who loved her, all of whom were eager to do everything possible to help her body rest and elevate her spirits. Theodocia described her condition in a letter to Dall:

> Her strength was so reduced that during the four weeks that she remained with us the greater part of the time was spent in bed or on the lounge although she generally joined us at lunch or dinner. . . . At no time did any of the "gloom" of the sick-room attend her. Everything was done to make those precious days as bright and cheerful as possible. It was too hard to believe that all the efforts of her physicians would be in vain, and we tried to shut our eyes to the heart-rending truth.

When it came to preparing for the return voyage, it is hardly surprising that Anandi "dreaded this final packing." Apart from the challenge of choosing what to bring with her and what to leave behind, she felt deeply nostalgic for the months and years that had sped by. She was about to be separated, possibly forever, from the people she loved and with whom she had formed deeply heartfelt bonds.

Significant keepsakes are at once spiritual and material. Although they are mere physical objects, they are treasured because they are infused with meaning. They make the intangible tangible. They hold the spirits, emotions, intentions, memories, and words of our near and dear ones. They carry within them the sounds, sights, and textures of our many meaningful life events and experiences. So, at the end of her American sojourn, the bulk of the belongings that Anandi packed were memory-laden artifacts and keepsakes. They were the physical means by which she hoped to remember the bonds she had formed with the many Americans who crossed her path. She had come as a student, but she was leaving as a family member, a friend, a courageous heroine, and a deeply accomplished, admired woman:

> When the packing was all done, of the eleven trunks,
> eight contained nothing but souvenirs, and the remain-
> ing three held a goodly proportion of the same.

Finally, Gopal abandoned his plans to stay in America or return to India by way of Russia. He set aside his acrimonious feelings sufficiently to return home as Anandi's husband and caregiver.

The return journey commenced with a carriage ride to the train station. Extra time was allotted for the short ride so that, along the route, Anandi "might see once more every home that had been open to her, and take a last look at that she had called her own." But so frail and weak was she that even the motion

proved challenging. As at every stage before and during her stay in America, Theodocia readily provided Anandi with support and comfort:

> *The motion of the cars made her uncomfortable, and she leaned on my shoulder for support until we reached the carriage in New York.*

The Carpenters accompanied the Joshees all the way to the ship. They then spoke to and urged the ship's staff to make Anandi's journey as smooth and easy as possible:

> *The purser and steward had been instructed ... to show Dr. Joshee special favor in regard to diet, and the physician in charge promised watchful care.*

And with that, Anandi and Gopal set sail for home.

"I Have Done All That
I Could"

*I have tried to keep on with my striving because this is
the only hope I have of ever achieving anything
worthwhile and lasting.*

Arthur Ashe

The steamer *Etruria*, carrying Gopal and a very sick Anandi,
sailed from New York Harbor on October 9, 1886. Anandi
was confined to bed and Gopal attended to all of her needs.
Two days into the journey, the ship encountered very rough
seas. Even though Anandi's cough had somewhat subsided, she
was so seasick that she "throws out everything she takes in."
However, as a result of the Carpenters' request before the ship
set sail, "the doctor and all other officers were very attentive,"
and the Joshees got "all they wanted" to eat.

Sadly, the relative relief from her cough did not last long.
By the 13th Anandi had "caught cold in her chest and the
tickling of the cough was so constant that [they] at once resorted
to the severest dose of medicine." That was brandy in hot and
cold water, in addition to the medicine that the ship's doctor
could provide her.

The turn for the worse shook Anandi. Certain that the end
was at hand, she exclaimed, "I am going now, my time has

come. Send my respects to Aunt and several in India." She burst into tears, confessing that she "had been trying to cry out these four days, but could not do so" while her husband closely watched.

There were many reasons for Anandi to feel tearful and overwhelmed. She had left America sooner than anticipated, without completing her internship. Her physical condition showed no signs of sustained improvement. She also worried about the lack of money. That she also felt it necessary to hide her tears from her husband seems the most heartbreaking aspect of her condition.

Even though Anandi and Gopal had begun this long journey as partners, and even though she had achieved their audacious goal, she could no longer count on her husband's sympathy. Even in her debilitated state, Anandi found it preferable to hide her suffering rather than possibly expose herself to Gopal's stern response. Ironically, and tragically, her achievements had robbed her of the earlier privilege she knew of seeking relief by sharing her sorrows and worries.

The extent of Anandi's physical weakness is seen in Gopal's description of one of her *better* days:

> *Today it has been mild. Dr. Joshee did not bring out anything she ate. She seems sprightly and willing to go on deck, but the trouble we have in dressing her hair is another anxiety. I could not do it nicely. She therefore had to do it herself which exhausted her so much that all the vigor she showed vanished in the twinkling of an eye.*

The *Etruria* reached Liverpool on October 17—a little over a week after it left New York. The Joshees were booked on the *Hergoda* to take them from London to Bombay on the 20th. Gopal chose this particular sailing because, given his great distrust of the English, he wanted to minimize the number of days he and Anandi spent in England:

> ... *I knew that I would be ill-treated by the English for my outspokenness and ultimately imprisoned for life or committed to the gallows.*

Gopal's entry to and exit from England did not attract the kind of attention his overwrought, almost paranoid, imagination had feared. However, he had an experience that was so extreme that he worried about how he and Anandi would get to India.

When Gopal went to the agent's office to ascertain the time at which the *Hergoda* would set sail, he received the classic *runaround*, typical of a hostile bureaucracy. At first, he was told there was no record of his booked passage. After some additional inquiries, his reservation was located, but it was wrongly claimed that it had not been paid for. The reason for this intransigence was finally revealed by an agent:

> A buoyant burlesque young looking English cur told me that a berth was reserved but he did know it was for a Hindu lady. The company and the agents do not book any Hindu passengers because of the avowed reluctance of the white passengers to travel with a Hindu in their company. He said as the passage money was not paid he would not grant a ticket for a Hindu lady.

Gopal's indignant reaction to this revelation expresses the litany of Indian resentments about British rule:

I was all wrath and indignation. I burst as is my wont into bitter exclamations. I abused the English right and left and said that their houses in India should be blown up and every insult retaliated by bloodshed. "Ah that day will come," continued I. "I must go back, awake, and stir up my people to their duty from their present lethargy. Oh, you English curs and blockheads, if you do not wish to associate with Hindus, why do you go to India? You are begotten of madmen. You live on Indian bread and butter; you are fattened like pigs in India; and yet you don't want to travel with a Hindu. Ah, you mean villains!"

Fortunately, Gopal was neither detained nor restrained after this outburst. He was likely nothing more than a minor irritant to the machinery of Empire. The shipping agent refunded their fares, but those monies were insufficient to book passage on another ship, especially after paying for additional nights in London. Short of money, with an extremely sick wife to care for, and having no friends to call upon, Gopal was in a fix. Dejected, he returned to the hotel where Anandi was resting.

Two English women came to the hotel to wish them goodbye. They expressed regret that the Joshees could not stay longer in London. Having heard from an American friend that Gopal was "very much prejudiced against Christians," they may have wanted to check the man out for themselves. When Gopal related their predicament to the women, "Mrs. Pattison and her husband" took matters into their own hands:

They cancelled all their engagements for the day and called on Cook & Son with an attorney. They found all we had said was true, and felt it was a shame to a Christian nation to have treated the heathen so mercilessly. Next morning I called on Mr. Pattison, the

> *husband of one of the ladies who called on us the pre-*
> *vious day. He inquired as to the probable deficiency of*
> *our funds if we went by the expensive line the next day*
> *and placed in my hand a cheque for eighty or ninety*
> *pounds.*

This experience not only entirely cooled Gopal's anger, it gave him reason to believe in both a divine plan and in the goodness of *some* fellow human beings:

> *Some may say there is no God; some may attribute such*
> *an instance to accident, but I cannot help believing*
> *there is an unseen power at work which relieves hu-*
> *manity of its severest pangs. Why should that woman*
> *come in just the time when the metal of mind was*
> *melted in the furnace of trial? That lady, who was the*
> *solace and comfort to the weary and forsaken, came a*
> *long distance to bid us farewell. Her words at parting*
> *were more consoling and redeeming than all the dollars*
> *Dr. Joshee received as presents from her American*
> *friends in pomp. "I hope," said she, "you will not go*
> *home believing that there are no good people in Eng-*
> *land."*

With the additional funds, Gopal immediately booked their passage to Bombay on the *Peshawar*. There was only enough money for a berth for Anandi and a deck seat for himself as her servant—*"a position too humiliating for me to undertake, but too dutiful for me to neglect."*

Unfortunately, even when closed doors are forced open simply as a matter of fairness, there is no guarantee of accept- ance into the salon. The treatment that Anandi and Gopal re- ceived on the *Peshawar* was in sharp contrast both to their

experiences in America and to the courtesies that they had received on the *Etruria* during their journey from New York to Liverpool:

> While she was in America and up to the time of her leaving in England she never knew what kind of animosity between the black and white races was fostered by the English. She lived nearly four years right among white people and was respectfully treated as a lady.

Seeing the dark-skinned Hindu woman in a first-class cabin, a server questioned her right to be there. "This is not your place; you are a third-class passenger; go away." Anandi responded in a cool and detached manner. "It would not cost you a bit to be polite and civil. You ought to have asked my ticket for inspection rather than to say what class I belong to." However, the rude treatment continued—from both staff and fellow passengers alike.

> Dr. Joshee had not been feeling very well. She was not inquired after by the doctor and stewardess on board until they were sent for, with the stewardess addressing her thus: "Why are you sitting here? Where is your mistress or are you in charge of a child?" Not a single lady passenger has spoken to her or inquired after her health; on the contrary they enjoyed the fun when one evening, while Dr. Joshee was at table one waiter struck her so hard on the head with a chair that it immediately produced a bump; neither the waiter begged to be excused nor did the passengers, among whom were lords and peasants, express any regret. They looked at one another and enjoyed a laugh over it. . . We came from New York to Liverpool well cared for and looked after. The doctor on board called twice a day. The steward and stewardess were always in attendance whenever the call bell rang.

But why such a difference on Anglo Indian steamers?

Gopal's situation as a servant on deck was, in some ways, even worse:

> *I have learned from experience that the English mean by a native servant to be a living being good for nothing. . . . The high-toned purser gives me to understand that I have no place to sit during the day or to sleep at night except on deck where cold is penetrating and the pitiless waves constantly roll over.*

And worst of all was the paucity of food and the hostile attitude of the staff whose job it was to provide it.

> *We are, as you know, perfect vegetarians. On board the Etruria special regard was shown for our food; the chief steward sent us any quantity of grapes, apples, pears and peaches besides vegetable soups, baked apples and tomatoes, ice cream and puddings. On that steamer we were respected for being vegetarians but on the Peshawar those things which Dr. Joshee did not eat were always offered. If she told the stewardess she did not want any kind of animal food she would invariably ask, "Do you want beef tea?"*

Knowing that providing appropriate and timely nourishment to the vegetarian passengers would have been inexpensive as well as less laborious only enhanced Gopal's frustration:

> *The P&O Co have been carrying hundreds of natives to England almost every year and should have learned by this time what kind of food they require. They could, at less cost, give us the simple dishes we want but if they do so how could they get a chance to slight us by offering beef tea? . . . [We are served] a cup of arrowroot three times a day and occasionally a few*

grapes and oranges as a favor. Beef and meat eaters are
served first, the cooks always forgetting to prepare ar-
rowroot and sago and the stewardess bringing in ex-
cuses.

There could hardly have been a greater agony than being
almost starved and then also being subjected to insulting and
uncivil treatment:

Starvation! Starvation!! . . . As a deck passenger, I have
had hardly anything to eat these ten days. Last night I
took a piece of bread and asked for jam or pickles. "Eat
what you have before you," said the second steward.
"Nothing else can be had." I was proceeding to argue
when "Shut up" was the last insult.

There was one unusual bright spot in the midst of all the hu-
miliations and privations:

Someone who came to know of our being refused on
another steamer sent word to us that if we needed any
money he would be very glad to lend and receive it
back at our convenience, say 100 years hence. I have
not personally seen him nor do I know which of the
passengers is our benefactor.

While it is not known whether the Joshees took the money
so generously offered, the sympathy and sense of humor re-
vealed in the offer of a "100-year loan" must have allowed them
to feel at least a bit less beleaguered and isolated.

Anandi's health continued to swing between bad and worse.
Even so, she managed to write a letter to Theodocia which was
mailed from Gibraltar—their first stop after leaving London:

There has not been a day since the 9th when I did not
miss your precious company.

When Gopal asked Anandi what she would like to do on landing, she gave a one-word answer—food. "She wants to eat her food. She daily mentions thousand and one things that she likes to eat. Eat, eat is the gospel of life."

The ship was in Aden on November 9, just a week away from arrival in Bombay. Anandi took a turn for the worse:

> Her tickling cough still disturbs her. It has not abated in the least. Her low state of health precludes taking any nourishment. She brings out everything she eats. The surgeon, on board, recommended champagne, brandy, claret and whiskey. She drank more of them in these three days than she did in America in 3 years.

The resort to alcohol, in large variety and quantity, was an indication of Anandi's dire condition. As Theodocia would later clarify, "Dr. Joshee never took stimulants except for medicine and never for that if she thought it avoidable."

Although Anandi and Gopal could not know this, their arrival in Bombay was being anticipated with great excitement. The *Indu Prakash* noted, "This enterprising lady and her husband have set a courageous example to their countrymen and countrywomen." It closed with the hope that "she will on her return be given a suitable public reception." The newspaper did its part to create a feeling of respect and welcome in the hearts of its readers.

The *Peshawar* reached Bombay on November 16, 1886. Anandi mustered the energy to carefully prepare for her re-entry. Eschewing the Gujarati style of draping the sari that she had adopted in America in order to stay warm, she donned the traditional nine-yard sari worn by women of her Chitpawan

Brahmin caste; the sari was a black "*Narayan-pethi chandrakala*," a much-loved ceremonial design. In addition, she put on the nose ring and ear ornaments that women typically wore to celebratory events. Anandi was asserting that she was indeed returning, as she had promised, as a cultured Hindu woman.

Several of Gopal's friends were at the harbor to greet the couple as they disembarked. As was the custom, they showered the couple with flowers. Indeed, the Joshees' arrival was treated as the triumphant return of a conquering hero—or, as in this case, heroine.

Newspaper reports were exuberant in their praise of the fact that Anandi had retained her religious and cultural identity. The November 21 issue of *Subodh Patrika* noted:

> All the patriots of India and those who value female education cannot but be pleased by the Joshees' arrival. After all, this is the first time ever that an Indian has gone abroad for an education, studied hard, passed the examinations, achieved a medical degree, and returned to India. It is particularly satisfying that she will now serve the country and her people.

Accolades and telegrams of congratulations poured in. An admirer sent a letter regretting his inability to be in Bombay to welcome Anandi in person. He assured her that news of her achievement and of her return had reached even his small town. With words of gratitude and reverence, he expressed hope that Anandi would use her education to educate others. He closed by wishing the Joshees good health and long lives.

Anandi's mother, grandmother, and sisters rushed to Bombay, as did her mother-in-law and Gopal's younger brother. Putting past acrimonies aside, all were eager to welcome her and

nurse her back to health.

The Dewan of Kolapore, who had made the formal job offer to Anandi, happened to be in Bombay. Aware of the fact that Anandi's internship in Boston had been cut short because of her health, he suggested that she "… attend either Cama or J. J. Hospital or both for two months in order to acquire practical knowledge." Anandi would be paid an allowance equal to half her salary during this "internship." The Cama Hospital had opened just a few months earlier, whereas the J. J. Hospital had been in operation since the 1840s. Both hospitals were the result of collaborations between the British government and wealthy Parsi businessmen.

All the goodwill and plans notwithstanding, the Joshees faced challenges almost immediately. Anandi's declining health was the most significant one. She continued to run a fever and have uncontrollable bouts of cough; she was often too weak even to get out of bed. Many people believed—or just wished— that her illness was nothing beyond exhaustion, as a result of the years spent in a challenging climate with inadequate vegetarian food, and followed by a long and difficult voyage.

Addressing Anandi's condition was made more difficult in that the Joshees had no home of their own in Bombay. Instead, they had to rely on the kindness and generosity of their relatives and well-wishers. But these people lived in small tenement homes that were barely sufficient for their own families' needs. They simply could not offer the comfort and hospitality to the extent that Anandi desperately needed.

During their first several weeks back in India, Anandi and

Gopal had to move four times. Anandi's mental anguish must have been amplified even further, for she could not be herself or feel "at home" wherever she happened to be staying. Her mother and sisters did not have the room to provide the care and nurturing that she needed. She continued to miss the comfort foods that she had craved for so long. Can a person truly feel at home if these needs of body and soul are largely unmet? In any event, dwelling on the deprivation of "home" was a luxury that neither Gopal nor Anandi could afford.

Anandi adhered to the gracious habits that had served her so well in America. She welcomed her visitors and exchanged a few words with each, despite the physical toll that extracted. If she suspected the gravity of her condition—which she must have, given her medical training—she kept those worries to herself. Indeed, she invested in the hope of a full recovery, making a request that "subscriptions should be made to several medical journals in America." Lacking financial resources, she affirmed that "the money [would] be forwarded after she reached Kolapore."

Gopal was consumed by worry about his wife's health. His hopes for Anandi's recovery were raised during her occasional better days or periods. But these brief intervals were then followed by days of increased fever and cough. "She is not much more than skin and bones," he wrote in a letter. "All of India has become a devotee of Dr. Joshee and is worried about her health."

Local European doctors were consulted. Ironically, in doing so, the Joshees overcame the barrier—that male doctors could not treat female patients—that had first impelled them to pursue Anandi's medical education. The consensus among those

doctors was that Anandi's case was hopeless, and some went so far as to suggest that she might be suffering from "consumption," or tuberculosis.

Straddling a pendulum he could not control, Gopal felt nearly defeated. Desperate for a breakthrough and after consultation with one of the doctors, Gopal decided that they should move to Poona. He hoped that the city's higher elevation and its dry and temperate weather would more than make up for the difficult train journey. Also, both he and Anandi put their faith in consulting Bapu-rao Mehendale, the most highly regarded *vaidya*, or Ayurvedic doctor, in Poona. They hoped that this "native" doctor would have the appropriate skill and insight necessary for restoring her to health.

The cool breezes and low humidity, distinctive of Poona, are especially appreciated by people arriving from oppressively hot and humid Bombay. The city's famed breezes seemed to extend a salubrious welcome to Anandi. Soon after arriving in Poona, her cough lessened. Despite not taking any medicine for three days, her appetite returned and she began to feel energetic.

Once again, this reprieve in health did not last long, and Anandi's condition deteriorated over the next few weeks. "Hoping for the best and preparing for the worst" became the motto of the Joshees as well as of the local community.

Members of the community were so moved by compassion and sympathy for Anandi that they no longer shunned the couple who were, in their view, sinners. Gopal was amazed that among their many visitors were old-timers and even Hindu conservatives—the ones he expected would be the staunchest

in rejecting Anandi, and most likely to see in her difficulties a just punishment from God.

Dropping their opposition to the ones who had, in their view, committed sin by crossing the seas and living among non-Brahmins, the Hindu priests offered to perform *puja* rituals. Gopal participated, not because he necessarily believed that the rituals would help Anandi's health improve, but out of respect for the generosity and forgiveness shown. Maybe this is how faith works. For some it is the belief that fervent prayer will lead to a desired outcome. Non-believers who, setting aside their own disbelief, honor such faith, sometimes find that their cynicism or feeling of helplessness is replaced by feelings of hope and agency.

Given Anandi's weakened condition, it fell to Gopal to write to Theodocia. He asked her to continue to pray for Anandi's health. He wrote:

> *She has read your letters over and over again. It has proved a tonic to her in her sickness. A kind and encouraging word from you is worth millions. I will write to you and you reply to her so that she will think of it as if it were her own.*

In fact, between the end of November and the end of December Gopal sent four letters to Theodocia. Amazingly, the man who had repeatedly railed against Christians and their ways made sure to convey fond Christmas greetings to the Carpenters.

Anandi's reaction to her condition was also out of character. Gone was the young woman who had courageously defied family, community, and religion. In her place was a patient conformist who was willing to embrace the faith of those near and dear to her. She rejected being touched by people of another

caste—the European women who visited her as well as the maidservant who waited on her.

Gopal "showed her the foolishness of such thoughts being entertained by one who had spent some years in America." Anandi's stated defense was that her grandmother, mother, and sisters (who had all followed her to Poona in order to continue to care for her) "abhorred" such practices and that she "must try to please them." Maybe that is how tolerance works. When we extend compassion rather than judgment to those with whom we disagree, they in turn feel inspired to do the same.

As Anandi was in no position to begin her job in Kolapore, she had no choice but to request a time extension from her future employer, as well as a continuation of the allowance that was being paid, with the understanding that she would acquire additional practical experience at the hospitals in Bombay. Although a two-month extension was granted, the council regretted "their inability to continue [your] allowance during the extended period." This was a big blow and the response that Anandi wrote, requesting a reconsideration of the decision, underscores her desperate situation on both health and financial fronts:

> The grant of extension without an allowance enhances my difficulties immeasurably. I therefore hope that the Council of Administration will kindly reconsider the matter, as financially I am very much strained. . . . In my present condition, confined as I have been to my bed for several months, I shall be placed in very great difficulty for want of funds. I shall esteem it as a final favor if the present Council of Administration will. . . sanction the allowance.

It must have been humiliating to have to essentially beg for an unearned income. And so, as an afterthought, she added a postscript to her letter:

> *I need hardly add that I should not have ventured to make any such request if I had not been confined to bed by a serious disorder.*

It is not known whether the court administrators responded favorably to Anandi's plea. However, some financial help did arrive. It was from two entirely unexpected sources.

Although Anandi had been away for just under four years, there had already been major changes in the attitudes toward women in India. Indeed, education had taken something of a back seat to the expressed urgency of making medical care available to women. Hospitals were being opened in numerous towns and cities across the country. These projects were supported by the British government and were financed by Indian businessmen. In addition to the Cama Hospital in Bombay and the Albert Edward Hospital in Kolapore, the Victoria Jubilee Hospital had opened in Madras and the Victoria Jubilee Female Dispensary in Ahmedabad.

There can be no better example of the interest that the British elite took in this matter than Lady Dufferin, the wife of the Viceroy. Soon after arriving in Calcutta in 1884 (just a year after Anandi left the city), Lady Dufferin set up the "National Association for Supplying Medical Aid to the Women of India." Amazingly, "she had been asked to take an interest in the medical relief of Indian women by Queen Victoria, who had been upset by the accounts of Mary Scharlieb and Elizabeth

Bielby.... regarding their experience in this matter."

The aim of the Association, which soon became known as the *Lady Dufferin Fund*, was "to train women as doctors, nurses and midwives, to provide female wards in existing hospitals, and to endow hospitals for women and children." Lady Dufferin believed passionately in this cause and lent the full weight of her husband's office and her celebrity to fundraising efforts. A letter she sent to the *Indian Magazine* appealed to well-heeled women in England as well as in India.

"Lady Dufferin" hospitals, medical colleges, and clinics dot India and Pakistan even to the present day and continue to provide care to women and children. Some locations with Lady Dufferin hospitals are Kolkata, Amravati, Kanpur, Lucknow, and Karachi.

British officials and their wives joined the fundraising efforts. Notable among these was Lady Reay, the wife of the governor of Bombay, who established the Bombay branch of the Dufferin Fund. When word of the financial travails of the Joshees reached her, she arranged to send them a sum of one hundred rupees. This amounted to about a third of Anandi's anticipated monthly salary. Through her donation, Lady Reay not only helped a woman seriously in need of medical care, but also acknowledged the special role that Anandi was expected to play in bringing such care to the women of India.

Those who came to know of this gift could not help noting the lack of a similar gesture by any member of the Indian community. However, it was not long before a fellow Indian also sent a donation to the Joshees. This was Bal Gangadhar Tilak, who, only about a decade older than Anandi, had already made a name for himself as an Indian nationalist, teacher, social re-

former, and publisher of two newspapers. Though it was a sum he could ill afford, he did it as a way to honor Anandi's courage and achievement.

The availability of these funds alleviated the immediate financial pressures facing the Joshees. However, Anandi's dire health remained their primary challenge and Gopal remained focused on finding the breakthrough that might turn things around.

Within days of getting settled in Poona, Gopal consulted Vaidya Mehendale, who immediately put Anandi on a regimen of Ayurvedic medicines and a strict diet. Unfortunately, her condition failed to show sustained improvement and Gopal discontinued the regimen. Despite his lack of medical training, Gopal independently disregarded the advice of the very expert they had moved to Poona to consult. In response, Mehendale promptly declined to continue to treat Anandi.

The totality of Anandi's symptoms pointed to a diagnosis of "kshay." At the time, this disease was colloquially translated as *phthisis* (now, tuberculosis). The literal meaning of *kshay* is "corrosion," a parallel to Western *wasting*. In Ayurvedic science the disease is considered to be correlated with tuberculosis, but not entirely identical to it. According to Ayurvedic understanding, it is a syndrome characterized by lack of energy, cough, and loss of appetite. It was believed to be caused by a confluence of extreme mental or emotional stress, lack of adequate food and nourishment, and a muzzling of physical or emotional urges. Even a casual observer could see that all of these factors had confronted Anandi for some years.

The first medicine that the next *vaidya* prescribed was a tea prepared using several herbs. The recipe called for the use of seven leaves of the *adulsa* plant. This plant continues to be utilized in over-the-counter Ayurvedic treatments for cough and congestion.

Once again, Gopal second-guessed professional advice. In an attempt to accelerate Anandi's recovery, he doubled and then tripled the number of adulsa leaves in the tea. Anandi tried to dissuade Gopal, urging caution. He did not relent and as she feared, the modification caused an extreme reaction and had to be discontinued.

Gopal consulted a third *vaidya* who prescribed an intense regimen, considered an option of last resort. For seven days, the patient was allowed to consume only cow's or goat's milk. She could not have any food or water. The lack of food presented no added hardship as Anandi already had virtually no appetite. However, deprivation of water proved enormously challenging. Feeling parched, she was reduced to begging and pleading for water. After half a day of extreme agony, and unable to see Anandi suffer so greatly, Gopal relented and gave her some water. By this time, Anandi's condition had become undeniably bleak. Noting her swollen feet, people who were familiar with the progression of the disease knew that Anandi had reached its final stage.

It was now eight weeks since Anandi and Gopal moved to Poona. During that time, they had had to move three times within the city. Their final stop was the home of Anandi's grandfather, the very home where she had entered the world. Too weak to walk, she had to be carried in a chair. She was surrounded by her mother, grandmother, and sisters. Both Indian

and European well-wishers continued to visit her, offering their prayers and best wishes.

Notwithstanding his reactive interference, Gopal was still Anandi's primary caregiver. He did everything from washing her after she had spells of phlegm-producing cough, to keeping her company during the long nights without sleep or tormented by nightmares.

She would dream that she had started her job in Kolapore and that she was busy treating patients; she would be interrupted by missionary women who would insist on explaining the science to her patients; there would be disagreements and to settle these, they would have to appeal to the government. This final escalation would jolt her awake with intense feelings of fear and despair. Beyond her formidable physical challenges, she was tormented by the heartbreak of being thwarted from her mission.

In one of her early letters to Theodocia, long before America emerged as her chosen destination, Anandi had eloquently described the role that dreams played in her ability to figure things out:

> *To tell you the truth I always labor under inward impressions. I solve many difficult things while sleeping...*
> *. I do not know who teaches me but I make my progress thus.*

Nearing the end of her life, with unfinished business and unresolved conflicts, Anandi's exhausted mind still used the same skills to process, and prepare to accept, the final verdict. There would be no vindication and there would be no redemption.

February 26, 1887 was a Saturday. On that day, her mother and sisters were near, as was Gopal. All were dedicated to ensuring Anandi's comfort, as that was all they could do for her. To keep her engaged and entertained, her sisters took turns talking to her, especially reminiscing about earlier times. Her mother fed her a few morsels of food, but Anandi could not keep them down. Finally, Gopal fed her a few spoons of milk, hoping that those would give her some energy. Seeing that she stabilized somewhat, both mother and Gopal tried to get some rest.

After a short while, Anandi screamed in agony. Abruptly awakened, her mother rushed to her bedside, only to hear Anandi's last words:

"I have done all that I could."

Epilogue

Life is the childhood of our immortality.
Johann Wolfgang Von Goethe

*A*t the time of her death, Anandi was a month shy of her twenty-second birthday. Hundreds attended her funeral. Over the following days, notices were published in newspapers all over India, in English as well as in local languages. They appeared in major cities like Bombay, Calcutta, Lahore, and Karachi as well as in small towns like Harda and Bankipur. The names of the newspapers reflected their aspirations and worldviews: *Nyaya Sudha* (Elixir of Justice), *Deen Bandhu* (Brother of the Poor), *Young India, Native Opinion* and *Mahomedan Observer.*

Each of the obituaries provided a rough outline of Anandi's life story and condolences to her husband. Some saw her death as a great loss to the country:

> "Why has worth so short a date? While villains ripen
> grey with time.".... Death has seldom closed a more
> promising career.... No disappointment could be bit-
> terer no loss heavier.... In her, India has lost one of her
> noblest and bravest daughters!

There was praise for her courage and sacrifice:

... the example she has set will not be fruitless. It is indeed wonderful that a Brahman lady has proved to the world that the great qualities of perseverance, unselfishness, undaunted courage and an eager desire to serve one's country do exist in the so-called weaker sex... Although she suffered more than words can express from her mortal disease, phthisis, not a word either of complaint or impatience escaped her lips at any time... After months of dreadful suffering she was reduced to skin and bone, and every one that looked at her could not but be greatly pained; yet, wonderful to relate, Anandibai thought it her present duty to suffer silently and cheerfully.

There was regret for what her death might mean for the cause of women's education and their access to medical care:

The country expected great things from her, but alas! All these hopes have so soon and so sadly been brought to the dust.... female education will not fail to suffer in the estimation of our people for some time... It will be very long indeed before India rears another martyr to science and missionary of progress like Anandibai Joshi [sp]... Her loss at a time when the value of female physicians is beginning to be realized in India is specially to be deplored.

There were calls to action that she might be remembered and honored, that the work that she had begun might continue, and that her life might inspire others:

[Our countrymen]...ought to first take up the noble example set up by her and follow her in her integrity of purpose, perseverance and exceptional courage to overthrow the social thraldom of her sex... We ought as a people to do something that will remind us of her and bear witness forever to her wondrous virtues; in our

opinion, this debt of gratitude to Anandibai cannot be better discharged than by providing a lady, who will be willing to study medicine, with all the pecuniary aid necessary. Thus may the memory of the late distinguished lady be perpetuated.

Anandi's success was seen as proof positive that Indian women were indeed capable of learning and achieving, of thinking and doing, and of being of service beyond the narrow realm of home and family. A newspaper that remained skeptical about Indian women pursuing education in foreign lands nevertheless acknowledged Anandi's vast achievements; another challenged educated men, in particular, to both honor and continue to pursue the changes she had set in motion:

> Even before she went to America for her medical education, Anandibai took pleasure not in clothing or ornamenting herself richly but rather in sparing what she could for the benefit of the needy and now that she has sacrificed her life in the laudable ambition her name ought not to be forgotten. The educated men of Maharashtra owe this duty to her memory and we hope they will duly respond to its call.

America had adopted Anandi as a niece before India could fully accept her—and grieve her death—as a daughter. Notices of Anandi's death were published in Western newspapers as well. The obituary published by the *Philadelphia Telegraph* and reprinted in the *New York Times* was representative of the sentiments expressed:

> Those who knew Anandabai Joshee, the Hindu woman who studied medicine in this city and who graduated and took the M.D. degree in 1886, and who at all understood the nature of the mission she undertook, will

hear with the very sincerest regret of her death. It requires much courage for an American woman to study medicine and to practice it as a profession, but this Hindu woman, in undertaking this study, violated some of the most important traditions of her race and defied the most bigoted opinions of the social order to which she belonged. She did what she did because she knew that there was a pressing need in India for the ministrations of female physicians, and her memory deserves to be held in lasting honor for the courage and consistency with which she sought to perform a great and pressingly important duty.

Caroline Dall's biography of Anandi, titled, *The Life of Dr. Anandabai Joshee: A Kinswoman of the Pundita Ramabai*, was published in 1888—just a year after Anandi's passing. Dall was motivated to honor Anandi's courage, suffering, and character. So deep was her regard for Anandi—who was several decades younger than she—that Dall felt "obliged to moderate the terms of affection and admiration which would have seemed extravagant to those who never saw her, or saw her only after her star 'drooped toward its setting.'" In the closing words of the biography, Dall expressed hope that Anandi's short life may yet be redeemed:

> We feel that her death, in sorrow, disappointment, and bodily anguish, will in God's own way accomplish still more than the life for which we prayed.

Dall proved to be remarkably prescient. Thanks to the projects to digitize books whose copyrights had expired, her book got a second life more than a century after it was originally published. It is now available as a free download on Google

Books and on archive.org. In this internet age, her book is a first introduction for people seeking information about Anandi. And Dall's book is just informative enough to motivate readers to want to know more.

Dall's secondary motivation was to raise funds for Indian women's education through sales of the book. Her book succeeded in meeting this goal as well.

Three other books were published over the next three years; each of the books was a first in the realm of women's achievement.

A biography about Anandi's life was published in India in 1889. It was written in Marathi by a woman named Kashi-bai Kanetkar. Her husband, though living in a small town far from the metropolises of Bombay and Poona, was swept up in the fervor of social reform and homeschooled Kashi-bai. Believing passionately in the importance of telling Anandi's story, but lacking self-confidence, Kashi-bai begged many able men to write the biography. With none forthcoming, she finally undertook the writing as her own labor of love. Kashi-bai deserves credit for two firsts. She wrote the first biography *of* an Indian woman, and she was the first Indian woman to *write* a biography.

Dean Bodley's and Rama-bai's shared love of Christ and their belief in women's empowerment was the fertile ground in which they planted seeds of activism. Rama-bai wrote a book called "The High-Caste Hindoo Woman" and she had Dean Bodley write its introduction. Sales of that book raised thousands of dollars for Indian women's education.

Finally, Rama-bai also became the first Indian woman to write a travelogue. It provided "rare and remarkable insight into

an Indian woman's take on American culture in the 19th century." Written in Marathi, it gave Indian readers a glimpse of the society that had welcomed Anandi and facilitated her achievements.

According to social scientists like Elisabeth Kubler-Ross, the initial recognition of one's own approaching death is surely accompanied by shock. After subsequently passing through various stages that likely include denial, anger, bargaining, and depression, a person grieving his or her own end may finally reach the stage of acceptance. In this stage, the mind turns to the tasks of closing the books on unfinished business, to finally having one's say, and to asserting one's deeply held desires.

In life, Anandi exercised but one degree of freedom—pursuing an education in a land across the oceans. However, even this was not entirely of her own choosing, for it had been, at least initially, at the behest of her husband. In the course of pursuing that goal, she had to adhere to many restrictions pertaining to diet, attire, and religion. Had she had the freedom to eschew those restrictions, she would surely have had an easier path and it would quite possibly have preserved her health.

So, as the end of her life drew near, Anandi recognized that she would never again be in the company of her dear Aunt Theodocia. With that realization Anandi claimed a final degree of freedom. She made Gopal promise that after her death he would send her ashes to America, to be buried in the Eighmie family plot in Poughkeepsie, New York.

Anandi was no longer willing to follow religious customs that no longer made sense to her, nor would she let the great distance separate her from her aunt any longer. She would *return*

to her aunt and she would be "home"—visited by members of the Carpenter family who had accepted her as their own, resting among them.

Iconoclast that he was, Gopal agreed to his wife's unusual last request. Perhaps in the end, he was motivated most by compassion for his long-suffering wife and respect for the depth of her relationship with Theodocia. Six years passed before he was able to find a courier able to deliver Anandi's ashes to Theodocia.

In the meantime, Gopal returned to his erratic ways, challenging his society and its customs with full force. In a letter to the *Poona Vaibhav*, he explained why he was disenchanted with Hinduism and considering converting to Christianity:

> *There are four castes in the Hindu religion. This I do not assent to. All men are one. Keep up these distinctions at home if you wish. But I do not regard that as a divine religion that allows the Brahman to go into the house of God and forbids the Mahar [a "low" caste] to go.*

Next, he voiced strong disapproval of Hinduism's path of "washing away sins":

> *According to the Hindu religion a man must spend his whole life in wearisome labors to get rid of sin and after all he doesn't know in what state his future birth will find him. For this reason the Hindus have lost ambition and are brought down to the dust. The method of washing away sin in the Christian religion is rational. It is not necessary to kill the body. There is no need of austerities. Bathing is for cleanliness. The way of eternal happiness is the same for all...*

Strangely enough, just a few months later, Gopal actually converted to Christianity. This he accomplished very publicly, in a way that suggested his genuine desire to correct a past wrong:

> *I have not been an admirer of Christ and his disciples. I have spoken hard things against Christianity and the missionaries in general. I have vilified them to the bitterest point possible. Mr. James Taylor was the missionary alluded to in all my lectures in America against Christianity. And is it not right for me to receive baptism at the hands of one whom I have vilified?*

However, his was a conversion unlike any other. Gopal continued to wear his sacred Hindu thread and the mark on his forehead. He stated that, although he had "accepted Christ as his Saviour, he does not cease to be a Hindu." And then, after only a month or so, he returned formally to the Hindu fold.

Gopal instigated two additional controversies over the course of the following year. In one bizarre instance, he conducted a *public wedding of two donkeys*. This was his way of protesting the child marriages that were still taking place.

The second instance was essentially a literal "storm in a teacup." A meeting was held in Poona which included progressive and conservative Hindus as well as local missionaries. Tea and biscuits were served and were shared by most in attendance. Six months later, Gopal published the names of all the attendees in a local newspaper, causing them great embarrassment. The sharing of food with Christians was considered tantamount to giving up the Hindu faith. Worse yet, the Indian progressives were portrayed as being in cahoots with the missionaries to undermine caste orthodoxy, while the very

presence of the more orthodox at the gathering undermined their standing as upholders of traditional values. The result was a stirring of much acrimony between and within the conservative and reform Hindu communities. Once again, Gopal managed to poke the establishment right in the eye.

Alongside these events, a hunger for progress fueled the evolution of Indians' attitudes toward the status of women. In 1890, Manak-bai Lad launched a Marathi magazine called *Arya Bhagini*—Aryan Sister—which easily received over five hundred subscriptions. Lad chose topics that encouraged progressive thinking relating to women, such as "The Education of Children" and "Female Education." The magazine offered critiques of practices that were detrimental to women's well-being—"Early Marriage" and "Marriages of Old Men with Young Girls." India, even in the short years following Anandi's death, experienced much restlessness and was on the threshold of significant change.

Gopal sent Anandi's ashes to America with two individuals who sailed there in 1893. Rev. B. B. Nagarkar was a member of the Brahmo Samaj, a progressive Hindu sect that sought to marry the best of Christianity to the best of Hinduism. Jeanne Sorabji hailed from a Parsi family that had converted to Christianity. The two were part of a contingent of representatives of the many religions of India, setting off to America to attend the first Parliament of World Religions.

That event was part of the 1893 World's Columbian Exposition organized in Chicago in celebration of the 400th anni-

versary of the discovery of America by Christopher Columbus. True to its grand scale—spread over more than six hundred land acres and with representatives from forty-six countries—and ambition, the Exposition featured exhibits on content as diverse as anthropology, guns, artillery, architecture, and horticulture. Products that are still with us today, like Cream of Wheat and Pabst Blue Ribbon beer, were introduced there. Another first was a "moving walkway" which "allowed people to walk along or ride in seats."

A most unusual "first" in this mecca of industry, innovation, consumerism, and entertainment, was the Parliament of World Religions. It was "the first formal gathering of representatives of Eastern and Western spiritual traditions from around the world." Indeed, this "parliament" is widely recognized as the inception of a formal worldwide interfaith dialogue. It brought together representatives of mainstream Christian denominations, large and small Eastern religions, as well as newer faith traditions, such as Brahmo, Theosophy, Spiritualism, and Christian Science.

At the gathering, Rev. Nagarkar spoke about the need for social and religious reform in India. Jeanne Sorabji, one of only nineteen women speakers, described the state of Indian women. "They live in seclusion, not ignorance," she stated while listing the many positive changes that had taken place or were already under way for the women of India. She ended her speech with words of ambition and confidence:

> My countrywomen will soon be spoken of as the greatest scientists, artists, mathematicians and preachers of the world.

Over the ensuing years, the Parliament came to be billed as the first encounter of America with Hinduism. This was due to

an energetically delivered and enthusiastically received speech by Swami Vivekananda. But of course, an introduction had taken place more than a decade before when Anandi Joshee landed in New York in the spring of 1883 and then spent several months with the Carpenter family in Roselle, New Jersey. Though Anandi's arrival and period of study in America was groundbreaking and received coverage by the news media of the time, Swami Vivekananda's speech was witnessed by vaster crowds, and in a larger, more publicized setting.

On Sunday October 22 1893, a service was held at the All Souls' Unitarian Church in Chicago. The speakers that day were Rev. Jenkin Lloyd Jones, the presiding minister, Rev. Nagarkar, Theodocia Carpenter, and Jeanne Sorabji.

An urn made of "Benares" brass was placed on a flower-adorned table. About nine inches in height, it was beautifully carved and featured a likeness of the Hindu god Vishnu. As for the attendees, "The church was crowded even beyond its limits, out into the halls and to the doors." Rev. Jones opened the service and singing of the hymn, "Very Near," one of Anandi's favorites, followed. Rev. Nagarkar spoke of Anandi's early life and of her strong desire of an education.

Theodocia knew that this would be the last public event dedicated to Anandi. As such, she allowed herself the opportunity to relate her personal story with Anandi and, in particular, speak about the divine inspiration that she believed compelled her to write her first letter to the Joshees:

> *The Indian letters aroused my deepest sympathies, but*
> *Rev. Wilder's called forth a feeling of indignation, that*
> *an appeal in behalf of education should be met with*

> *advice to stay where they were and to work for a reli-*
> *gion in which they had no faith.*

She described how her impulse to reach out and offer help and encouragement was checked by other considerations:

> *I knew of no situation ready and adapted to the call*
> *and abilities of Mr. Joshee and with so many of our*
> *people out of employment and failing to find it to their*
> *satisfaction, I could not encourage him to come on an*
> *uncertainty.*

However, an unusual occurrence the next morning changed everything:

> *Without having said a word to anybody about what I*
> *had read nor giving a hint that I thought of writing*
> *to Mr. and Mrs. Joshee you may judge of my surprise*
> *when the following morning my little daughter said,*
> *"Mamma, I dreamed today that you were going to*
> *write to somebody in Hindostan."*

Theodocia's daughter was too young to have studied the map of India. In keeping with prevalent convention, Theodocia tended to think of the faraway land as "British India," rather than "Hindostan." At that moment, her Spiritualist beliefs inclined her to believe in a divine plan with the intervention of helpful spirits. "Someone beside me must be interested in this," she thought to herself. And so she "wrote to the child wife, and after some years of correspondence brought her out here."

So it was that Anandi was home with the Carpenters once again. Her ashes were buried in their family plot, as she had requested. Theodocia and her older daughter, Eighmie, were buried next to her after their deaths. Theodocia's and Anandi's tombstones remain side by side in plot 216-A of Poughkeepsie

Rural Cemetery. They continue to silently proclaim the eternal bond forged by two remarkable women, who joined in kinship from opposite sides of the globe. That bond has already endured for well over a century, and it continues to quietly inspire those who are fortunate enough to learn of it.

The International Astronomical Union (IAU) sets the naming conventions for planets and their features. Because Venus is the only major planet named for a female deity, the IAU decided to assign female names to all features on Venus. Their guidelines stipulated that the names should be commemorative of noteworthy historical women. However, the women cannot be political or military figures of the nineteenth or twentieth centuries, nor can they be religious figures of any era. Suggestions for commemorations go through a lengthy review process, administered by the US Geological Survey in Flagstaff, Arizona.

The craters number about nine hundred and are named after women scientists, physicians, artists, writers, journalists, and educators from all over the world. Notable among them are Irene Joliot-Curie (daughter of Marie and Pierre Curie), Harriet Beecher Stowe, Sojourner Truth, Harriet Tubman, and Rachel Carson.

Three of the craters are named after Indian women. The "Medhavi" crater is named after Anandi's cousin Rama-bai in recognition of her work on behalf of Indian women's education. The "Jhirad" crater is named after Dr. Jerusha Jhirad, who belonged to the Bene Israel Indian Jewish community and was the first Indian woman to be granted a scholarship by the (British) Indian government to study abroad. The third crater,

also the most well-known, is the "Joshee" crater. It honors Anandi and her remarkable life and achievements.

Anandi set out to become a doctor so she could *be useful* to her countrywomen by providing medical care and alleviating their suffering. As it turned out, she achieved her purpose in a different, but no less significant way—by proving, beyond the shadow of a doubt, that women are indeed capable of being useful and that the world needs the talents and unique contributions of all individuals, including its women.

ACKNOWLEDGMENTS

We build on foundations we did not lay
We warm ourselves by fires we did not light
We sit in the shade of trees we did not plant
We drink from wells we did not dig
We are ever bound in community.

<div align="center">

Peter Raible
Unitarian Universalist Minister

</div>

I have built this book on foundations laid by people both known and unknown to me. Composing these acknowledgments is my opportunity to let them know that their work mattered beyond what they may have heretofore known or imagined.

The first among these is Robert Kanigel, author of the beautiful biography of Indian mathematician S. Ramanujan, *The Man Who Knew Infinity*. I thank Robert for igniting my interest in the biography genre. After I decided to write this book, he helped me by answering my occasional queries and by encouraging my efforts.

Next, I would like to thank Rohini Godbole and Ram Ramaswamy who edited a volume of personal essays by Indian women titled *Lilavati's Daughters*. I would also like to thank the Indian Academy of Sciences (Bangalore), for publishing the volume in 2008 and making it freely available online. Pooja Thakkar deserves special gratitude because it was her essay about Anandi Joshee that inspired me to look deeper into the story.

The staff at Poughkeepsie Rural Cemetery was extremely welcoming and helpful. They provided a packet containing a map of the Eighmie (Carpenter) cemetery plot and other information about the family. They also provided the name and

313 • *Radical Spirits*

address of a descendant of the Carpenter family.

I thank Theodocia's great-granddaughter, Nancy Cobb Stone. She generously invited me to her home. She shared recollections of her grandmother Helena, who was a little girl during the several years Anandi was in the United States. I realized that in meeting Mrs. Stone, I was within three degrees of separation from Anandi! Mrs. Stone lent me the entire collection of letters that had been exchanged by Anandi and Theodocia.

Google Books was an invaluable resource. If they had not digitized old books, made them searchable, and made them freely available, I am uncertain as to whether I would have been inspired to pursue the story. Indeed, without Google Books I would not have located the countless fascinating references that enabled me to tell a richly layered story.

The Massachusetts Historical Society, which houses the papers of Caroline Dall, was helpful beyond imagination. Their well-documented web site helped me identify the relevant microfiche reels. Purely on my telephone request (and even though I did not have any institutional affiliation), they mailed the reels I requested to the library in Raleigh (where I live). I thank the Wake County Library system for making microfiche readers available and for receiving and mailing back these microfiche reels.

I thank the Drexel University School of Medicine Archives in Philadelphia for their extensive collection of materials relating to Woman's Medical College of Pennsylvania. In particular, Matthew Herbison was immensely helpful to my endeavor. His remarks about the outsize appeal of "Joshee's story" (based on the number of queries received) felt like a much-needed vote of

confidence in what seemed at the time as my lonely and quixotic quest.

I wanted to access the archives of the *Times of India* in Mumbai. An in-person visit to the newspaper's offices in Mumbai had proved fruitless. As a result of a chance interaction, I learned that I would be able to access the archives much closer to home. I wish to thank the Duke University Library for their collections, facilities, and helpful staff.

The support of two other institutions deserves mention. I learned that the full text of the speech delivered by Anandi in Calcutta was available in the archives of the British Library in London. A quick phone call, a credit card payment, and voila—in a few weeks I received a CD containing the original speech, including the Sanskrit quotations with which Anandi peppered her speech. In a similar fashion, I was able to obtain a copy of a speech delivered by Gopal Joshee in Rochester, NY, from the New York Public Library.

I wish to thank Dr. Anjali Kirtane and the late Mrs. Kashbai Kanetkar. Mrs. Kanetkar's Marathi biography of Anandi was published in 1889. Dr. Kirtane's Marathi biography was published in 1991. Both books were indispensable resources that illuminated the Indian side of the story. Finally, all of Anandi's available letters were compiled in a book in 1997. I thank the editors of "Anandi-Gopal: New Profiles from Unpublished Sources": Dr. C. N. Parchure, Dr. Supriya Atre, and Mr. M. M. Omkar for this.

The person who helped and supported me most is Dr. Michele Zembow. She held my hand and stood with me during stressful periods. She is my champion and sounding board. She also made a final edit of this book. Everyone should have at least

one friend like Michele.

Dr. Ranjani Rao, who lives in Singapore, is much more than my writing partner. We co-founded Story Artisan Press and have, to date, published five short anthologies of personal essays and short stories. With her energy and knack for marketing she is an able social media consultant for this book. Our weekly video calls, which are typically two hours long, are a lifeline on my writing and publishing journey. At the risk of repeating myself, I state that everyone should have a friend like Ranjani.

My first reader was Anne Slater. Her thoughtful and encouraging feedback helped me develop confidence in my authority and ability to write this book. My second reader was the late Caroline Bridgman-Rees. Decades older than I, a lifelong peace activist, and a feminist who loved India, she was my *Caroline Dall.*

Melinda Fine designed the book's interior. Her patience and commitment to my book were exceptional.

Last, but not least, I thank my family members.

My parents, Sunita and Bhalchandra Patwardhan, and my grandparents Vimal and Shankar Damle, raised me to be an empowered woman and a lifelong learner.

My children, Ashley and Ryan, and my son-in-law, Elie Schoppik are a source of tremendous pride and joy. And my husband, Sameer Pandya, is the original history buff in our family. For a decade, Sameer has faithfully stood by me and picked up the slack created by my consuming preoccupation with this book.

Namaste!

NOTES

Abbreviations

CARPENTER-JOSHEE *Letters between Theodocia Carpenter and Anandi Joshee.*
Carpenter family private collection.

DALL: Dall, Caroline W. H. (1888). *The Life of Dr. Anandabai Joshee.* Boston: Roberts Brothers.

KANETKAR: Kanetkar, K. (1889, 2002). *Dr. Anandibai Joshee Yanche Charitra.* Mumbai, India: Popular Prakashan.

KIRTANE Kirtane, A. (1997, 2003). *Dr. Anandibai Joshee: Kaal ani Kartritva.* Mumbai, India: Majestic Prakashan.

PARCHURE: PARCHURE, Atre, Omkar (eds.) (1997). *Anandi-Gopal: New Profiles from Published Sources.* Pune, India: Bharatiya Itihas Sankalan Samiti, Maharashtra.

CHAPTER 1. A CLUB OF ICONOCLASTS

1 ***One tombstone distinguishes this lot:***
https://tinyurl.com/radspi-0101

4 ***lay passive:*** Dall, Caroline W. H. (1888) *The Life of Dr. Anandabai Joshee* Boston: Roberts Brothers, p. 22.

6 ***tread in my footsteps:*** DALL, p. 24.

7 ***frugal, pushing, active:*** Johnson, G. "Chitpavan Brahmins and Politics in Western India." (1970) in *Elites in South Asia,* eds E. Leach & S. N. Mukherjee Cambridge: University Press, p. 99.

8 ***open schools and colleges:*** JOHNSON, pp. 107-117.

8 ***embraced the importance of education:*** Kanetkar, K. *Dr. Anandibai Joshee Yanche Charitra.* (1889, 2002) Mumbai, India: Popular Prakashan, pp. 11-34.

14 ***sister's married life:*** Kirtane, A. (1997, 2003). *Dr. Anandibai Joshee: Kaal ani Kartritva.* Mumbai, India: Majestic Prakashan, p. 58.

20 ***What if I were to become a doctor:*** KIRTANE, p. 72.

CHAPTER 2. MISSIONARY ZEAL

21 ***grief:*** DALL, p. 32.

22 ***started to learn English:*** Joshee, Gopal to Wilder R. G. Kolapore

1878-Apr-09.

22 **move to a place:** KANETKAR, p 35.

22 **Mary J. Moysey:** *Journal of the National Indian Association* in *Aid of Social Progress in India,* No. 61. January 1876, pp. 267-270.

23 **handful of colleges:** Tikekar, Arun (2006). *The Cloister's Pale: A Biography of the University of Mumbai.* Mumbai, India: Popular Prakashan, p. 6.

23 **Anandi would ride in Miss Moysey's horse carriage:** KANETKAR, p. 36.

23 **Waves of Christian missionaries:** https://tinyurl.com/radspi-0201

23 **"broad" Unitarians:** DALL, p. 156.

24 **forced conversions:** https://en.wikipedia.org/wiki/Goa_Inquisition

24 **Dr. John Wilson:** TIKEKAR, pp. 62, 112, 141.

24 **The most surprising group:** Emily Conroy-Krutz (2015). *Christian Imperialism: Converting the World in the Early American Republic.* Ithaca and London: Cornell University Press, pp. 2-5.

24 **too small a presence:** EMILY CONROY-KRUTZ, pp. 62-64.

24 **Rev. Royal G. Wilder:** *The Record of the Presbyterian Church in the United States of America, Volumes 20-21* (1869), p. 57. https://tinyurl.com/radspi-0202

24 **Rev. Joseph M. Goheen:** https://tinyurl.com/radspi-0203

24 **noble and unselfish:** *Presbyterian Church in the U.S.A.* Board of Foreign Missions (1907), p. 212.

25 **idol worship:** EMILY CONROY-KRUTZ, pp. 80, 94.

25 **Gopal did not believe in idol worship:** Wilder, R. G. (1878). *The Missionary Review,* Volume I. Princeton, NJ, p. 48.

26 **returning from India in 1877:** https://tinyurl.com/radspi-0204

28 **purpose of my soul:** Wilder, R. G. (1861). *Mission Schools in India of the American Board of Commissioners for Foreign Missions: With Sketches of the Missions Among the North American Indians, the Sandwich Islands, the Armenians of Turkey, and the Nestorians of Persia.* New York: A.D.F. Randolph, p. v (Preface).

29 **attain equality:** Wilder, R. G. (1878). *Annual Report of the Regents,* Volume 91. Albany, NY: Charles Van Banthuysen & Sons. p. 418.

31 **pictured:** WILDER, p. before Preface.

32 **man's articulateness:** Wilder, R. G. (1878). *The Missionary Review,* Volume I. Princeton, NJ, pp. 47-50.

33 **old problem of 1776:** Wilder, R. G (1878). *Annual Report of the Regents,* Volume 91. Albany, NY: Charles Van Banthuysen & Sons, p. 424.

35 **Karbhari:** http://en.wikipedia.org/wiki/Karbhari

35 **positions of increasing prestige:** *Bombay Presidency* (1877).

Bombay Civil List. Bombay: Government Central Press, p. 144.

35 *insufficient to ensure:* Johnson, G. (1970). "Chitpavan Brahmins and Politics in Western India." In E. Leach & S. N. Mukherjee. (Eds.) *Elites in South Asia*. Cambridge: University Press, p. 100.

35 *potential traitor and competitor:* KANETKAR, pp. 36-37.

36 *Frederick Schneider:* Asiatic Society Of Bombay (1880). *Journal of the Asiatic Society of Bombay*, Volume 14. Bombay: Society's Library, Town Hall, pp. 147-154.

36 *political agent:* https://en.wikipedia.org/wiki/Political_agent

36 *letter of reference:* KANETKAR, p. 41.

37 *primary cotton supplier:* Beckert, S. (2015). *Empire of Cotton: A Global History*, pp. 255-256.

37 *commercial and financial capital:* Compilation (1876). *The Church Missionary Intelligencer and Record*. London: Church Missionary House, p. 487.

37 *globalization:* Leonowens A. H. (1884). *Life and Travel in India: Being Recollections of a Journey Before the Days of Railroads*. Location not available: Porter & Coates. New York: Vintage Books, p. 25.

38 *businessmen secured land and funding:* The Victoria Magazine: *Volume 11* (1868). London: Emily Faithfull, p. 185.

38 *zeal for educating:* Tikekar, Arun (2006). *The Cloister's Pale: A Biography of the University of Mumbai*. Mumbai, India: Popular Prakashan, pp. 111-112.

38 *Miss Dobson:* Joshee, Anandibai to Carpenter, T. E. Bhuj 1880-Jul-05.

38 *blindness to the feelings of others:* DALL, p. 51. *Joshee, Anandibai to Carpenter, T. E.* Barrackpore Post Office, 1881-Dec-26.

39 *Fort to Native Town:* Kidambi, P. (2016). *The Making of an Indian Metropolis: Colonial Governance and Public Culture in Bombay, 1890-1920*. Oxford, England, Routledge.

39 *literate Maharashtrian middle classes:* Ibid.

40 *chawl:* https://en.wikipedia.org/wiki/Chawl

40 *boots-and-stockings:* KANETKAR, p. 42.

40 *her experiences thus:* DALL, p. 86.

41 *shared his worries:* KANETKAR, p. 44.

42 *too committed to his desire:* KANETKAR, p. 45.

CHAPTER 3. A DOOR OPENS

43 *letters from and about missionaries:* Wilder, R. G. (1878). *The Missionary Review*, Volume I. Princeton, NJ. pp. 47-50.

44 *full of charms:* Parchure, Atre, Omkar (eds.)(1997). *Anandi-Gopal: New Profiles from Published Sources*. Pune, India: Bharatiya Itihas

Sankalan Samiti, Maharashtra. *Carpenter, T. E. to Anandibai Joshee Roselle* 07/12/1880, p. 106.

44 *drawn to a letter written by a man named Gopal Joshee:* Wilder, R. G. (1878) *The Missionary Review*, Volume I. Princeton, NJ, pp. 47-50.

45 *work for a religion: Chicago Tribune* 1893-Oct-10, p. 3.

47 *taken a pass on winning souls for Christ:* Anandibai Joshee to Mrs. B. F. Carpenter. Bhuj 1880-Nov-11, *Letters between Theodocia Carpenter and Anandi Joshee.* Carpenter family private collection.

47 *forefront of bringing progress to the province: Gazetteer of the Bombay Presidency,* Volume V: Cutch, Palanpur, and Mahi Kantha (1880). Bombay: Government Central Press, p. 205.

48 *Vinayak-rao Bhagwat:* KANETKAR, p. 50.

48 *book fund: The Gujarat Government Gazette/The Gazette of India* (1962), p. 1101. (Google Books Search Term: "Vinayakrao Bhagwat Ratnagiri")

48 *Mrs. Battye:* KANETKAR, p. 50.

50 *that unwanted girl babies:* KIRTANE, p. 91.

50 *sati: Gazeteer of the Bombay Presidency:* Poona (1885) p. 209.

50 *an abode of superstition and orthodoxy:* CARPENTER-JOSHEE, Bhuj 1880-Nov-21.

51 *Dear Sister:* KANETKAR, p. 55.

52 *Know that my husband and I are your true friends:* Kanetkar, p. 57.

53 *Sankrant:* CARPENTER-JOSHEE, Bhuj 01/29/1881.

54 *exchanged photographs, locks of hair, and flowers:* DALL, pp. 36-37.

54 *not customary among us:* CARPENTER-JOSHEE, Bhuj 1880-Jun-19.

55 *do not expect much encouragement:* CARPENTER-JOSHEE, Bhuj 1880-Nov-15.

55 *are saved alike:* CARPENTER-JOSHEE, Bombay Presidency 1881-Mar-15.

55 *all these luxuries are for men:* CARPENTER-JOSHEE, Bhuj 1880-Jun-19.

55 *indecent to let them get the knowledge:* CARPENTER-JOSHEE, Bhuj 1880-Nov-01.

56 *her head is shaved:* CARPENTER-JOSHEE, Bhuj 1880-Nov-01.

57 *do not share the old prejudices:* CARPENTER-JOSHEE, Calcutta 1881-Aug-17.

57 *circumstances which enfeeble women:* CARPENTER-JOSHEE, Calcutta 1881-Aug-17.

58 *no taste for reading correspondence:* CARPENTER-JOSHEE, Bhuj 1880-Nov-15.

59 *call you my aunt:* CARPENTER-JOSHEE, Kalyan 1881-Jan-29.

60 *field of labor:* CARPENTER-JOSHEE, Roselle 1880-Jun-03.

61 *Seekers after knowledge:* CARPENTER-JOSHEE, Roselle 1880-Jun-03.

61 *try to convert me by letter:* PARCHURE, p. 110.

CHAPTER 4. FRIENDS IN A STRANGE LAND

63 *The History of the Origin of All Things:* Arnold, L. M. (1852).
 The History of the Origin of All Things. New York: Fowlers and Wells.

63 *Principles of Nature:* King, Maria (1880). *Principles of Nature,*
 Volume I. Boston: Colby & Rich.

68 *confidential clerk and silent partner:*
 https://tinyurl.com/radspi-0401.

69 *Spiritualism:* https://en.wikipedia.org/wiki/Spiritualism

69 *The Principles of Nature:* Davis, A. J. (1852). T*he Principles of
 Nature, Her Divine Revelations, and a Voice to Mankind.* Boston:
 Colby & Rich, Banner Publishing House.

70 *not all feminists were Spiritualists:* Braude, Ann (2001). *Radical
 Spirits: Spiritualism and Women's Rights in Nineteenth-century Amer-
 ica.* Bloomington and Indianapolis: Indiana University Press, p. 3.

70 *Woman's freedom is the world's redemption:* Ibid, p. 57.

71 *Arthur Conan Doyle:* https://tinyurl.com/radspi-0403

71 *Mark Twain:* Phipps, W. E. (2003). *Mark Twain's Religion.* Macon,
 GA: Mercer University Press, p. 320.

71 *two siblings who were Spiritualists:* https://www.harrietbeecher-
 stowecenter.org/harriet-beecher-stowe/family/

71 *Mary Todd Lincoln:* Horowitz, Mitch (2009). *Occult America: The
 Secret History of how Mysticism Shaped Our Nation.* New York:
 Bantam Books. pp. 58-62.

71 *skeptics:* Braude, Ann (2001). *Radical Spirits: Spiritualism and
 Women's Rights in Nineteenth-century America.* Bloomington and In-
 dianapolis: Indiana University Press, pp. 45-46.

71 *in the late 1870s:* http://uudb.org/articles/spiritualism.html

72 *Jeremiah Eighmie:* Jones, A. T. (1910). *A Psychic Autobiography.*
 New York: Greaves Publishing Company, pp. 267, 271, 449.

72 *Hicksite Society of Friends:* https://tinyurl.com/radspi-0401 .

73 *Madame Blavatsky and Colonel Olcott:* Horowitz, Mitch (2009).
 *Occult America: The Secret History of how Mysticism Shaped Our
 Nation.* New York: Bantam Books, pp. 46-47.

CHAPTER 5. PREPARING FOR TAKEOFF

75 *unexpected development:* CARPENTER-JOSHEE, Calcutta 1881-Apr.

75 *center of progressive thought:* Kopf, D. (1969). *British Orientalism*

and the Bengal Renaissance. Berkeley and Los Angeles: University of California Press.

75 **education were enormous:** Lourdusamy, J. *Science and Educational Consciousness in Bengal 1870-1930.* New Delhi: Orient Longman Private Limited.

75 **get to know more Europeans:** http://uudb.org/articles/charlesdall.html

76 **Second City of the British Empire:** Dutta, K. (2003). *Calcutta: A Cultural and Literary History.* Oxford: Signal Books Limited, pp. viii, 22, 115, front cover.

76 **Cashmere, Afghanistan, China:** Mattson, Hans (1891). *Reminiscences: The Story of an Emigrant.* Saint Paul: D. D. Merrill Company, p. 175.

76 **German landlady:** CARPENTER-JOSHEE, Calcutta Park Street P.O. 1881-May-09.

80 **Patwardhan and Dandekar:** KIRTANE, p. 104.

80 **bow down before me:** CARPENTER-JOSHEE, Serampore 1882-May-16.

81 **Rama-bai Dongre:** Chakravarti, U. (2013). *Rewriting History: The Life and Times of Pandita Ramabai.* New Delhi: Zubaan.

81 **rejected and even shunned:** DALL, preface.

82 **seem less daunting:** CARPENTER-JOSHEE, Calcutta 1881-Oct-17.

82 **actual plans:** CARPENTER-JOSHEE, Barrackpore P.O. 1882-Mar-20.

82 **high cost of passage:** CARPENTER-JOSHEE, Serampore 1882-Aug-12.

83 **understandably exuberant:** CARPENTER-JOSHEE, Serampore 1882-Nov-28.

83 **without Gopal by her side:** CARPENTER-JOSHEE, Calcutta 1881-Oct-17.

83 **were not pleased at all:** KIRTANE, p. 121.

84 **warm supportive tone:** CARPENTER-JOSHEE,Roselle, NJ 1882-Dec-31.

85 **Benjamin Joy:** https://tinyurl.com/radspi-0501

85 **Hans Mattson:** Mattson, Hans (1891). *Reminiscences: The Story of an Emigrant.* Saint Paul: D. D. Merrill Company.

91 **thriving literary and artistic culture:** Dutta, K. (2003). *Calcutta: A Cultural and Literary History.* Oxford: Signal Books Limited.

91 **Brahmo Samaj:** Kopf, D. (1979).*The Brahmo Samaj and the Shaping of the Modern Indian* Mind. Princeton, NJ: Princeton University Press, pp. 15-20.

91 **Theosophical Society:** http://www.blavatskyarchives.com/sen.htm Reprinted from *The Indian Mirror* (Calcutta), Vol. XXII, April 14, 1882, p. 2.

91 **an angry reaction:** DALL, p. 80.

92 **she should give the speech:** Ibid.

92 **exceed his wildest expectations:** KIRTANE, p. 124.

93 **published in its entirety:** Native Opinion (1883). *A Speech by a Hindu Lady* (Mrs. Anandibai Joshi) [on her projected visit to America, to study medicine]. British Library.

97 **congratulatory notes:** DALL, p. 92.

97 **H. E. M. James:** DALL, p.113.

97 **Postmaster General of Bengal:** Buckland, C. E. (1906). *Dictionary of Indian Biography.* New York: Haskell House Publishers Ltd., p. 220.

98 **sent a report:** DALL, p. 105.

98 **Frank Leslie's Sunday Magazine:** Talmage, T. D. (Editor). *Frank Leslie's Sunday Magazine.* Volume XIV. New York: Frank Leslie's Publishing House, p. 209.

CHAPTER 6. CROSSING OVER

100 **response was disappointing:** *Mama Goheen to Anandibai Joshee,* Panhala 1882-Oct-19.

101 **was not persuaded:** CARPENTER-JOSHEE, Serampore 1883-Jan-18.

102 **Thoburn cautioned him:** CARPENTER-JOSHEE, Serampore 1883-Feb-13.

102 **missionary rate:** CARPENTER-JOSHEE, Serampore 1883-Feb-13.

102 **met with Mrs. Johnson:** KANETKAR, pp. 143-144.

104 **as a mother would:** KIRTANE, p. 136.

104 **response was extremely upsetting:** KANETKAR, p. 119.

104 **terribly disappointed:** Kirtane, A. (1997, 2003). *Dr. Anandibai Joshee Kaal ani Kartritva.* Mumbai, India: Majestic Prakashan, p. 137.

104 **as self-sufficient as possible:** KANETKAR, p. 119.

105 **full of anticipation:** DALL, p. 93.

105 **consumed by fuel storage:** https://tinyurl.com/radspi-0601 .

105 **packet boats:** https://en.wikipedia.org/wiki/Packet_boat.

105 **City of Calcutta:** http://www.clydeships.co.uk/view.php?ref=23466

105 **coast of Ceylon:** https://tinyurl.com/radspi-0602 *The Theosophist* October 1883, (pdf) pp. 50-51.

107 **made no reply:** https://tinyurl.com/radspi-0602 *The Theosophist* October 1883, (pdf) pp. 50-51.

107 **ayahs:** *ayah* is a maidservant or other female help. In the race, caste and class-based Indian and European society of the time, the *ayahs* occupied a decidedly low rung in the hierarchy. Familiar with the way the society was structured, Anandi recognized, rightly, that her companions were seeing her as one of the poor, illiterate, and "low caste" domestic help and not as the educated, cultured, and, "high caste" woman that she was.

108 **swollen gums:** https://tinyurl.com/radspi-0602 *The Theosophist* October 1883, (pdf) pp. 50-51.

108 **my repose disturbed:** https://tinyurl.com/radspi-0602 *The Theosophist* October 1883, (pdf) pp. 50-51.

108 **a fine alternative companion:** https://tinyurl.com/radspi-0602. *The Theosophist* October 1883, (pdf) pp. 50-51.

109 **willing martyr:** https://tinyurl.com/radspi-0602 *The Theosophist* October 1883, (pdf) pp. 50-51.

110 **first letter to Anandi:** KANETKAR, pp. 125-126.

111 **face social criticism:** KANETKAR, pp. 125-126.

111 **wrote to Benjamin Carpenter:** DALL, p. 93.

112 **Victoria Dock:** KIRTANE, p. 155.

112 **accommodate large steam ships:** https://en.wikipedia.org/wiki/Royal_Victoria_Dock

112 **London Lodging House:** KANETKAR, p. 145.

112 **room of her own:** KANETKAR, p. 145.

112 **laugh at her attire:** KANETKAR, p. 145.

112 **group of Irish bystanders:** KIRTANE, pp. 156-157.

113 **joyful proclamation:** KANETKAR, p. 145.

113 **City of Berlin:** https://en.wikipedia.org/wiki/SS_City_of_Berlin and http://www.norwayheritage.com/p_ship.asp?sh=ciber.

113 **erstwhile tormentors:** https://tinyurl.com/radspi-0602. *The Theosophist* October 1883, (pdf) pp. 50-51.

CHAPTER 7. SUMMER OF JOY

118 **June 5, 1883:** "Passengers Arrived" Section. *New York Times* p. 8, Column 7.

119 **would be in safe hands:** https://tinyurl.com/radspi-0602. *The Theosophist* October 1883, (pdf) pp. 50-51.

119 **Theodocia graciously invited:** "Mrs. Anandibai Joshi" *Times of India* 1883-Aug-25, p. 3.

119 **visitors began to pour in:** "Mrs. Anandibai Joshi" *Times of India* 1883-Jul-17, p. 3.

120 **summarized her first day in America:** "Mrs. Anandibai Joshi" *Times of India* 1883-Jul-17, p. 3.

120 **sent a letter:** "Mrs. Anandibai Joshi" *Times of India* 1883-Aug-25, p. 3.

121 **changed her mind about Mrs. Johnson:** "Mrs. Anandibai Joshi" *Times of India* 1883-Aug-25, p. 3.

121 **attended church:** DALL, p. 117.

121 **zealous missionary ladies:** DALL, p. 51. *Joshee, Anandibai to Carpenter*, T. E. Barrackpore Post Office, 1881-Dec-26.

121 *mental photograph:* DALL, preface.

122 *she had written to Theodocia:* CARPENTER-JOSHEE, Bhuj
 1880-Dec-15.

122 *very beautiful:* DALL, p. 117.

123 *traditional Indian feast:* DALL, pp. 97-100.

125 *first village:* https://tinyurl.com/radspi-0701

125 *visited Tiffany's:* DALL, p. 96.

125 *palace of jewels:* Christopher Gray (07/02/2006). "Before Tiffany
 & Co. Moved Uptown." *The New York Times.*

125 *Highland Park:* KANETKAR, pp. 153-154.

126 *happiest period:* DALL, p.96.

126 *silent till the next mail day:* DALL, p. 100.

126 *mother's anguish:* KANETKAR, p. 127.

127 *far more serious:* KANETKAR, pp. 132-133.

128 *would scrutinize:* CARPENTER-JOSHEE, Calcutta 1881-Oct-17.

128 *shawl passing between the legs:* DALL, p. 102.

129 *questioned even its underlying meaning:* DALL, p. 106.

129 *specialized in homeopathy:* White, F. E. (1895). *Medical News.*
 Philadelphia: Lea Brothers and Company, pp. 123-125.

129 *keen on admitting:* KANETKAR,p. 157.

129 *Charles Eliot:* https://tinyurl.com/radspi-0702 .

130 *Elizabeth Blackwell:* https://tinyurl.com/radspi-0703

131 *Woman's Medical College of Pennsylvania:* Peitzman, S.J. (2000).
 A New and Untried Course. New Brunswick, NJ: Rutgers
 University Press.

131 *New York Infirmary:* https://tinyurl.com/radspi-0704.

131 *Even two decades after:* Regina Morantz-Sanchez (2005).
 Sympathy and Science: Women Physicians in American Medicine.
 Chapel Hill, NC: University of North Carolina Press, p. 8.

131 *coarse and insulting reaction:* Ibid, p. 9.

132 *Marie Mergler:* Mergler, M. (1896). *Woman's Medical School,*
 Northwestern University (Woman's Medical College of Chicago):
 The Institution and Its Founders : Class Histories, 1870-1896.
 Chicago: H. G. Cutler, p. 92.

133 *Anna Thoburn:* Thoburn, Anna to Dean Bodley. Calcutta 1882-
 Nov-27.

134 *Theodocia also sent a letter:* Carpenter, T.E. to Dean Bodley.
 Roselle 1883-Jun-18.
 http://xdl.drexelmed.edu/item.php?object_id=1339 and
 http://xdl.drexelmed.edu/item.php?object_id=1338

135 *Arthur Jones:* Dean Bodley to Jones, A. Dean's Office Philadelphia
 1883-Jun-19. http://xdl.drexelmed.edu/item.php?object_id=1337

135 *Mrs. Gracey:* http://xdl.drexelmed.edu/item.php?object_id=1374

136 *from Anandi herself:*
 http://xdl.drexelmed.edu/item.php?object_id=1374
138 *scholarship of six hundred dollars:* KANETKAR, pp. 157.

CHAPTER 8. COLLEGE LIFE

139 *Theodocia's cousin:* CARPENTER-JOSHEE, Philadelphia
 1883-Oct-22.
139 *treasured possession:* KANETKAR, p. 173.
140 *attending school:* CARPENTER-JOSHEE, Barrackpore Post Office
 1881-Dec-26.
141 *the Bodley home:* 1400 North 21 Street in Philadelphia. College:
 North College Ave near Girard College.
141 *first sight of Anandi:* Pundita Ramabai Saraswati (1888). *The High
 Caste Hindu Woman.* London: George Bell and Sons. Introduction.
142 *Mrs. Hallman:* CARPENTER-JOSHEE, Philadelphia 1883-Oct-05.
142 *tend a fire:* KANETKAR, pp. 169-170.
142 *Miss Florence Sibley:* Graduated In 1884. Drexel University
 School of Medicine Archives. https://tinyurl.com/radspi-0801
142 *international students:* There were at least two students from
 India in Anandi's class of thirty-three. Isabella Cowie from Calcutta
 and Jessica Carlton from Ambala, North India. List of Matricu-
 lates. Drexel University School of Medicine Archives.
 Img_0581.jpg.
143 *professional class:* https://tinyurl.com/radspi-0602 *The Theosophist*
 December 1883, (pdf) pp. 139-140.
143 *great opposition:* "A Brahmin Lady in America." *Times of India*
 1883-Dec-01.
144 *Caroline Dall:* http://uudb.org/articles/carolinedall.html
144 *Dall's diary entry:* DALL, p. 115.
144 *not a common Hindoo trait:* DALL, p. 117.
144 *Austin Weekly Statesman:* 1883-Oct-18. p. 3, Column 3.
 https://tinyurl.com/radspi-0803A
145 *obituary poetry:* https://en.wikipedia.org/wiki/Obituary_poetry
145 *hearts and minds:* DALL, pp. 115-117.
145 *good-hearted indeed:* KANETKAR, p. 172.
145 *editor's note:* https://tinyurl.com/radspi-0602 *The Theosophist*
 December 1883, (pdf) pp. 139-140.
146 *overwhelmed by loneliness:* KANETKAR, p. 172.
149 *continued to worry:* PARCHURE, p. 136.
149 *highly critical letter:* KANETKAR, pp. 184-185.
149 *worry and anxiety:* PARCHURE, p. 146.
150 *Bhaskar Vinayak Rajwade:* KANETKAR, pp. 160, 182.

150 *surmised—disapprovingly:* Parchure, p. 144.

152 *course of instruction:* Kanetkar, p. 180. Also, *Drexel University School of Medicine Archives,* Img_0575.jpg to Img_0579.jpg

153 *study regimen:* Kirtane p. 225.

153 *Charlotte Abbey:* List of Matriculates *Drexel University College of Medicine Archives.* Img_0581.jpg

153 *Charlotte's great-grandmother:* Kanetkar, p. 204.

154 *Asiatic Society in Calcutta:* https://tinyurl.com/radspi-0805

154 *first cousin and namesake:* Chernow, R. (2005). *Alexander Hamilton.* New York: Penguin Group, p. 140.

155 *motherly tenderness: Drexel University College of Medicine Archives.* Img_0621.jpg.

155 *prospects of conversion: Drexel University College of Medicine Archives,* Img_0621.jpg.

155 *comparative study:* Parchure, p. 150.

156 *a distraction and a burden:* Parchure, p. 152.

156 *Bhau Beej:* https://en.wikipedia.org/wiki/Bhai_Dooj

157 *boundless joy:* Kanetkar, pp. 191-193.

158 *returning to Roselle:* Dall, p. 107.

158 *flexibility and convenience:* Parchure, p. 156.

Chapter 9. A Life of the Mind

160 *wheel-less cart:* Kanetkar, p. 221.

161 *not show it to anyone*: Parchure, p. 157.

161 *a letter from Grace*: Parchure, p. 158.

161 *beginning in 1853:* Badley, B. H. (1881). *Indian Missionary Directory and Memorial.* Lucknow: Methodist Episcopal Church Press, p. 139.

161 *remained passionate missionaries:* https://tinyurl.com/radspi-0901A

162 *Eliza Jane and Grace:* Russell, T. A. (2017). *Women Leaders in the Student Christian Movement: 1880-1920.* Maryknoll, NY: Orbis Books."Grave Evelyn Wilder".

162 *a kind of enslavement:* Parchure, p. 196.

162 *bottle up the snow:* Kanetkar, pp. 215-217.

162 *Fresh snow is like sugar:* Kanetkar, p. 221.

163 *growing bald spot*: Parchure, p. 161.

163 *diphtheria:* Dall, p. 108.

163 *caused her much worry:* Kirtane, p. 238.

163 *hands and legs start to shake:* Kanetkar, pp. 209.

163 *I feel very feeble:* Carpenter-Joshee, Philadelphia 1884-Oct-21.

163 *bitter enemy:* Dall, p. 108.

164 *her own internal resources:* DALL, p. 108.

164 *distressing letter from Gopal:* PARCHURE, p. 146.

165 *freedom to use her own judgment:* KANETKAR, p. 187.

165 *charitable explanation:* KANETKAR, p. 186.

165 *restrained and compassionate:* KANETKAR, p. 178.

166 *uncharacteristically forceful response:* KANETKAR, p. 188.

168 *concern was further amplified:* KANETKAR, pp. 197-198.

169 *dry letters:* KANETKAR, p. 236.

169 *sell her gold jewelry:* KANETKAR, p. 212.

169 *give her a new name:* KANETKAR, p. 202.

170 *truth and moral clarity:* KANETKAR, p. 194.

170 *love for all humanity:* KANETKAR, p. 202.

171 *wisdom and forethought:* KANETKAR, pp. 217-218, 224.

171 *in favor of returning home:* KANETKAR, p. 201.

171 *nominated by Providence:* KANETKAR, pp. 197, 202.

171 *Exasperated:* KANETKAR, p. 215.

172 *not share her letters:* KANETKAR, pp. 222, 227.

172 *drawn to many topics:* KANETKAR, p. 222.

172 *tug of war:* KANETKAR, p. 227.

173 *wild flowers and leaves:* KANETKAR, p. 210.

173 *French and Greek: Bhaskar to Anandibai Joshee,* Bombay: 1884-Aug-05.

173 *lack of time:* KANETKAR, p. 227.

173 *dialogue about Sanskrit:* KANETKAR, p. 219.

173 *Hinduism might regard the issues:* KANETKAR, p. 196.

174 *Girard College:* KANETKAR, p. 192.

175 *establishing orphanages in India:* KANETKAR, p. 213.

175 *school for the blind:* KANETKAR, p. 234.

175 *Norristown State Hospital:* https://tinyurl.com/radspi-0902

176 *resist the barely veiled criticism:* KANETKAR, pp. 204-205.

177 *Enlightenment concept of childhood:* http://chnm.gmu.edu/cyh/teaching-modules/230 .

178 *husband could support his wife:* https://tinyurl.com/radspi-0903

178 *US Census in 1890:* Haines, M. R. and Steckel, R. H. (2000). *A Population History of North America.* Cambridge, UK: Cambridge University Press, p. 319.

178 *close association with missionaries in foreign lands:* Mrs. George A. Paul (1894). Pierson, A. T. (Ed.). *The Missionary Review of the World, Volume 17.* New York: Funk and Wagnalls Company, pp. 267-270.

178 *well-acquainted with the ills:* KIRTANE, p. 246.

178 *genuine efforts to understand:* Pundita Ramabai Saraswati (1888), *The High Caste Hindu Woman.* London: George Bell and Sons, Introduction.

178 *genuine efforts to understand:* DALL, p. 109.
180 *over two thousand women:* PARCHURE, p. 167.

CHAPTER 10. THE YEAR OF CULTURAL EXPLORATION
181 *loving kindness:* KANETKAR, pp. 231-232.
182 *Charles Henry Appleton Dall:*
http://uudb.org/articles/charlesdall.html
182 *Charles G. Ames: The Unitarian Register, Volume 91.* American Unitarian Association. p. 363.
183 *Anandi's relationship to Ames:* DALL, p. 157.
183 *juxtaposed Hindu and Unitarian beliefs:* KANETKAR, pp. 199-201.
184 *market for Indian tea in America:* KANETKAR, p. 230.
185 *health and horses:* https://tinyurl.com/radspi-1001
185 *New York Herald:* 1884-Aug-03. *New York Herald.*
186 *wearing corsets:* KANETKAR, p. 208.
187 *the two "Indian" women:* DALL, p. 110.
187 *beautiful box:* KANETKAR, p. 239.
187 *modes of transport:* KANETKAR, p. 173.
187 *spread and adoption of electricity:*
https://tinyurl.com/radspi-1002
188 *entirely electrical in character:* Freeberg, E. (2013). *The Age of Edison: Electric Light and the Invention of Modern America.* New York: Penguin Books. "Inventive Nation."
188 *I enjoyed it very much:* DALL, p. 111.
189 *Ethnological Congress:* Goodall, J. (2002). *Performance and Evolution in the Age of Darwin: Out of the Natural Order.* London: Routledge, pp. 96-99.
190 *no pleasure whatsoever:* DALL, p. 109.
191 *Govind Sathe:* DALL, C. H. (1889). *The Unitarian Review.* Volume 31. Boston: Office of the Unitarian Review, pp. 401-410.
191 *Benjamin met Govind:* PARCHURE, p. 198.
192 *sit here and study:* CARPENTER-JOSHEE, Philadelphia:1884-Nov-22.
192 *flew into a rage:* KANETKAR, pp. 238, 250-251.
193 *December 26, 1884:* DALL, p. 117-120.
195 *James Walker:* United States Naval Institute (1913). Naval Institute Proceedings, Volume 39, p. 1257.
195 *John Wesley Powell:* https://tinyurl.com/radspi-1003

CHAPTER 11. CAUGHT IN THE MIDDLE
196 *doctor-in-training:* DALL, p. 111.
196 *following month she wrote:* CARPENTER-JOSHEE, Philadelphia:

1884-Nov-22.

197 *saved as much money as he could:* KANETKAR, p. 235.
197 *saved as much money as he could:* PARCHURE, p. 169.
197 *dismantled the home:* KANETKAR, p. 235.
197 *orange robe:* KANETKAR, p. 235.
198 *newspapers in India:* PARCHURE, p. 173.
199 *the Parsis of Hong Kong:* PARCHURE, pp. 188-189.
199 *independence of the local women:* PARCHURE, p. 175.
199 *looked forward to going there:* PARCHURE, p. 176.
199 *not under the control:*
 https://en.wikipedia.org/wiki/Straits_Settlements
200 *criticized Western civilization: China Mail.* Hong Kong, p. 2.
 1884-Nov-26.
203 *As Others See Us: The Straits Times,* p. 6. 1884-Dec-20.
204 *timid to go out:* CARPENTER-JOSHEE, Philadelphia:1885-Jan-26.
204 *began to eat eggs:* CARPENTER-JOSHEE,. Philadelphia:1885-Jan-26.
204 *patient with herself:* CARPENTER-JOSHEE,Philadelphia:1885-Jan-
 26.
205 *felt unfairly judged:* CARPENTER-JOSHEE, Philadelphia:1885-Jan-26.
205 *where her Christian duty lay: Drexel University College of Medicine
 Archives,* Img_0621.jpg.
206 *Prof. Bodley has commenced:* CARPENTER-JOSHEE, Philadelphia:
 1885-Feb-12.
208 *diagnosed her own headaches:* CARPENTER-JOSHEE, Philadelphia:
 1885-Mar-29.
208 *exhausted by his very lengthy journey:* CARPENTER-JOSHEE,
 Philadelphia:1885-Mar-16.
209 *asking only for Theodocia's advice:* CARPENTER-JOSHEE,
 Philadelphia:1885-Mar-16.
210 *greet one another when they were reunited:* PARCHURE, p. 209.
210 *prepare him for this change in her:* KANETKAR, p. 242.
211 *lecturer in Sanskrit:* KANETKAR, p. 241.
212 *true measure of her dilemma:* KANETKAR, pp. 248-249.
213 *decreased bank balance:* KANETKAR, p. 249.
215 *forceful about criticisms:* KANETKAR, pp. 250-251.

CHAPTER 12. GOPAL IN AMERICA

217 *huge oriental turban:* Debs, E. V. (Editor). "Out in the World."
 Brotherhood of Locomotive Firemen and Enginemen's Magazine,
 Volume 9. June 1885. Terre Haute, IN, p. 355.
217 *Lyceum Movement:* https://tinyurl.com/radspi-1201
217 *desirable platform for celebrities:* Ray, A. G. (2005). *The Lyceum*

and Public Culture in the Nineteenth-Century United States. East Lansing, MI: Michigan State University Press.

218 ***Domestic Monthly:***"Notes and Comments." *The Domestic Monthly: An Illustrated Magazine of Fashion, Literature, and the Domestic Arts, Volume 23.* New York: Blake and Company, p. 199.

220 ***Brahmin Theologist:*** "A Brahmin Theologist: A Hindoo Talks Religion and Politics." *San Francisco Chronicle.* 1885-Apr-20.

221 ***Sacramento Bee:*** "American Institutions as seen through Hindoo Glasses." reprinted in *Fort Wayne Daily Gazette*, 1885-Aug-08, p.2.

222 ***Leland Stanford:*** https://en.wikipedia.org/wiki/Leland_Stanford

222 ***Charles Crocker:*** https://en.wikipedia.org/wiki/Charles_Crocker

223 ***Salt Lake Tribune:*** "Distinguished Brahmin." *Salt Lake Herald,* 1885-Jun-18, p. 9.

224 ***leavened with open-mindedness:*** "Mormon Tolerance" *Salt Lake Tribune*, 1885-Jul-02, Salt Lake City, UT. Page 3.

225 ***Hindoo Tiger:*** "The Hindoo Tiger Hunts His Christian Foe" *Salt Lake Tribune,* 1885-Jul-02 Salt Lake City, UT. p. 4.

226 ***Dall read the newspaper reports:*** DALL, p. 124.

226 ***she noted the effect:*** DALL, p. 124.

227 ***sitting in a chair:*** KANETKAR, p. 252.

227 ***visit the churches of two eminent ministers:*** DALL, p. 124.

228 ***Rev. Talmage's sermons:*** https://tinyurl.com/radspi-1205

228 ***Rev. Henry Ward Beecher:*** https://en.wikipedia.org/wiki/Henry_Ward_Beecher

229 ***personally met them:*** KANETKAR, p. 253.

229 ***Green-Wood Cemetery:*** https://www.green-wood.com/about-history/

230 ***pelvic affliction:*** CARPENTER-JOSHEE, Philadelphia, 1885-Nov-02.

230 ***commission and omission:*** CARPENTER-JOSHEE, Philadelphia, 1885-Nov-04.

230 ***trip to Washington:*** DALL, p. 124.

231 ***reluctantly canceled plans:*** CARPENTER-JOSHEE, Philadelphia, 1885-Nov-22.

231 ***chose the latter:*** CARPENTER-JOSHEE, Philadelphia, 1885-Dec-17.

231 ***Theodocia helped:*** CARPENTER-JOSHEE, Philadelphia, 1885-Dec-17.

CHAPTER 13. COMMENCEMENT

232 ***write theses:*** "Requirements for Graduation" The Drexel University School of Medicine Legacy Center. Img_0580.jpg.

232 ***class of 1886:*** "Commencement" The Drexel University School of Medicine Legacy Center. Img_0574.jpg.

232 ***Obstetrics among the Aryan Hindoos:*** The Drexel University

School of Medicine Legacy Center.

232 *fifty pages:* CARPENTER-JOSHEE, Philadelphia: 1886-Jan-31.

233 *Frederic Tudor:* https://en.wikipedia.org/wiki/Frederic_Tudor

233 *ship blocks of ice:* Weightman, G. (2004). *The Frozen Water Trade.* New York: Hachette Books.

233 *only the one in Madras:* https://tinyurl.com/radspi-1301

233 *manufacture ice cheaply in India:* Cohen, B. B. (2015). *In The Club: Associational Life in Colonial South Asia.* Manchester, UK: Manchester University Press, p. 94.

235 *many tracts of merit:* Arnold, D. (2000). *The New Cambridge History of India: Science Technology, and Medicine in Colonial India.* Cambridge University Press, pp. 66-67.

239 *I suppose it is all right:* CARPENTER-JOSHEE,Philadelphia, 1886-Jan-14.

239 *relationship with Gopal continued to worsen:* CARPENTER-JOSHEE, Philadelphia, 1886-Feb-02.

242 *Rama-bai was a true believer:* Kosambi, M. (1988). Women, Emancipation and Equality: Pandita Ramabai's Contribution to Women's Cause. *Economic and Political Weekly*, 23(44), WS38-WS49.

242 *hoped to draw favorable attention:* Kosambi, M. (2003). *Pandita Ramabai's American Encounter: The Peoples of the United States* (1889). Bloomington, IN and Indianapolis, IN: Indiana University Press, p. 241.

243 *joy in having her by her side:* CARPENTER-JOSHEE,. Philadelphia, 1886-Mar-07.

245 *Jaysing-rao Ghatge:* Griffith, M. (1894). *India's Princes: Short Life Sketches of the Native Rulers of India.* London: W. H. Allen & Co. pp. 170-174.

245 *a formal offer was sent:* KIRTANE, pp. 495-497.

245 *Anandi's response to this clause:* DALL, p. 146.

246 *Regent Jaysing-rao Ghatge, passed away:* Griffith, M. (1894). *India's Princes: Short Life Sketches of the Native Rulers of India.* London: W. H. Allen & Co., p. 172.

247 *Rev. Dr. John Scudder:* https://tinyurl.com/radspi-1302

247 *Dr. Clara Swain:* https://en.wikipedia.org/wiki/Clara_Swain

248 *Bodley finally received:* The Drexel University School of Medicine Legacy Center. Img_0604.jpg, Img_0605.jpg, Img_0607.jpg.

248 *Looking ahead to the commencement:* CARPENTER-JOSHEE, Philadelphia, 1886-Jan-31.

248 *physical and mental exhaustion:* CARPENTER-JOSHEE, Philadelphia, 1886-Mar-07.

249 *Academy of Music:* https://tinyurl.com/radspi-1303

250 *newspaper report:* Kosambi, M. (2003). *Pandita Ramabai's American Encounter: The Peoples of the United States* (1889). Bloomington, IN and Indianapolis, IN: Indiana University Press, p. 3.

250 *commencement speech:* KIRTANE, pp. 483-494.

251 *aroused to an interest:* Hardy, A. and Conrad, L. (Editors)(2001). *Women and Modern Medicine.* Amsterdam, New York: Editions Rodopi B. V., p. 50.

251 *observed of all observers:* DALL, pp. 134-135.

252 *Rama-bai electrified her audience:* DALL, pp. 135-136.

253 *The High-Caste Hindu Woman:* Pundita Ramabai Saraswati (1888). *The High-Caste Hindu Woman.* London: George Bell and Sons.

253 *Anna Thoburn:* PARCHURE, pp. 257-258.

254 *letter to the Unitarian Index:* Potter, W. J. (Editor) and Underwood, B. F. (Editor). *The Index ...: A Weekly Paper,* Volume 6; Volume 17. Boston: Free Religious Association, pp. 421, 433, 476, 546.

254 *noticed the change in Anandi:* DALL, p. 140.

255 *offered Anandi an internship:* CARPENTER-JOSHEE, Philadelphia, 1886-Jan-31.

255 *Empress of India:* https://tinyurl.com/radspi-1304

256 *Queen Victoria's disdain:* Hardie, F. (1963). *The Political Influence of Queen Victoria, 1861-1901.* Frank Cass and Co Limited, pp. 139-140.

257 *understated and indirect manner:* "By the Queen's Command." *Public Ledger and Daily Transcript.* 1886-Aug-03. The Drexel University School of Medicine Legacy Center. http://xdl.drexelmed.edu/item.php?pbject_id=1373

CHAPTER 14. PROFESSIONAL WOMAN

258 *New England Hospital for Women and Children:* https://dimock.org/about/our-history/

258 *Dr. Elizabeth Keller:* Regina Morantz-Sanchez (2005). *Sympathy and Science: Women Physicians in American Medicine.* Chapel Hill, NC: University of North Carolina Press, pp. 9-10, 167, 221.

259 *despite a late application:* CARPENTER-JOSHEE,Philadelphia, 1886-Jan-31.

259 *duties commenced immediately:* DALL, pp. 148-150.

259 *a civil war in me:* CARPENTER-JOSHEE, Boston, 1886-May-12.

260 *St. Louis Obstetrical and Gynecological Society:* https://tinyurl.com/radspi-1401.

260 *a fine hospital:* CARPENTER-JOSHEE, Boston, 1886-May-12.

261 *missionaries and ice:* https://tinyurl.com/radspi-1402.

262 *teas at the Woman's Club:* DALL, p. 151.

262 *Free Religious Association:* https://tinyurl.com/radspi-1403.

262 *give up her studies at the Hospital:* DALL, p. 152.

263 *wide-ranging conversation:* DALL, pp. 154-155.

264 *excoriated Christianity:* DALL, p. 156.

267 *letter to her mother-in-law:* KANETKAR, pp. 263, 269.

270 *strawberry fields:* CARPENTER-JOSHEE,Boston, 1886-Jul-11 and 1886-Jul-15.

270 *crazy quilt:* https://en.wikipedia.org/wiki/Crazy_quilting .

270 *complete her crazy quilt:* This quilt is on display at the Raja Dinkar Kelkar Museum in Pune, India. https://tinyurl.com/radspi-1404.

270 *more acutely than before:* CARPENTER-JOSHEE, Boston, 1886-Jul-20.

271 *speech in Rochester:* "A Hindoo's Impressions of America: A Lecture Delivered in Rochester, NY on Aug. 19, 1886 by Gopal Vinayak Joshee" Available in the archives of New York Public Library.

273 *Woman's Hospital in Philadelphia:* KANETKAR, p. 268.

274 *Theodocia described her condition:* DALL, p. 169.

275 *Extra time had been allotted:* DALL, p. 170.

CHAPTER 15. "I HAVE DONE ALL THAT I COULD"

277 *throws out everything she takes in:* CARPENTER-JOSHEE, from the ship Etruria. Date of receipt unknown.

279 *distrust of the English:* Underwood, B. F. (Editor). *The Index...* Volumes 7-18. "An Indignant Letter from a Hindu Brahmin." 1886-Dec-23. Boston, MA: Index Association, pp. 309-310.

284 *bright spot:* CARPENTER-JOSHEE, from the ship Etruria. Date of receipt unknown.

285 *Indu Prakash:* *Times of India.* "A Hindu Lady Doctor" 1886-Nov-10.

286 *cultured Hindu woman:* KANETKAR, p. 282.

286 *Subodh Patrika:* KANETKAR, p. 283.

286 *admirer sent a letter:* PARCHURE, p. 307.

287 *attend either Cama or J. J. Hospital:* PARCHURE, p. 298.

287 *small tenement homes:* KANETKAR, p. 286.

288 *adhered to the gracious habits:* KANETKAR, p. 293.

288 *subscriptions should be made:* DALL, p. 180.

288 *not much more than skin and bones:* KANETKAR, p. 288.

288 *Local European doctors were consulted:* DALL, pp. 179.

289 *consumption:* CARPENTER-JOSHEE, from the ship Etruria. Date of receipt unknown.

290 *Hindu priests offered to perform puja rituals:* KANETKAR, p. 291

290 *Gopal participated:* KANETKAR, p. 291.

290 *read your letters over and over again:* CARPENTER-JOSHEE, from the ship Etruria. Date of receipt unknown.

290 *Gone was the young woman:* CARPENTER-JOSHEE, Poona, 1887-Feb-28.

291 *her desperate situation:* PARCHURE, p. 325.

292 *Lady Dufferin:* https://tinyurl.com/radspi-1501

293 *Indian Magazine: The Indian Magazine,* Issues 193-204. National Indian Association in Aid of Social Progress and Education in India. pp. 108-109, 152-153.

293 *Lady Reay:* Taleyarkhan, D. A. (1886). "Selections from My Recent Notes on the Indian Empire." *Times of India,* Steam Press, pp. 372-377.

293 *a fellow Indian also sent:* KANETKAR, p. 294.

293 *Bal Gangadhar Tilak:*
https://en.wikipedia.org/wiki/Bal_Gangadhar_Tilak

294 *Vaidya Mehendale:* KIRTANE, pp. 396-401. Detailed exposition of Mehenadale's career background and philosophy.

295 *seven leaves of the adulsa plant:* KANETKAR, p. 293.

295 *begging and pleading for water:* KANETKAR, p. 295.

295 *had to be carried in a chair:* KANETKAR, p. 292.

296 *She would dream:* KANETKAR, p. 295.

296 *role that dreams played:* CARPENTER-JOSHEE, Barrackpore Post Office, 1881-Dec-26.

297 *February 26, 1887 :* KANETKAR, pp. 296-297.

297 *Anandi's last words:* DALL, p. 185.

EPILOGUE

298 *obituaries:* "The Late Dr. Anandibai Joshee." March 1887. *The Voice of India* Volume 5. Bombay: Voice of India Printing Press, pp. 156-159.

300 *Philadelphia Telegraph:* "The Hindu Woman Physician." 1887-Apr-10. *The New York Times.*

302 *begged several able men:* KANETKAR, Introduction, pp. 11-12.

304 *disenchanted with Hinduism:* "A Notable Conversion in India." August 1889. *The Missionary Herald* Vol LXXXV Number VIII, pp. 317-318.

305 *returned formally to the Hindu fold:* "Anandibai Joshee: Retrieving a Fragmented Feminist Image" *Economic and Political*

Weekly, Vol. 31, No. 49 (1996), pp. 3189-3197.

305 *storm in a teacup:* https://tinyurl.com/radspi-1601

306 *Arya Bhagini:* "The Aryabhagini, or Aryan Sister." *The Times of India.* 1890-Nov-07, p. 5.

306 *Rev. Nagarkar: Proceedings of the First American Congress of Liberal Religious Societies* (1894). Chicago: Bloch and Newman Publishers, pp. 51-52.

306 *Brahmo Samaj:* https://en.wikipedia.org/wiki/Brahmo_Samaj .

306 *Jeanne Sorabji:* "An Angry Hindu." *San Francisco Call,* Volume 75, Number 63, 1894-Feb-01. https://tinyurl.com/radspi-1602

306 *Parliament of World Religions:* https://tinyurl.com/radspi-1603

306 *World's Columbian Exposition:* https://tinyurl.com/radspi-1604

307 *described the state of Indian women:* Barrows, J. H. (Ed.). Sorabji, J. (1893). *The World's Parliament of Religions: An Illustrated and Popular Story of the World's First Parliament of Religions,* Held in Chicago in Connection with the Columbian Exposition of 1893, Volume 2. Chicago: The Parliament Publishing Company. "Women of India," pp. 1037-1038.

308 *energetically delivered:* https://chicagovedanta.org/1893.html and https://www.ramakrishna.org/chcgfull.htm

308 *speech by Swami Vivekananda: Jones, J. L. (1893). A Chorus of Faith.* Chicago: The Unity Publishing Company, pp. 56, 163, 193, 280, 297.

308 *October 22 1893:* "Praise for a Martyr" *Chicago Tribune.* 1893-Oct-23.

308 *Jenkin Lloyd Jones:* https://en.wikipedia.org/wiki/Jenkin_Lloyd_Jones

310 *give female names to all features on Venus:* Russell, J, F. (1994). *Gazeteer of Venusian Nomenclature.* https://pubs.usgs.gov/of/1994/0235/report.pdf

INDEX